STEINBERG
AT
THE NEW YORKER

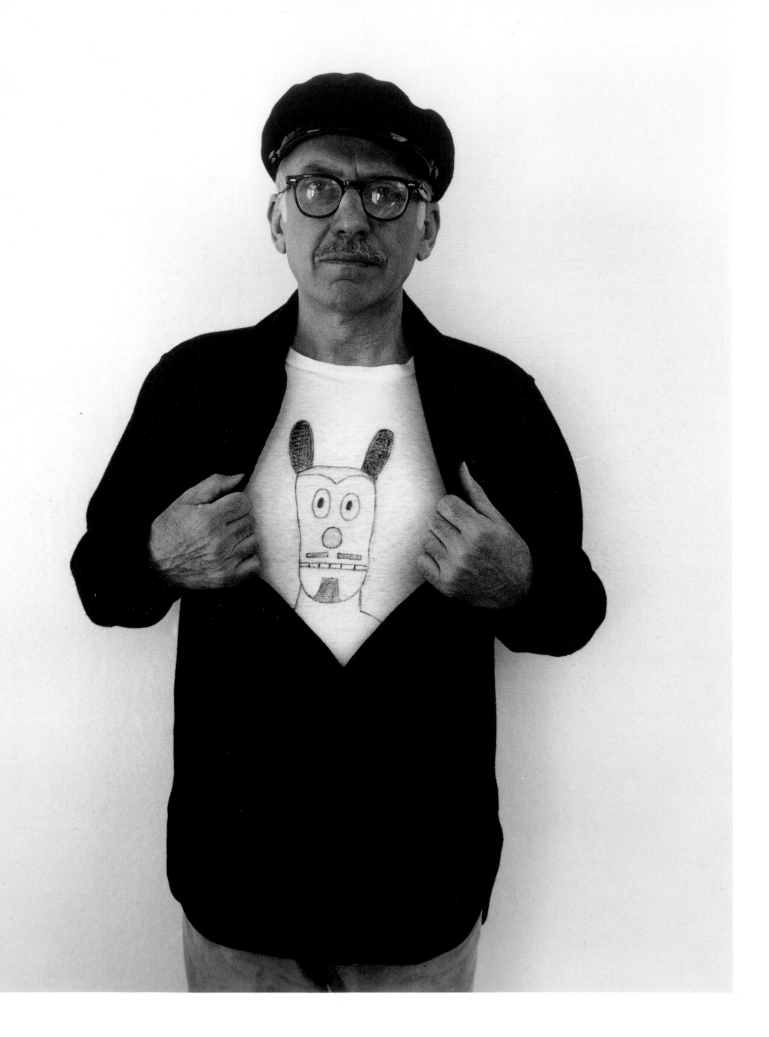

STEINBERG

AT

THE NEW YORKER

Joel Smith

Introduction by Ian Frazier

Harry N. Abrams, Inc., Publishers

Project Managers

The Saul Steinberg Foundation: Sheila Schwartz
The New Yorker: Matt Dellinger
Harry N. Abrams: Christopher Sweet

Designer: Katy Homans
Production Manager: Maria Pia Gramaglia

Library of Congress Cataloging-in-Publication Data

Smith, Joel, 1964-
 Steinberg at the New Yorker / by Joel Smith ; introduction by Ian Frazier.
 p. cm.
 Includes bibliographical references.
 ISBN 0-8109-5901-1 (hardcover : alk. paper)
 1. Steinberg, Saul. 2. Cartoonists—United States—Biography. 3. New Yorker (New York, N.Y. : 1925)
I. Frazier, Ian. II. Steinberg, Saul. III. New Yorker (New York, N.Y. : 1925) IV. Title.

 NC139.S65S58 2005
 741.5'092—dc22

 2004019498

Printed and bound in China

10 9 8 7 6 5 4 3 2 1

Harry N. Abrams, Inc.
100 Fifth Avenue
New York, N.Y. 10011
www.abramsbooks.com

Abrams is a subsidiary of

Contents

6 Preface

8 Introduction by Ian Frazier

13 Steinberg at *The New Yorker*

50 At War

58 Discovering a City

64 American Allegories

68 Travelogue

76 Playland USA

80 Natural History

88 Art World

94 Cat People

100 Thought and Spoken

110 In the Mail

114 Action Writing

122 The Good Life

126 Certified Landscapes

132 Reality Stamped Out

136 On a Pedestal

146 The Sexes

154 Mean Streets

164 Domestic Animals

172 Seeing Through Metaphors

182 A Self-Made World

186 Drawn from Life

190 Steinberg's Century

198 American Scenes

210 Inner City

220 Mapping Time

226 Endnotes

229 Selected Bibliography

230 The Covers, 1945–2004

Preface

Saul Steinberg was one of the most prolific artists of his era and, thanks to the drawings he published for nearly sixty years in *The New Yorker*, one of the most widely seen. The primary aim of this book is to tell the story of an artist and a magazine that, in the course of inventing each other, did much to invent postwar American visual culture. But telling any story of Steinberg means negotiating the deflective masks and baffles of his public persona. An articulate subject of numerous interviews, he was among the most quotable, and mischievous, of self-chroniclers, serving up riffs and anecdotes that were diverting in more than one sense. (It took decades before an early remark, crediting his mother's cake decorations for his beginnings in art, faded from popular profiles of the artist.) While not wishing to spoil Steinberg's sport, I hope that this volume—the first to draw upon documents in the artist's collected papers—succeeds in at least tilting the posthumous study of his life and work toward a more factual basis.

Since his death in May 1999, Steinberg's art has continued to appear in the pages of *The New Yorker*. Initially, only drawings he himself had turned over to the magazine were published, but in more recent years readers have begun seeing some of the many works that he left to The Saul Steinberg Foundation and to the Yale Collection of American Literature. Out of respect for the close self-editing that helped define Steinberg's published oeuvre, the present study is restricted to art that he approved for publication. (The exceptions are the two most recent entries in the cover chronology on pp. 230–39 and one unused cover design which, having proven irresistible, appears on p. 221.)

To date, Steinberg's contributions to *The New Yorker* comprise 89 covers, more than 650 independent cartoons and drawings, and nearly 500 drawings that appeared within multipage features. Over 1,200 drawings in all: enough to fill two thick, oversized books of clippings in the magazine's library. Every fan, the author included, is bound to regret the absence of some favorites from these pages. Besides the need to meet the physical constraints of a book, the painful work of pulling apart and resequencing Steinberg's legacy was guided by a desire to reveal the unity of a body of work rich in styles, ideas, and approaches. What began as a year-by-year survey soon demanded a more flexible format. A pop-historical arc still characterizes the overall plate sequence, which begins in war, traverses national prosperity and its pitfalls, and ends with a wary eye to the twenty-first century. But within each thematic section, chronology takes a backseat to the recurring preoccupations of Steinberg's *New Yorker* work, which transcended the passing of years.

A technical note: until the artist's final decade, *The New Yorker* published inside art in black-and-white only. Some works that were published in the magazine's pre-color days are seen here in color. They have been rephotographed from original art in the collection of The Saul Steinberg Foundation, the better to show the care and subtlety of tonal effect that Steinberg brought even to work intended for reproduction in black-and-white.

The flaws in this book are my own; its merits owe much to the assistance, support, expertise, and generosity of other people. For sharing memories of the artist, his milieu, and the magazine he knew, my thanks go to Roger Angell, R.O. Blechman, Prudence Crowther, Ian Frazier, Lee Lorenz, Frank Modell, Françoise Mouly, Hedda Sterne, and

Anton Van Dalen. The professional dedication of Christopher Sweet, the project's editor at Harry N. Abrams, was invaluable. Katy Homans displayed grace and ingenuity while creating a design that does the same. At *The New Yorker* and Condé Nast Publications, I am indebted to Greg Captain, Denise Benitez and The New Yorker Imaging Center, Chris Curry, Matt Dellinger, Robert Mankoff, Pam McCarthy, Jon Michaud, and Emily Richards. Among the friends whose support means so much, I am especially grateful to Mia Fineman for her critical insights and for her encouragement by word, deed, and example. I owe a unique debt of gratitude to Sheila Schwartz, executive director of The Saul Steinberg Foundation, who first proposed a book of the artist's *New Yorker* covers, and whose engaged advocacy and close attention to detail at all stages of an ever-expanding project have been indispensable.

Joel Smith

Introduction

Ian Frazier

Saul Steinberg once said that after he died he would be reincarnated as a dog's eyebrow. He often made such remarks—the kind that seemed tossed-off, but changed reality. I don't own a dog, but when I'm in the presence of one, and the dog looks up to see if it's time for dinner or a walk, the dog's right or left eyebrow always rises, and I always think of Saul. My ideas about the afterlife are fervent but unformed, and that dog's-eyebrow moment is near their center.

I met Saul in 1977, and we were friends until he died in 1999. I was interested to read (p. 44) that Saul thought an artist in later years inevitably became a teacher; Saul often took on a teacher's role with me. I thought he was the funniest, most brilliant, coolest person I ever met, so naturally I listened. A lot of what he had to say was about art, and particularly about drawing (and writing) for *The New Yorker*.

(A shudder of misgiving went over me just now as I imagined what Saul might think reading this. For example, he would probably disapprove of the superlatives in the previous paragraph. Saul's work was sometimes completely misunderstood, and he also didn't like being understood too easily. In fact, I think he preferred the first to the second. While reading, you might keep in mind an image of Saul shaking his head skeptically and veiling his eyes.)

Saul believed in the power of the spontaneous gesture, the single touch of the wand. For him first impressions were almost everything, and occasionally he went to great effort to knock away accumulations of experience so as to give himself an impression that was absolutely new. His preferred method of working was at the peak of his interest and concentration and inspiration, for perhaps only a couple of hours in the afternoon. And what he most avoided and feared was a grim, vaguely defined horror called "homework." Anything he found labored or formulaic or struggled-over he dismissed with a wave of a hand: "Ah, it's just homework."

In *The Years with Ross*, James Thurber describes his own beginnings as an artist at the magazine; Thurber says that, having had success at his now-famous quickly sketched freehand drawings, he sat down and did some proper ones, with full attention to detail, shading, perspective, and so on. When he showed them to his colleague E.B. White, White took one look and said, "Don't do that. If you ever got good you'd be mediocre." This story, really a parable, speaks to the aspirations of the magazine's founders; they would leap for the heights and disdain the middle. As I understood Saul's notion of "homework," it was anything that fell in the humdrum middle and included all art that, if you got good at it, you'd be mediocre.

The no-homework approach was, I guess, a practical version of the streamlining sophistications of modernism. Saul was a modernist—of his own particular stamp—by training, in the milieu of the architecture school in Milan which he attended in his youth, and by circumstance, as a member of the generation born in Europe before World War I. Modernism was a movement which he knew and breathed. Thurber and White (and *The New Yorker*'s founding editor, Harold Ross) came to their own theories of good art and bad art less consciously. Their convictions were less part of a movement and more the result of a then-American tendency for straightforwardness and simplicity and clear, laconic

self-expression. Thurber's drawing and E.B. White's sentences were modernist as if by accident. However arrived at, the aesthetic of the magazine appealed, immediately and completely, to Saul.

Publishing a good piece in a magazine is a particular kind of fun. It combines the thrill of artistic success with the real-time excitement of a work performed live; there's an element of team spirit to it, too. I imagine the satisfaction is like what a baseball player feels when he knocks a game-winning single over the second baseman's head to instant and surrounding applause. When your work is in a magazine, your usual artistic solitude gets a reprieve. After decades of acclaimed publication, equaling or topping himself year after year, Saul still got a kick when his work appeared in *The New Yorker*. Whenever the issue on the newsstand had a piece by him, he used to go around sort of humming with expectation. His spontaneous, no-homework art needed a similarly immediate venue in which to appear, and for that, a weekly magazine, one as smart as *The New Yorker*, proved to be ideal.

I even think that at moments Saul understood *The New Yorker* better than those who founded it and edited it. When Saul first came to America, Harold Ross, with his genius's penchant for occasional boneheadedness, took him aside and told him that he would now have to draw the noses on his characters a bit smaller; in America, Ross informed him, people did not have such big noses. Saul thought that was a hoot and luckily for everybody went on drawing his people just as he always had. A downside of magazine publication is the piece that gets rejected or falls flat, making you feel as if you'd been yanked offstage before you began. A painful rejection can derail you for months, but Saul's olympian attitude seemed to render him rejection-proof. Once he told me that when he received an envelope from the magazine containing drawings of his it had turned down, he simply put them in another envelope and mailed them back. He said he sometimes had to do that three or four times before the editors got the message and accepted them.

Saul called *The New Yorker* his "*patria*" (p. 48). It was that almost literally, with the help it gave him getting to America during World War II. Like any citizen, he felt differently about his *patria* at different times. As he got older, he approved of the magazine less, in general. He missed William Shawn, the editor who had published him the longest, after Shawn was fired in 1987. During a low period in his later years, Saul told me he thought he was "overqualified" to do pieces for the magazine. By then he had the unusual creative obstacle of his long history and many past successes at the magazine. The ubiquitous knockoffs of his famous *View of the World from 9th Avenue* cover vexed him like horseflies. When he ran into one of them on the street—on a billboard, on a bus shelter— he assumed his stoical face and walked by. With museum shows and gallery exhibitions opening regularly, and a first-tier reputation, and admirers buying his work in Europe and America, Saul didn't "need" *The New Yorker* for his career. But he kept up with the magazine carefully and continued to publish in it (though not as frequently), and said it would remain his *patria* always.

Saul was, in all, a magic person. He could enchant ordinary life in an instant, as if with a finger-snap. I saw him do that on the phone, at parties, at gaming tables in Atlantic

City, in restaurants. Once, we had finished dinner at an Italian place he liked, and we decided to order a single dessert and split it. Saul told the waiter, "Bring us one dessert, please, and a blank plate." I remember the beauty of that plate when it arrived—its gleaming whiteness, and the plain line of its red or blue border. A blank plate; offhandedly, Saul made the plate a Steinberg. He knew his own richness of invention and enjoyed its company. The chief occupation of his life was seeing what new idea each day or mood would bring. This anthology is a compendium of magic gestures by Saul, some done in a minute, some resulting from much sketching and resketching and rethinking, all of it homework-free. Among the greatest of *The New Yorker*'s accomplishments is that it provided an enduring *patria* for Saul.

October 12, 1946

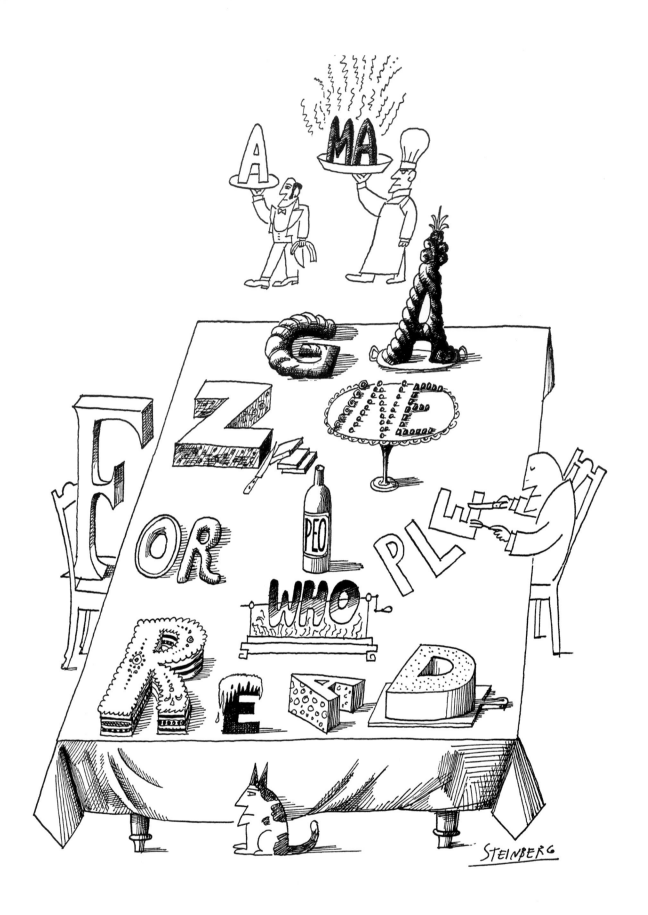

THE NEW YORKER

a magazine for people who read

Steinberg at
The New Yorker

Humor is the avant-garde of sensibilities. Under laughter's sign, taboos are freely broken, pies thrown and eyes poked, subversion is rewarded, virtue mocked, language torn down and rebuilt. Saul Steinberg operated in a self-made world between modern art and the popular cartoon, but he shrugged when he was called a humorist and bragged that he made a bad fit for the avant-garde. Steinberg said things—and thought them, and drew them—"funny"; like Groucho Marx or Marcel Duchamp, he twisted and tested every idea that came to hand. But his ambition was neither to amuse the lowest common denominator ("the barber in Peru," in Groucho's phrase) nor to impress a tiny intellectual counterculture. Steinberg called his drawings "attractive traps." The quarry he was after was a smart, selective, yet sizable audience: members of the general-interest intelligentsia who—upon arriving home from the office or shopping, or a Duchamp retrospective, or a Marx Brothers movie—would sit down, open the latest issue of *The New Yorker*, and tumble into his labyrinth.

Between 1941 and his death in 1999, Steinberg addressed that readership through art of every category *The New Yorker* published, including cartoons, "spots" (filler drawings), covers, feature illustrations, portfolios, and even campaigns for a few advertisers. He first drew for *The New Yorker* when it was still edited by its founder, Harold Ross, and his last work was published under David Remnick, who currently heads the magazine. Steinberg worked longest with William Shawn, a friend and admirer; between 1952 and 1988 Shawn published seventy of Steinberg's eighty-five lifetime covers and over fifty of his multipage portfolios. With Tina Brown, who reinvented *The New Yorker*'s look and content in the 1990s, Steinberg's relationship was more distant, but the color she brought to the inside pages was beautifully suited to his pared-down late style. Despite differing visions for the magazine, each editor has recognized that *The New Yorker* is, as Steinberg's 1969 series of newspaper advertisements announced, "a magazine for people who read" (fig. 1)—and specifically, for readers prone to hunger after the kind of intensely literate, idea-dense drawing that Steinberg brought to the table.

Steinberg's idiom was grounded in the cartoon, and the venue he preferred was, by and large, the printed page seen by legions as opposed to the collector's or museum's wall. In 1936, as a cash-strapped architecture student in Milan, he began providing the house brand of madcap drawings to the twice-weekly satirical paper *Bertoldo*; cartoons paid the bills, won him a fan base, and brought him to the attention of American publishers. But once established in New York, Steinberg also came to enjoy success as an exhibiting fine artist, with his work ultimately commanding high prices in galleries and traveling to museums around the world. Between the extremes of staff clown and modern old master stretches the arc of his career at *The New Yorker*, which took him from overseas graphic reportage during World War II to quiet and biting satires of postwar life to philosophical puzzle-pictures to probing reflections on history as he had seen, lived, and read it. All along the way, Steinberg spun lucid visual commentary that made an adopted city and nation his own.

1. Advertisement for *The New Yorker*,
The New York Times, November 26, 1969

In the summer of 1941, Harold Ross' sixteen-year-old enterprise was an even greater source of worry to him than usual. Isolationist in his politics and wary by nature, Ross was facing growing pressure from highly placed friends to put *The New Yorker* on the side of American entry into the war in Europe, a scenario that raised the prospect of losing essential staff and contributors to a massive military effort. His art editor, James Geraghty, kept reminding Ross that, even should peace prevail, *The New Yorker* needed fresh talent if it was to maintain its improbable place among the smartest-looking mass-market periodicals in America. Improbable, in that the pages of this most literate of weeklies lacked the fundamentals of graphic design that all but defined the modern magazine: photographs, dynamic typography, and color art. Geraghty did what he could to make a virtue of *The New Yorker*'s visual austerity, filling out its regular, three-column pages of text with drawings by artists working in highly individual styles. (The art editor had little role in designing layouts, a task that Ross left, newspaper-style, to technicians in the make-up department.) The stylizations of Peter Arno, Charles Addams, Helen Hokinson, and others both complemented and relieved the visual constancy of *New Yorker* pages, but Geraghty was ever on the hunt for new contributors whose art would be distinct, effective in black-and-white, self-sustaining, and copious.

Saul Steinberg, just turned twenty-seven, was spending the summer of 1941 adjusting to life in Ciudad Trujillo, Santo Domingo.[1] Romanian by birth, he was in exile not only from the homeland he had eagerly abandoned in 1933 but from Milan, his adoptive hometown in the intervening years. Italy's anti-Semitic race laws of 1938 had rendered Steinberg's architectural diploma from the Reggio Politecnico a piece of ornate scrap paper, awarded to "Saul Steinberg, of the Hebrew race." Life in Milan, nonetheless, had proven an idyll of collegial encouragement, close friendships, and youthful romance. But when his residency papers ran afoul of government regulations in 1940, he was interned at the Tortoreto prison camp, in the Abruzzi; he finally made his way to Lisbon and onto a ship to America. Thanks to tactical support from New York City relatives and from Cesare Civita, a Milan friend and illustrators' agent who plied the North and South American magazine markets, on July 4, 1941, Steinberg got as close to Manhattan as Ellis Island. He was there, however, only to be processed en route to Santo Domingo, where the Dominican Settlement Association had arranged for him to stay up to a year while applying for an American visa on the quota system.

With the doors closed on the life he had known, New York was the way ahead. Steinberg dispatched a bundle of new drawings every few days to Civita's Manhattan branch office, where he found strong advocates in Cesare's brother, Victor Civita, and assistant, Gertrude Einstein. Besides apportioning Steinberg's cartoons among suitable magazine art directors, in the year ahead Einstein and the Civitas provided long-distance sounding boards for an artist working to adapt his humor to American tastes. A notable result of their intimate editorial give-and-take was Steinberg's gradual weaning from the language- and culture-dependent caption cartoon in favor of drawings that rewarded close inspection on their own, even when edited for space or content (figs. 2–4).

2. Uncaptioned drawing, 1941 or 1942. At upper right, Steinberg's penciled note to Victor Civita proposes possible variants on the image. Film copy, Saul Steinberg Papers, Yale Collection of American Literature, Yale University

3. Fig. 2, cropped and published as a one-column-wide "spot" drawing in *The New Yorker*, November 20, 1943

4. Fig. 2, reproduced in Steinberg's first book, *All in Line*, 1945

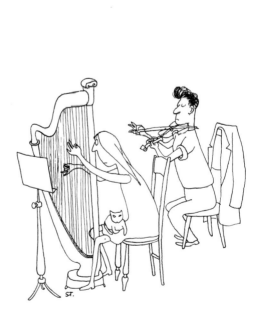

*"You see, if it comes down in a meadow,
no one will notice it . . ."*

5. From "Persiflage from Paris," *Harper's Bazaar*,
March 15, 1940

6. February 21, 1942

*"Br-r-r, it was cold! Even the Führer himself was nothing
but a mass of goose pimples."*

Cartooning under watchful Fascist eyes had taught Steinberg to poke fun at war in general rather than condemn its proponents; in fact, the first set of drawings he published in America had satirized, of all things, French defense efforts (fig. 5). Now many of the gag cartoons he was sending to New York turned the same light touch to lampooning a venal Führer and doltish Duce (fig. 6). Up to this point, most American propaganda advocating war on Hitler had relied on grim depictions of Nazi bloodlust; humor not only made Steinberg's work stand out from the field but gave even those skeptical about intervention a reason to keep on looking. When Einstein brought a batch of Steinberg's drawings to *The New Yorker* offices, she explained his circumstances to an attentive Geraghty, who had likely seen the portfolios of his work published the year before in *Harper's Bazaar* and *Life*.[2] By the time Steinberg's first cartoon ran in the October 25, 1941 *New Yorker* (fig. 7), Geraghty had pressed a strong case for him with Ross—neither as a departure into war-related cartooning for the magazine (though this would be desired within a few short weeks) nor as a deserving refugee case, but as an investment opportunity, worthy of a first-look contract.[3]

The appeal was mutual. On November 17, 1941, when Steinberg finally got hold of a copy of *The New Yorker* containing his work, he wrote, in his developing English, to his cousin in New York: "I was very satisfied for I realize how important and smart is this magazine. I have read it in Italy too and I know also the very good English like 'Punch' and 'Humorist' etc., but I think the New Yorker is the top. Is very flattery for me."[4]

Meanwhile, the magazine's administrative editor Ik Shuman had gone to work researching the artist's immigration case. In a memo dated the same week as Steinberg's celebratory letter, Shuman urged both Ross and Geraghty to "avoid seeming to say [to

7. October 25, 1941

"But it __is__ half man and half horse."

government officials] we guarantee [Steinberg] work as this would be a violation of law prohibiting labor contracts with prospective immigrants; we should say that we feel his talents would enable him to get work."[5] The argument needed no padding; during what stretched into a full year's wait for a visa, Steinberg began seeing his cartoons published regularly in *American Mercury, PM,* and *Liberty,* along with two features in *Mademoiselle* and five more cartoons in *The New Yorker.* In late June 1942, overseen from afar by Shuman, the artist finally flew from Santo Domingo to Miami, where he boarded a bus to New York—the first of many long American bus trips—in confidence that an eager market awaited him.

Awaiting him, too, was a war now grown to global proportions. Wartime applicants for American citizenship were required to register for the draft. Ross, keen to keep Steinberg working for *The New Yorker* and the magazine supplied with material on the war that had become its consuming topic, began pulling strings to land his multilingual new contributor a job producing propaganda for the European theater. Steinberg's aptitude for such a position was demonstrated by a steady flow of *New Yorker* cartoons (fig. 8), and by November he was a Consultant for the Graphics Division of the Office of War Information.[6] Nonetheless, when, on February 19, 1943, he was naturalized as a U.S. citizen, the price was joining the Naval Reserve. Made an ensign, he was assigned to Naval Intelligence in Washington, D.C.

8. March 6, 1943

Steinberg's first New York interlude, though brief, was a great success, on both personal and professional fronts. Earlier in February, a fellow expatriate Romanian artist named Hedda Sterne, charmed by drawings she had seen in the fashion magazines, had invited their creator to tea at her studio apartment on East 50th Street. Steinberg came and, as Sterne recalls it simply, "he stayed"; they would marry upon his return from the war.[7] Just the month before, Steinberg had initiated two other enduring American romances, with the open road and with Hollywood. Trailing high-powered letters of introduction from Ross, he had made his first transcontinental trip to see the film studios in action.[8] By the time he shipped out in the spring, his departure was a matter of comment in the press, as was the first American exhibition of his work, organized for a gallery on East 55th Street by a young woman named Betty Parsons.[9]

Ross' effort to find Steinberg's talents a fitting military role initially came to little: by August 1943, the artist had landed in an outpost near Kunming, in southwestern China's remote Happy Valley, where American intelligence forces were training Chinese Nationalist troops for anti-Japanese sabotage missions.[10] Wartime security called for absolute secrecy about the nature of all activities at Happy Valley; the result was an air of mystery about Steinberg's role there that he was only too glad to maintain for the rest of his life.[11] What is clear is that his hunt for drawing-worthy subjects was ideally served by his few months in the Far East, and by the round-the-world tour of military outposts that followed. In December, the young Office of Strategic Services plucked him from Kunming and sent him "over the hump" of the Himalayas to India, on to North Africa and from there, finally, to Allied-occupied Rome.[12] There he worked with a team turning out ersatz German resistance propaganda that was planted behind enemy lines to give the appearance of an active underground movement.

Throughout his travels, Steinberg sent Geraghty thick packets of drawings depicting the constant trials and occasional charms of military life. *The New Yorker* published ten spreads of drawings between January 1944 and April 1945 under the recurring titles "China," "India," "Italy," and "North Africa" (pp. 52–57), each of which was promptly republished in periodicals around the world. Collectively, they gave their author a unique position among *New Yorker* artists as a major contributor to what the magazine called its department of fact—the department which, under managing editor William Shawn, was fueling *The New Yorker*'s meteoric rise in journalistic stature. Wartime readers, estimated at 10-to-1 military-to-civilian,[13] were not shy about interpreting Steinberg's wordless dispatches as pictorial reportage: the magazine's mailroom forwarded the artist detailed praise and still more detailed corrections about his portrayal of British officers' uniforms, the availability of hot water taps in Indian billets, and wiring insulation on the streets of Algiers.[14] By the end of the war, which found Steinberg stationed in Washington while doubling as a war correspondent for the magazine, these features had been adapted for publication in his first collection of drawings. Assembled during his absence through the combined efforts of Geraghty, Hedda Sterne, and Victor Civita, the book appeared in June 1945, sold over 20,000 copies, and became a bestseller for the Book-of-the-Month Club.

Steinberg in the OSS Office of Morale Operations, Rome, 1944

The collection's punning title—*All in Line*—identifies the quality that made Steinberg's work phenomenally popular upon his return to civilian life, to New York, and to commercial practice in January 1946. His pen-and-ink line—acute, blithe, and unmistakable—appealed to postwar tastemakers of all strata, from *The New Yorker*'s weekly competitors such as *Collier's* to advertising agencies to highbrow journals and The Museum of Modern Art, where curator Dorothy Miller included Steinberg in the traveling exhibition "Fourteen Americans" in September 1946. Quickly spawning imitators, Steinberg's line defined a new school of graphic art based on wiry, informal wit and attuned to the jittery optimism of the Atomic era. In print, the unadorned line shot presented a clean break from the long-reigning "Uncle Joe School of realistic illustration"[15] exemplified by Norman Rockwell, whose feel-good covers for *The Saturday Evening Post* looked like a middlebrow dream of art (they were, after all, oil paintings), gratifying readers' eyes and hearts but firing no mental synapses.

Millimeter for millimeter, Steinberg's line looked less like drawing than handwriting: an unpremeditated outpouring of personality that happened to take the form of articulate ideas and observations. In the lively presence it brought to the page, his line seemed to speak for the playful inner individualist in a society being overcome by work-driven corporatist conformity. ("I draw something that fits the finger," he explained, "and then labor does not enter in."[16]) Through his work, mainstream readers got a taste of the ethic of "spontaneous" self-expression that animated Action Painting, bebop improvisation, Beat poetics, and free-association standup comedy.[17] Steinberg's line on a *New Yorker* page bodied forth precision but also, in contrast to the typography surrounding it, the intimate physical action of the hand. Its warmth provided a visual counterpart to writing that was wide-ranging in coverage, conversational in tone, smart and worldly, but untainted by highbrow disaffection. A Steinberg drawing, like a sentence by E.B. White or Janet Flanner, appears to have flowed irresistibly onto paper, saying something unexpected without obscurity or ostentation, yet irreducibly and with style (fig. 9).

Steinberg's *New Yorker* work soon formed the center, but only the center, of an unrelenting annual workload. From the close of the war through the early 1960s, he

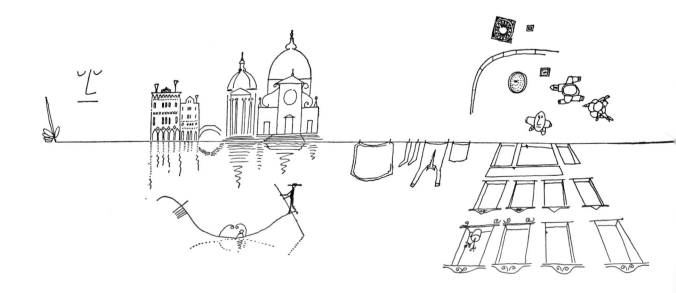

9. September 18, 1954

illustrated scores of dust jackets and print advertisements, designed fabrics, wallpapers, Christmas cards, and calendars, supplied drawings for one-artist shows in New York, Paris, London, São Paolo, Los Angeles, and Rome, produced features for general-interest periodicals such as *Life*, *Flair*, *Harper's*, and *Fortune* as well as architectural journals, issued rich and meticulously sequenced books of drawings (*The Art of Living*, 1949; *The Passport*, 1954; *The Labyrinth*, 1960; *The New World*, 1965), and filled mural commissions for ocean liners, museum exhibitions, department stores, architectural expos, and hotels. Much of this work relied for its appeal on Steinberg's color sense and his knack for finding pictorial roles for non-art materials (a ripped chunk of corrugated cardboard becomes a baseball catcher's chest protector) and non-art devices (desktop rubber stamps fill the talk balloons in a couple's dressing-room dialogue: "RUSH," he says, and she replies "O.K. O.K.").[18]

Yet even as his vocabulary of techniques grew constantly to meet the varied needs of outside clients, for close to two decades Steinberg's *New Yorker* work remained limited to pen-and-ink drawings, whether for cartoons, reportage, illustrations, spots, or "spot-pluses."[19] In January 1945, Geraghty managed to give one of Steinberg's wartime China drawings enough color to make it usable as a cover — the artist's first (p. 51) — by laying in an "Oriental" background texture supplied by Rea Irvin.[20] Not until 1954 would the face of the magazine again feature Steinberg's work. This time, his line drawing of a fatherless cat family gained its splash of color from a bit of collage (p. 97).[21] Steinberg's art and the magazine's cover needs would not converge consistently for a few more years.

About the Steinberg drawings that *The New Yorker* did publish, however, and about *The New Yorker* as a means of disseminating them, the artist evinced deep satisfaction. "In my unbiased opinion, I think the only thing good here [in New York], honest and genuine, is the cartoon, the humorous drawing," he wrote to his Milan friend Aldo Buzzi late in 1945, adding shortly thereafter: "The *New Yorker* is perhaps the only publication that is perfectly free and more intelligent than its time."[22] He spent three hours or so daily doing free drawing, and the "perfectly free" magazine was his constant notional venue for work undertaken without assignment, preconception, or the need to be funny. Writing to Ross on board a train to Mexico City in 1947, Steinberg regretted that he had

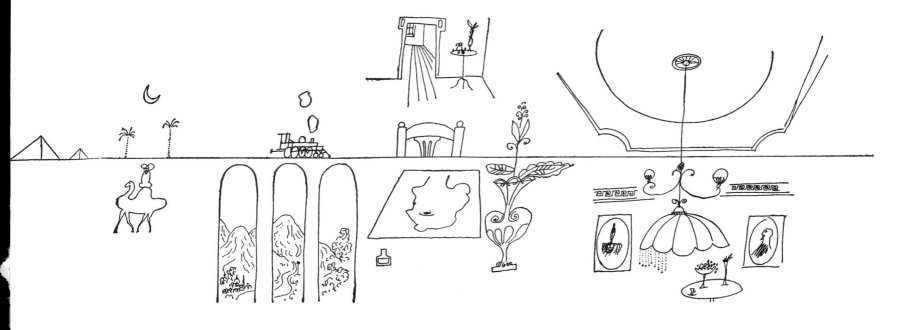

been "too busy in the last months [making] drawings for fashion or literary magazines, illustrations for books I didn't read and other rush things that made me feel like a bookkeeper. I hope I'll do some good cartoons in Mexico, that's relaxing work."[23] With characteristic precision, he was telling Ross that making "good cartoons"—good enough for *The New Yorker*—was relaxing, and that it was work. He later described drawing for the magazine as "the best calisthenics one can have," and declared it "much more difficult than anything else I do."[24]

"I have many friends: artists, musicians, actors, and writers," Steinberg wrote to Buzzi soon after settling in Manhattan at war's end, then qualified: "True friendship, which is a provincial art, doesn't exist in New York. It's more a matter of seeing each other at parties and other daily, dissolute, alcoholic festivities."[25] Festive and anything but friendless, the Steinberg-Sterne household linked many overlapping circles of acquaintance, including painters with whom the couple shared gallery representation at the Betty Parsons and Sidney Janis galleries; expatriate Italian designers and writers; *New Yorker* contributors such as Charles Addams, Geoffrey Hellmann, Joseph Mitchell, and S.J. Perelman; the crowd around *Partisan Review*; and Alexander Calder and his family. From early 1952 to 1958, the couple's capacious brownstone on East 71st Street formed the center of a culture all its own at the heart of the intellectual establishment. The house schedule included two dinnertimes, a social one and a "new dinner" after midnight, with extra time for drawing in between.[26]

As for artistic company on the pages of *The New Yorker*, Steinberg had debuted at the magazine years later than the other artists associated most indelibly with it. James

10. The Funny Little Man as seen by *New Yorker* artists.

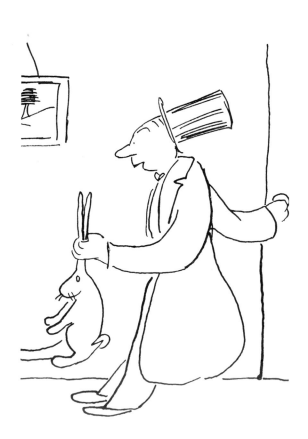

James Thurber, December 30, 1933

Gluyas Williams, April 9, 1938

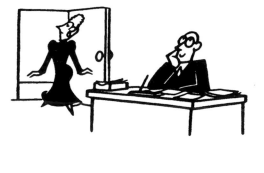

Otto Soglow, January 24, 1948

Thurber, Peter Arno, Helen Hokinson, and William Steig had all first appeared in the magazine in the 1920s, Charles Addams and George Price early in the next decade. Steinberg's moment of arrival, at the outset of World War II, turned out to be the start of the magazine's decades of greatest growth and cultural influence. His typical figure, a mute, open-eyed urbanite, swiftly assumed a place in the clan of Funny Little Men who—Eustace Tilley notwithstanding—provided the true models of sensibility to *New Yorker* readers (fig. 10).[27] The forebears of Steinberg Man at the magazine included Thurber's harried squiggles, disheveled even in their crudely inked anatomy, and Gluyas Williams' silent, meticulous, but equally hapless sufferers.[28] Amid the opening columns of Talk of the Town, Otto Soglow's sleek miniatures bustled about; his pop-eyed men, like Steinberg's, were often bald, as though hair would have looked like rhetorical excess alongside E.B. White's prose. When Sam Cobean's people sprouted thought-balloon desires and calculations more real to them than reality, the conceit not only influenced Steinberg's vision of speech and thought as physical entities (pp. 100–09), but gave rise to a whole genre of cartoon humor about contests between mind and matter, a staple of popular Existentialism.

If *The New Yorker*'s pensive, Keatonesque cartoon figures occasionally cracked a thin smile or frown, they appeared to lack the moving parts to register flights of bliss or rage, however extreme the turn of events. (Charles Addams' bizarre scenarios, the closest thing to violence in the magazine, were saved for comedy by the etherized calm of his wash technique.) The sangfroid that defined the magazine's personality becomes evident in a comparison of its Little Men with those of the competition. For *Punch*, Roland Emett and Ronald Searle set down paragons of British propriety in scenes of bombed-out

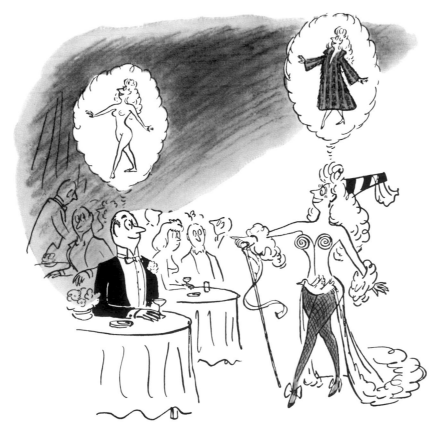

Sam Cobean, February 5, 1949

Saul Steinberg, May 21, 1949

Thurber, Peter Arno, Helen Hokinson, and William Steig had all first appeared in the magazine in the 1920s, Charles Addams and George Price early in the next decade. Steinberg's moment of arrival, at the outset of World War II, turned out to be the start of the magazine's decades of greatest growth and cultural influence. His typical figure, a mute, open-eyed urbanite, swiftly assumed a place in the clan of Funny Little Men who— Eustace Tilley notwithstanding—provided the true models of sensibility to *New Yorker* readers (fig. 10).[27] The forebears of Steinberg Man at the magazine included Thurber's harried squiggles, disheveled even in their crudely inked anatomy, and Gluyas Williams' silent, meticulous, but equally hapless sufferers.[28] Amid the opening columns of Talk of the Town, Otto Soglow's sleek miniatures bustled about; his pop-eyed men, like Steinberg's, were often bald, as though hair would have looked like rhetorical excess along-side E.B. White's prose. When Sam Cobean's people sprouted thought-balloon desires and calculations more real to them than reality, the conceit not only influenced Steinberg's vision of speech and thought as physical entities (pp. 100–09), but gave rise to a whole genre of cartoon humor about contests between mind and matter, a staple of popular Existentialism.

If *The New Yorker*'s pensive, Keatonesque cartoon figures occasionally cracked a thin smile or frown, they appeared to lack the moving parts to register flights of bliss or rage, however extreme the turn of events. (Charles Addams' bizarre scenarios, the closest thing to violence in the magazine, were saved for comedy by the etherized calm of his wash technique.) The sangfroid that defined the magazine's personality becomes evident in a comparison of its Little Men with those of the competition. For *Punch*, Roland Emett and Ronald Searle set down paragons of British propriety in scenes of bombed-out

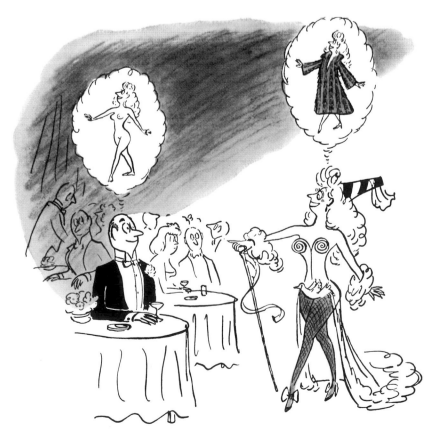

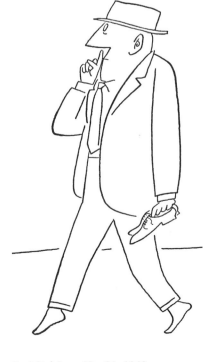

Sam Cobean, February 5, 1949

Saul Steinberg, May 21, 1949

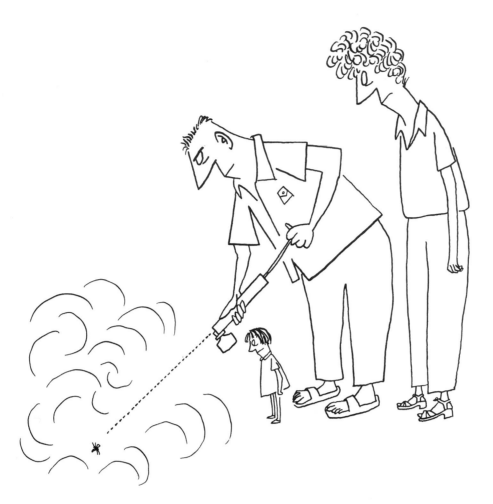

disrepair or lumpen mass-society conditions. Searle played up the contrast between his own caricatural style and Steinberg's deadpan manner in a fan sketch he sent to him in 1950, in which a florid, mustachioed Searlite kneels in homage before a baffled Steinberg Man (fig. 12). At an opposite extreme, the ex-G.I.s that Virgil F. Partch (ViP) drew for men's magazines such as *True*, and for scores of print ads, stood out in their brutality; one that ran in *The New Yorker* featured a man stuffing his wife face-down into a garbage disposal for having failed to use Angostura Bitters in his drink.[29] Steinberg more subtly forecast the challenge of postwar readjustment with a 1945 cartoon in which wife and child watch their conquering hero exert lethal force—on an insect (fig. 11). Robert Osborn's bilious ranters underwent expressionist distortion in *Harper's*; their later counterparts, the chicken-scratched self-doubters of Jules Feiffer, would mope aloud and at length in *The Village Voice*. Through it all, Steinberg's sharp-billed little man grew in prominence as the figural epitome of *The New Yorker*.[30] Impassive yet alert, he did not recall any other cartoon figure so much as he seemed to represent a down-to-size, porch-reader's version of Alberto Giacometti's striding ciphers or Samuel Beckett's wry cynics.

The range of existentialist sensibility in *New Yorker* art might be measured as the distance separating Steinberg and William Steig (fig. 13). Initially fast friends, the artists drifted apart in the 1950s while maintaining respect for each other's work. Steig's basic subject was the animal or child mind at the core of experience. He once wrote that in his art, "I am essentially identified with nature's point of view, as against civilization's";[31] he would find a rich visual and narrative outlet for his cathartic idiom as a creator of children's storybooks, starting with *Roland the Minstrel Pig* (1968). Steinberg's mordant take

12. Ronald Searle, drawing in a letter to Saul Steinberg, April 22, 1950. Saul Steinberg Papers, Yale Collection of American Literature, Yale University

13. William Steig, May 9, 1953

on children ("enemies of civilized life")[32] could not have differed more. His own youth was defined, in his mind, by the thrice-scorned status of a Jewish Romanian minor who had learned early on that all politics are corrupt, all dignities imperiled by power.[33] The universe in Steinberg's art is that of an acculturated intellectual mind, saturate with received ideas that it turns over in an effort at self-analysis—the job description, after all, of the modern artist. If Steig's street-smart urchins and worldly-wise animals lived lives attuned to the id, Steinberg grew into the role of his culture's superego, remarking, "Without wanting to, I have become a moralist."[34] It is as hard to imagine Steig drawing a "view of the world," from 9th Avenue or anyplace, as to conceive of Steinberg titling a drawing "Mother Loved Me, But She Died."

In February 1952, the helm of the magazine passed to Ross' equal among Steinberg enthusiasts, William Shawn. The line of succession had been clear to many at the magazine since the war, but its full implications would emerge only after several years. As shaped by Shawn, *The New Yorker* remained a venue for great individual voices, comic and otherwise, but it also gave space to investigative journalism, thought pieces on major public issues, and the calm yet firm defense of liberal convictions. Shawn's quietly absolute style of command also made for changes in the handling of art, as he reduced the cast of the weekly art meetings from seven to two: Geraghty and himself. Lee Lorenz, cartoonist at the magazine since 1957 and its art editor from 1973 to 1994, reflects that "Ross had been more Steinberg's kind of guy"—an organic rather than self-conscious intellectual—but that

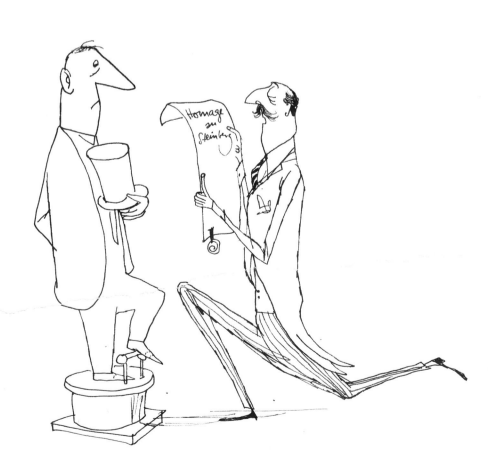

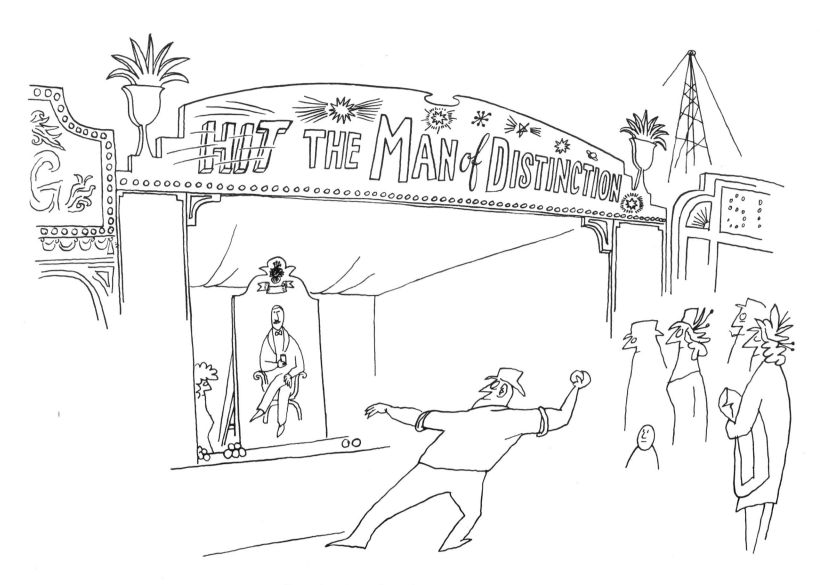

14. September 20, 1947

"Steinberg's art fit in better in Shawn's magazine."[35] Ross had been forever seeking elusive rational formulas by which his magazine could be made to run itself; Shawn trusted the magazine to take shape around material that struck him as brilliant. Steinberg's art, simply by reflecting the personal evolution of its idiosyncratic author, supplied a peculiarly representative image for Shawn's *New Yorker* as its intellectual commitments deepened and its audience matured in the second half of the century.

Early in 1956, thanks to Shawn's doggedness in securing a visa for the artist, Steinberg visited the Soviet Union for six weeks, then swiftly turned in two portfolios that were published as Reporter At Large features (pp. 72–75). "Moscow in Winter" and "Samarkand, USSR" were the nearest Shawn ever came to publishing the kind of exotic-locale photo-essay that was the bread-and-butter of popular magazines such as *Life* and *Holiday*. But if Steinberg in effect provided the magazine with a camera eye here (as he had done in Berlin and Hollywood in Ross' late years; pp. 50, 78–79), it was a highly literate and personal camera, appropriate to a magazine that orbited around the craft of writing. In place of *Life*'s succession of disparate visual facts strung together by leading captions, Steinberg used line and space to re-create an unfolding experience, giving a feel for the texture of time spent in what were, for American readers, unimaginably foreign places. Steinberg's drawings, like A.J. Liebling's evocations of a boxing match or political convention, invited readers behind the eyes and into the mind of a reporter-at-large.

The evolution of Steinberg's *New Yorker* work in the 1950s sometimes paralleled and often anticipated broader trends in American culture. It also reflected a long-term shift in his perspective: from a cartoonist's detached observation of his fellow New Yorkers to anthropological absorption in the character of the country as a whole, to a philosopher's inquiry into the psyche of an epoch coming adrift from its past, shadowed by the Bomb. Contradictions in American values—such as the myth of meritocracy that led Madison Avenue to put "men of distinction" on a pedestal, and the inverse snobbism that inspired consumers to shoot them down—amused and fascinated him (fig. 14). He shared with his friend Walker Evans a tender and sardonic fascination with American vernacular forms (storefronts, doorjambs, monuments, postcards) and a depthless curiosity about their origins. Our jukeboxes and diners, he noted, were descended via the Chrysler Building from Parisian Art Deco, itself the commercial offspring of Cubism. America, the end of the line of many such stylistic genealogies, presented an inexhaustible supply of investigative topics.[36] What Steinberg called his "stenographic" line was ideally suited to advancing the proposition that style is substance: that the form of a thing (rocking chair, car grille, sunglasses, skyscraper) expressed its origins, and that outward likeness always indicated some essential relation—whether between a diploma and a champagne label (the grammar of congratulation), between a thumbprint and a passport photograph (every citizen a criminal), or between the sound of a tuba and the gravity of architectural ornament (pp. 174–75, 180).[37]

America appealed to Steinberg as an unself-conscious collage created by history's dropouts. At once fearful and admiring, he saw Americans as primitives who had left behind their lands of origin and rigged up a New World out of the half-understood, half-resented stuff they had brought along (pp. 206–09).[38] He felt at home in this world, having been "lucky enough to be born in a college for collages"—meaning both the crossroads culture of Romania and more specifically the Steinberg family business, which had involved turning fine art into modest, functional objects. His father, a boxmaker and job-printer, "had marvelous things, albums with examples of paintings, reproductions of paintings for candy boxes. These were mostly Madonnas in the most *pompier* [academic] style, or else paintings by Millet. This was in effect my artistic education, through these reproductions."[39] For him, as for Americans born an ocean apart from treasures of the Old World, to encounter Jean-François Millet's *Angelus* in a museum was to meet "a fictitious personage" whose original lived on the printed page (p. 35).[40] Museums were among those realms of ponderous officialdom and lockstep conformity that Steinberg considered best represented through accretions of rubber-stamps (p. 135). His rubber-stamp drawings, a variation on the piecemeal procedure of collage, recall architectural rendering—his educational entrée into drawing—in which the draftsman invents by pushing rote graphic clichés around into novel combinations.

A critical participant-observer of American culture, Steinberg directed recurrent attention to such dark matters as the bureaucratic complication of everyday life, alienation between the sexes (figs. 15, 16, p. 147), and the prospect of a society of happy Organization Men (fig. 17). The occasional charges of cynicism leveled at him he attributed to "the

15. September 26, 1953

16. October 20, 1962

Anglo-Saxon dislike of anything that is anti-social; but there is also an element of goodness in my pictures, sympathy for things too small to be noticed."[41] His adroit doodles and, in time, his sensuously colored *New Yorker* covers celebrated the joys of reading, memory, travel, fine design, romantic love, gallery-going, people-watching, gossip, gardening: pleasures now discernible as the signal privileges of the American Century (pp. 122–25).

When he arrived in America, Steinberg was still working out what to do in, and with, his art. Fortuitously, working out what to do proved to be a great theme in American art in the rich, troubled era ahead. The modern artist, as Steinberg saw his role, was distinguished by not being "subjected to the pope and the prince. The nature of the modern artist is to search, is to be in a precarious position and to be non-professional."[42] Steinberg charted a prehistory of the modern condition in his sequence of monuments to conquerors (p. 139). Knight slays dragon, monarchy overwhelms chivalry, Jacobins slaughter king, bourgeoisie tramples *le peuple*, state overtakes market, everyman outlives totalitarianism and finally—Pyrrhic victory—he has nothing to topple but his own doubt-laden head: meet the modernist.

His mental image of the artist, Steinberg said, was the novelist, who writes into being a world where everything, from a finger to the cosmos, is expressed as part of an unfolding of consciousness. If painting vied, somewhat awkwardly, for a dignified role in the world of concrete things (fig. 19), drawing, like writing, was what Leonardo had called a *cosa mentale*: a mental thing, directly and minutely reflecting the mechanics of thought (fig. 18).[43] Drawing's real subject, for Steinberg, was the movement of a pen point through time and over paper—a movement subsequently re-created by the "complicity" of a viewer's eye tracing the line and extracting from it, like a phonograph needle from a groove, the music of ideas that had set the stylus in motion. His own line, the artist said, "wants to remind constantly that it's made of ink."[44] One is reminded, too, that the more elemental the pictorial means employed, the closer looking comes to literacy. Steinberg's straight horizontal line, morphing in significance from join between land and sky to table's edge to string of laundry, puts the viewer's eye into a creative, punning mode matching that of the draftsman's hand (fig. 9).

Steinberg's perception of drawing as a temporal contest between mind, ink, and paper matched that of the abstract artists whom his close friend, critic Harold Rosenberg, dubbed Action Painters—the social circle into which, through Sterne, Steinberg was literally married. But Steinberg's job, however obliquely, was journalistic in its basis, and the commitment to subject matter it demanded set his art sharply apart from the work of friends such as Willem de Kooning or Mark Rothko. "I belong to a generation that was preoccupied with the human figure," the latter reflected in 1958. "It was with the utmost reluctance that I found that it did not meet my needs. Whoever used it mutilated it. No one could paint the figure as it was and feel that he could produce something that could express the world. I refuse to mutilate and had to find another means of expression."[45] For Rothko, an art naïvely imitating outward appearances—"the figure as it was"—had limited relevance in a world of high-speed air travel, particle physics, Jungian psychiatry, broadcast media, and mass-produced culture—phenomena which fragmented, dematerialized, or diminished the evidence of the senses.

Steinberg and the abstractionists agreed up to that point. But while painters sought to divorce their art from visual representation, Steinberg turned in quite a different direction, to the demotic language of comics. Against the simple conceit of realist painting—that visual facts about the world are adequate, in Rothko's phrase, to "express the world"—the expansive vocabulary of comics provides visible forms for invisible phenomena: sound effects, thought and talk balloons, popping sweat-beads of emotion, stink lines, and outsize punctuation marks to signal relief and ecstasy and pain. Steinberg drew in the language of comics insofar as he portrayed things not as they appear but as the multisensory mind pictures them. But the subjects he drew *about*—memory, geometry, history, semantics, reason, weather, language itself—departed drastically from the typical thematic range of comics, and of *New Yorker* cartoons as they had existed before him.[46]

"I am a writer who draws," Steinberg half-explained, and in *The New Yorker*, his art indeed functioned less like the work of his fellow cartoonists than like the fiction of, say, John Cheever or J.D. Salinger: crystallizing the experience of thoughtful readers, he

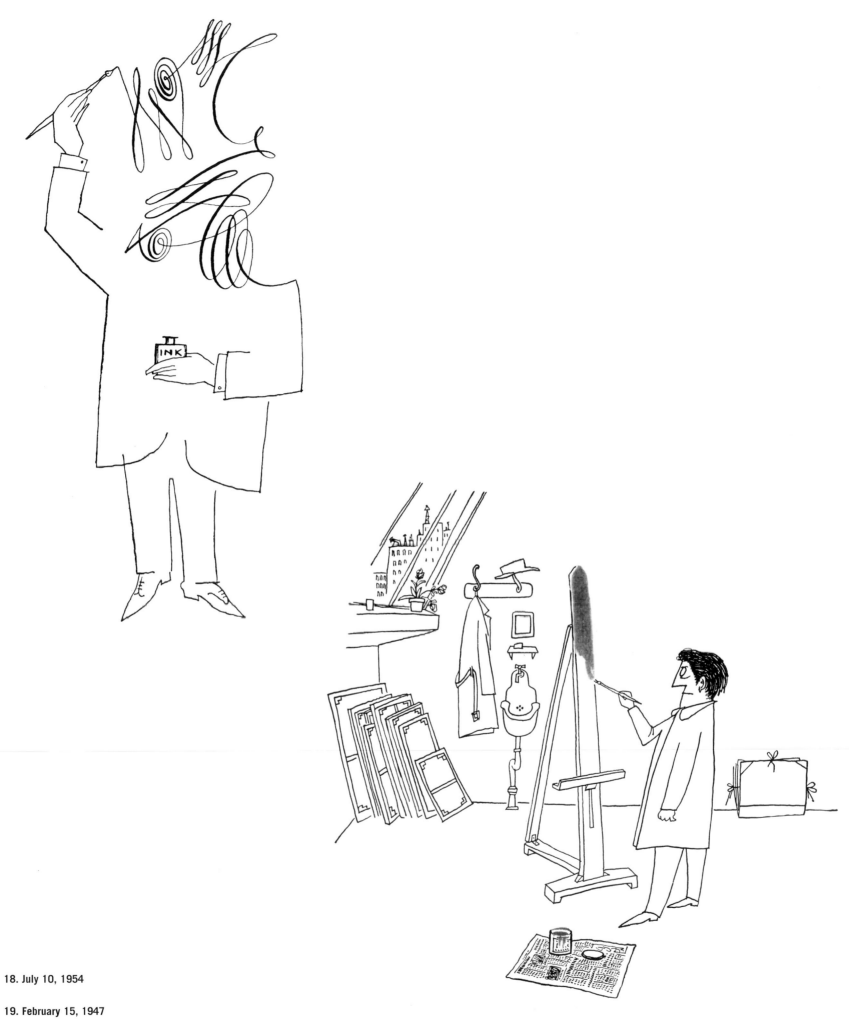

18. July 10, 1954

19. February 15, 1947

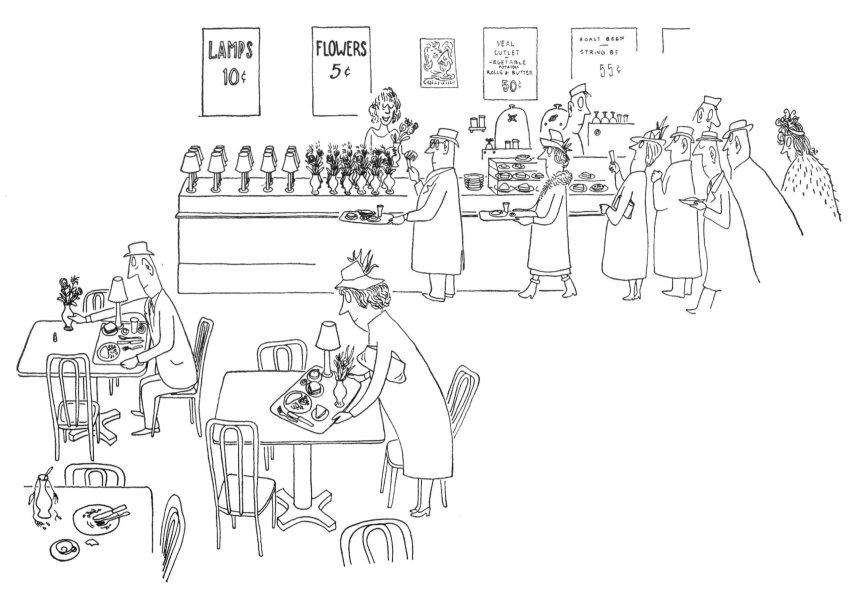

20. December 23, 1944

proposed vivid emblems for their daily habits of mind. Even in his most straightforward early cartoons, he was liable to pose intellectual puzzles about representation (pp. 92 bottom, 182 bottom) or address modern alienation, as in his image of Automat patrons purchasing lamps and flowers against the peril of mealtime loneliness (fig. 20).[47]

He differed from other cartoonists, too, in his propensity for irresolution. Gag cartoonists work by finding outlandish new uses for conventional symbols of social order, rather like Charles Addams' boy playing God with a toy school bus and train set (fig. 21). Steinberg's variation (fig. 22) proposes a more charming, impenetrable relationship: a girl has tied her indulgent father to the tracks, and in happy anticipation they eye the oncoming train. How to interpret this "problem cartoon" (to adapt the label employed for Shakespeare plays in which pratfalls and patricide mingle)? An allegory of love? A meditation on the erotics of adolescence? Whatever Steinberg supplies in the way of content, motive—the heart of Addams' humor—is kept out of reach. "People who see a drawing in *The New Yorker* will think automatically that it's funny because it is a cartoon," Steinberg observed. "If they see it in a museum, they think it is artistic; and if they find it in a fortune cookie, they think it's a prediction. . . . I try to make them jittery by giving them situations that are out of context and contain several interpretations."[48] He noted that quite early on he had given himself license to take advantage

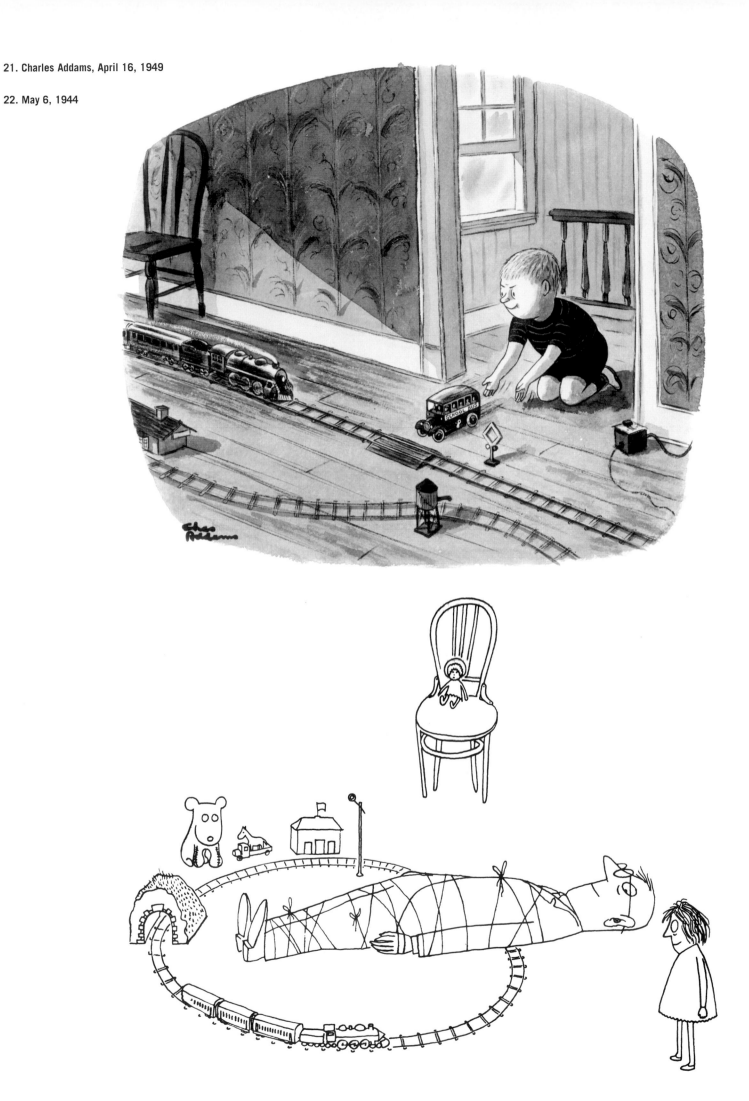

of the magazine's "snobbishness": "so many people pretended to understand it. They wouldn't admit that they don't understand a *New Yorker*."[49] And yet, he confessed, the magazine had "published one or two of my drawings that I myself didn't quite understand."[50]

Steinberg became a regular contributor of cover art in 1959, an advent marked by his allegorical monument to Prosperity in America, where Freud and Santa Claus share the dais, Statistics slay Inflation, and Uncle Sam shakes hands with Uncle Tom (p. 65). The magazine would publish as many as five covers by Steinberg nearly every year for the rest of his life.[51] Until this time, Steinberg's art for publications had consisted of two fairly distinct bodies of work. Line work for the inside pages of *The New Yorker* had served him as a laboratory for new ideas, expressed with maximum graphic concision and distinguished by visual restraint. Few art directors—whether for fashion magazines, general-market titles such as *Life*, or advertising agencies—edited Steinberg's work for ideas with the rigor of Geraghty, Ross, or Shawn. But supplying image-driven publications with art that shouted rather than whispered gave Steinberg an opportunity to try new techniques, maximize whimsy, and test color ideas. [52] By the end of the 1950s, with his stature in the publishing world secure and his personal finances firm, Steinberg had begun taking far fewer outside jobs and contributing more work to *The New Yorker*, thus bringing to the magazine the full dimensions of a talent at the height of its powers.

Steinberg's debut as a regular cover contributor marks one in a series of chapters in the evolution of the cover's function for the magazine.[53] At the outset, in 1925, a typical *New Yorker* cover was calculated to make its issue jump off crowded city newsstands: the ink colors were intense and solid and the characteristic style a jazzy, Deco-derived syncopation that complemented burlesque and satirical subject matter. During the Depression, as readership of the magazine shifted to a basis in regional and then national subscriptions, the trend was toward more observational covers, with the menu of genres expanding to embrace countryside pleasures and seasonal change as well as city types at work and play. World War II brought a new topicality that persisted into the late 1940s with images portraying a corporatized culture adjusting itself to peace. In the 1950s, the magazine, fattened by deluxe advertising and ever-lengthening fiction and Profiles, became a staple on the coffee tables of suburbia, and its covers settled into a comforting round of themes, including holidays, gags, urban vignettes, vacations, and annual events such as the Westminster Dog Show. The complacent cover repertoire of the mid-1950s was increasingly at odds with the magazine's contents, which epitomized intellectual independence in Eisenhower's America. A subtle note of dissent rang at last in an occasional series of pattern covers by Charles E. Martin (cem), beginning in 1955 (fig. 23).[54] Martin identified a new genre of *New Yorker* topic in the ripe-for-deflation cliché, and by implication the cliché-based culture of conformity itself. Mildly subversive mental wallpaper samples, cem's patterns took the *New Yorker* cover beyond prettiness, seasonality, or wit, expressing a fundamental doubt about trends in American consumer society. Both in sentiment and sensibility, they announce the coming age of the Steinberg cover.

23. Charles E. Martin (cem), November 7, 1959

June 6, 1970

THE NEW YORKER

Price 50 cents

STEINBERG

Changes in Steinberg's psyche and personal life paralleled his shift in status to cover artist at the end of the 1950s. He once commented that his mid-40s were a time of productive midlife crisis through which "I suddenly discovered with delight and surprise that the truth doesn't come from outside but from inside—from me—from a combination of knowledge, instinct and the emotion of the moment. . . . What happened? I had learned to think with the speed of speech."[55] Action followed. In the spring of 1958, he used the occasion of an extended stay in Brussels, where he had been commissioned to create a 240-foot-long mural for the American pavilion at the World's Fair, to move out of the house that he and Sterne had shared for six years. Upon returning to New York, he rented a modest-sized apartment in Washington Square Village and went public with his German-born girlfriend, Sigrid Spaeth. (Steinberg and Sterne never divorced, and soon became close friends, speaking on the phone daily until the end of his life.)

For work space, Steinberg rented a large studio on the eleventh floor of a building on Union Square West where, a few years later, Andy Warhol's Factory would become his downstairs neighbor. He and Sterne had already spent a few summers as guests in the homes of painter friends in eastern Long Island. More and more, the countryside portion of each year revitalized him, and in 1959 he bought a house in Springs, near Amagansett; over the years, it became his primary residence. In a wartime letter to Ross, he had foreseen that the city-born soldiers around him who were getting a taste of the outdoors would "settle after the war somewhere in farms or village—It's not a bad idea."[56] Now, for the first time, Steinberg was himself becoming what he called a "country man," his mind and senses attuned to the weather, seasons, turning foliage, birds, and wildlife that inspired many of his covers directly (pp. 81, 95, 131, 171), and to which he attributed his "excursions in watercolor" generally.[57]

Even as the fullness of nature came into Steinberg's cover art, his drawings inside the magazine grew more cerebral and divorced from the observed world. A decade into Shawn's tenure, moreover, *The New Yorker* began publishing investigative and reflective pieces that set it apart as a mainstream magazine with intellectual credentials. Steinberg's

24. March 12, 1960

drawings for work by Ved Mehta and Joseph Mitchell, among others, explored a visual rhetoric that matched their writing for elegance, range, and intricacy (pp. 129, 130, 134, 154). During a decade when the magazine became identified with liberal politics, Steinberg contributed more cartoons (146) and more covers (31) than he did in any other decade. While only rarely alluding explicitly to specific politicians or issues (p. 169 top), his drawings often invoked the public intellectual's task of speaking truth to power (fig. 24) or questioned conventional articles of faith, such as the equation of prestige with individual happiness (fig. 25). Steinberg's art had always spoken in two voices at once: slapstick and sophisticated in his 1940s cartoons; documentary and critical in his travelogues and

26. Drawing accompanying Thomas Whiteside, "Cutting Down," December 19, 1970

American-scene imagery of the 1950s; and, in his work of the 1960s, comic and philosophical. A magazine prized for its ear for language was well served by drawings that neither spent themselves on sight gags nor simply illustrated punch lines, but reminded readers, as a poem does, of the fluidity of meaning in every jotted syllable.

The drawings Steinberg provided for Profiles and other nonfiction features seldom really "illustrate"; more typically, they complement the article simply by suggesting the inexhaustibility of the subject at hand. When asked to contribute an image to accompany an article, he usually began by rifling through his studio archive for unpublished work that might serve—a procedural guarantee against overly literal relationships between word and image. For Thomas Whiteside's piece on the banning of cigarette advertising on television, published when Steinberg was kicking his own substantial habit, the artist supplied a smoker seated before a television, thus passably referencing Whiteside's topic (fig. 26). But clearly the draftsman's primary interest lay in cataloguing varieties of cigarette smoke— blown, exhaled through the nose, smoldering up from the ashen tip. (Two pet Steinberg theories held that Art Nouveau's sinuous line was the offspring of cigarette smoke and that electric light, with its multiple overlapping shadows, had inspired the fractured planes of Cubism.[58]) Likewise, Roger Angell's baseball pieces of the 1970s were paired with images that Steinberg created on his own, with no more specific editorial connection than the artist's and writer's shared devotion to the game (fig. 27).

"This is not a pipe," the famous disclaimer inscribed on René Magritte's painting of a pipe, epitomizes modern art's prickly insistence on being seen as something more than illustration. Cartoons, on the other hand, are predicated on their transparency: without

27. Drawing accompanying Roger Angell, "Buttercups Rampant," November 11, 1972

knowing the set-up, who's speaking, what the upshot is—no joke. Steinberg considered painting and collage "delights compared with the torture of finding an idea and then representing it in a less personal way, since otherwise you spoil the clarity of the idea."[59] He had complained in 1949 that cartoon work was "depressing because once you've found the idea you must completely change your way of thinking in order to find another. It would be nice instead to do many variations on the same theme but unfortunately that's considered repetition."[60] In the 1960s, he finally overcame this problem (to which painter friends such as Ad Reinhardt had long enjoyed immunity) when he turned out extended features on numbers, question marks, social masquerade, and other topics (pp. 117, 120, 121, 150). His theme-and-variation portfolios conjured a graphic universe in the space between the cartoon's directness and modernism's obliquity and taught readers to enjoy wondering, "Should I ask whether this is funny, or whether it's art?"

Steinberg's portfolios took a more personal turn in the 1970s. Through features that provided him with enough space to articulate the singularity of his life experience, the artist in effect became his own department of fact, using the century's familiar coordinates to map evocative narratives known to himself alone. Memory, personal and historical, was his subject in "Italy—1938" (1974), "Uncles" (1978), and "Cousins" (1979) (pp. 192–93), which share a place among New Yorker émigré memoirs with the work of Vladimir Nabokov and Ved Mehta. Elsewhere, Steinberg offered ongoing reflections on his visual preoccupations, including nature's own representational medium, reflection itself (fig. 28). "The City" (1973) and "Fast Food" (1976) marked a return, in his magazine work, to the social landscape of New York City (pp. 156, 157, 159). It was as though, after detours into

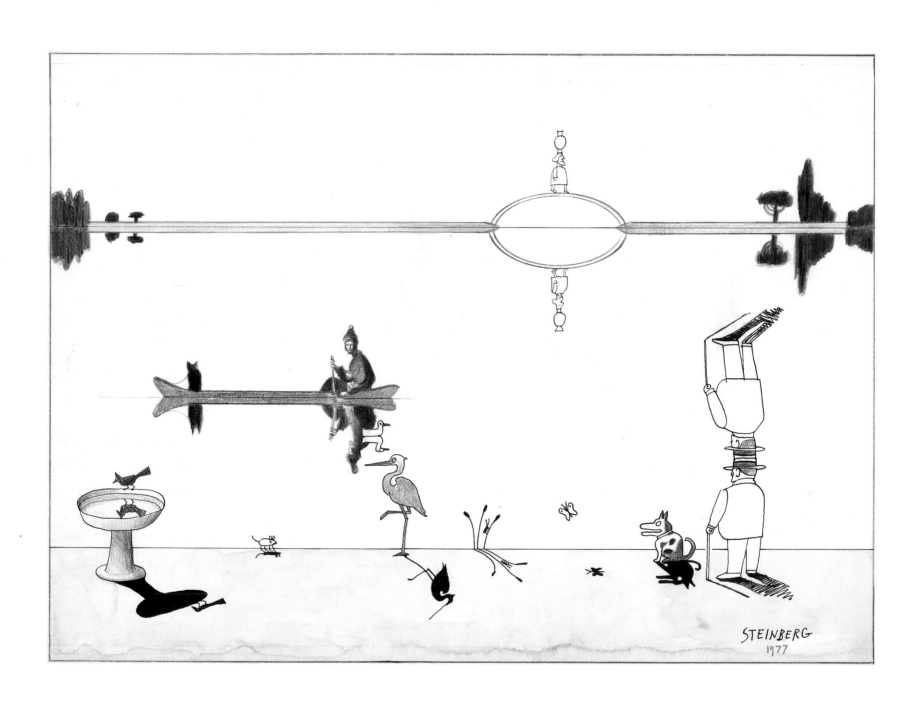

28. From "Shadows and Reflected Images," November 21,
1977 (published in black-and-white)

sheer matters of the mind in the 1960s, he had left his study for the streets. But in a meta-morphosis as total as that of New York itself, he had evolved from, in Adam Gopnik's words, "the Beerbohm of the Eisenhower era" to "the Bosch of the age of Nixon." [61] Assigning himself the role of The Inspector (the Gogolian title of his 1973 book of draw-ings), he steered wide-eyed among the crocodiles, necrophiles, and Mickey Mouse thugs of 14th Street. The city revealed to him there was the capital of a nervous nation—a place where, as Susan Sontag wrote, "Hobbesian man roams the streets, quite visible, with glitter in his hair."[62]

For decades, Steinberg had created virtually all his drawings for inside the maga-zine in a pen-and-ink line that projected the lucidity and vigor of script. But by 1970 he was finishing much of his work in watercolor, felt-tip pen, and colored pencil, media whose nuance and vulnerability were at odds with *The New Yorker*'s means of reproduc-tion. Until inside color art became the norm under Tina Brown in the 1990s, Steinberg's drawings had to be printed in halftone, thus bringing shades of gray to an oeuvre once composed of vivid black-and-white (pp. 193, 208, 212). Both for his covers and inside art, moreover, he asked that the make-up department leave visible all signs of erasure, along with corrections he made by such crude expedients as pressure-sensitive address labels (p. 211).[63] The result was a reversal of the usual aesthetics of printed illustration: rather than reproduction lending his work the sleek polish of photomechanical printing, his drawings gave the printed page the appearance of a much-handled sheet of sketch paper. Like Abstract Expressionist paintings, his late drawings were in large part about the physical process by which they had evolved.

Steinberg took exquisite pleasure at seeing his drawings printed well. His longtime studio assistant, Anton Van Dalen, recalls that whenever a packet of proofs of a new cover arrived, Steinberg would study a copy closely, holding it before him flat, "as though it were on a silver platter."[64] Just as a habitable construction is the architect's ultimate aim, Steinberg's goal was the reproduction, the magazine page his object. His original drawing, like an architect's sketch, was simultaneously work-product—a means to an end—and as intimate a keepsake as a personal letter or poet's manuscript, which he preferred not to sell.[65] (He sold the magazine only rights of reproduction.) It pleased him, Van Dalen recalls, to give a drawing away to a friend or to barter it creatively for, say, a case of fine wine, thus effecting its escape from the art market.

Public attention never rewarded or burdened Steinberg so much as in the case of his most widely known drawing, which, like the *Mona Lisa* or Van Gogh's *Sunflowers*, has long been hard to see through its encrustation of fame. *View of the World from 9th Avenue*, the cover of the March 29, 1976 *New Yorker* (p. 42), brings together a few enduring Steinberg trademarks: mental maps of time and space, Manhattan's material decline, and the stark beauty of color deployed sparingly (note the quick-fading *Ukiyo-e* horizon and sky). In its function as a cover, the design neatly joins self-deprecation and self-exoneration by making subtle use of the magazine's floating title. Here, it says, is many a New Yorker's view of the world—but (insofar as it is an object of satire) not *The New Yorker*'s view, nor that of you, the reader. Steinberg almost never portrayed New York's skyline without

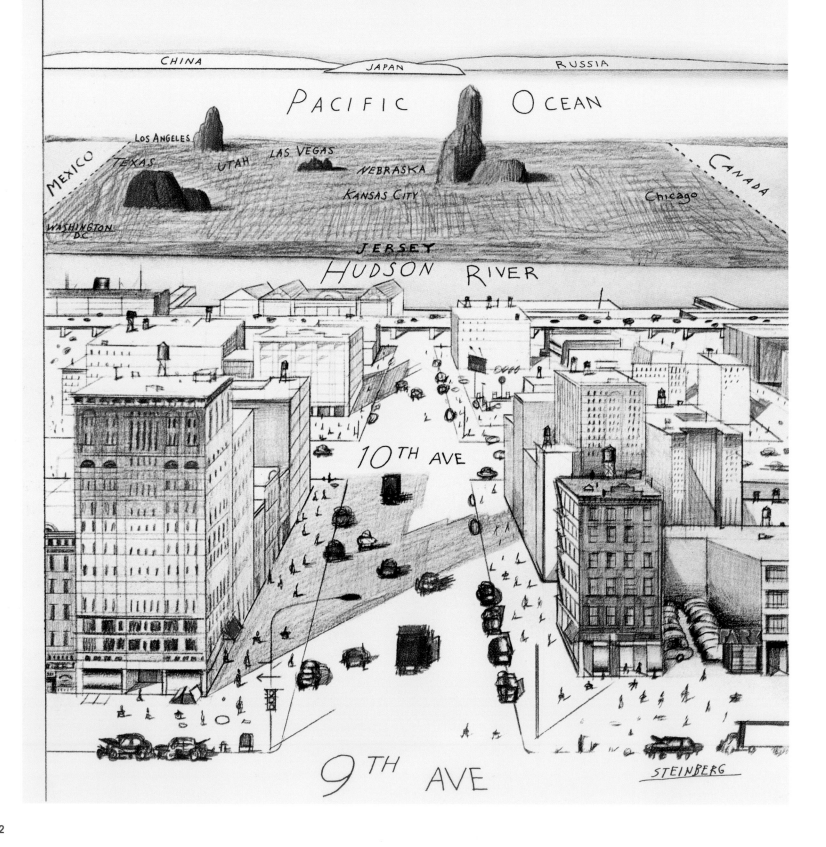

including its royal couple, the Empire State and Chrysler buildings (p. 162). The Statue of Liberty was another regular member of the company. But on the 1976 cover, none of New York's icons appears, for the theoretical viewer is pointedly sited in one of the city's pockets of nowhere. Steinberg's 9th Avenue—nobody's symbol of anything—is just a place where life in its usual way goes on at life size, while the rest of the planet shrinks to the horizon. In the course of the image's universal adaptation, the adaptors jettisoned its basic point: that the self-congratulation of a locale—any locale—is a mark of provinciality. His subject, Steinberg said, was the worldview of "the crummy people."[66]

As imitations of the cover were churned out for chambers of commerce everywhere from Vienna to Peoria, Steinberg grew increasingly disturbed at the prospect of his immortalization—uncompensated—on the basis of one misunderstood drawing. The 1984 film *Moscow on the Hudson* was advertised with a poster featuring an especially blatant steal. The artist went to court, and the ensuing civil case (*Steinberg v. Columbia Pictures,* 1987) earned him a major settlement. The defendants argued that their vista was based not on Steinberg's drawing but on the same buildings he'd drawn, an argument that collapsed in summary judgment since the buildings proved to be Steinberg's inventions. He taped photocopies of the settlement checks onto their award dates in his *New Yorker* appointment book for the year, and he told Lee Lorenz that the court's decision had given him satisfaction like "punching somebody in the nose."[67] With his point made and honor salvaged, Steinberg regarded the undiminishing tide of rip-offs with some indulgence, even entertaining the idea of anthologizing the cover's "best falsifications."[68]

In 1978, the Whitney Museum of American Art organized a full-scale traveling exhibition of Steinberg's art. The ostensible retrospective of over 250 pieces strongly favored works he had produced since 1965 for exhibition and sale, as opposed to drawings published in *The New Yorker* or elsewhere. ("Like all autobiographies it's going to be fairly fictitious," he conceded as the opening approached.[69]) The selection reflected Steinberg's equivocal feelings about his public image as a cartoonist. At *The New Yorker*, however, there were other concerns. Lorenz recalls worrying with Shawn, in an art meeting, that the exhibition might leave Steinberg "painted into a corner" by imposing structure, seriousness, and conventional success on an oeuvre that owed its unique charm to the artist's skill in shifting among genres, modes, techniques, and levels of sophistication.[70]

A greater worry for the artist was that, with nearly forty years of work on public view and reproduced in a large catalogue, he now faced the daunting task of avoiding self-plagiarism. He rallied with a series of thematic portfolios that found unity in cataloguing variations, whether of his own densely layered dream life ("Dreams"), Japanese art ("Rain on Hiroshige Bridge"), erotic fantasy ("Kiss"), the finer points of American civic architecture ("Bank," "Post Office," "Housing"), or Manhattanite cosmology ("Lexington Avenue") (fig. 29, pp. 86, 146, 209, 212 bottom). Mapping far corners of the artist's imagination, these two- and three-page features constituted a major presence in the magazine during the final decade of Shawn's editorship; eight of them ran in 1983 alone.

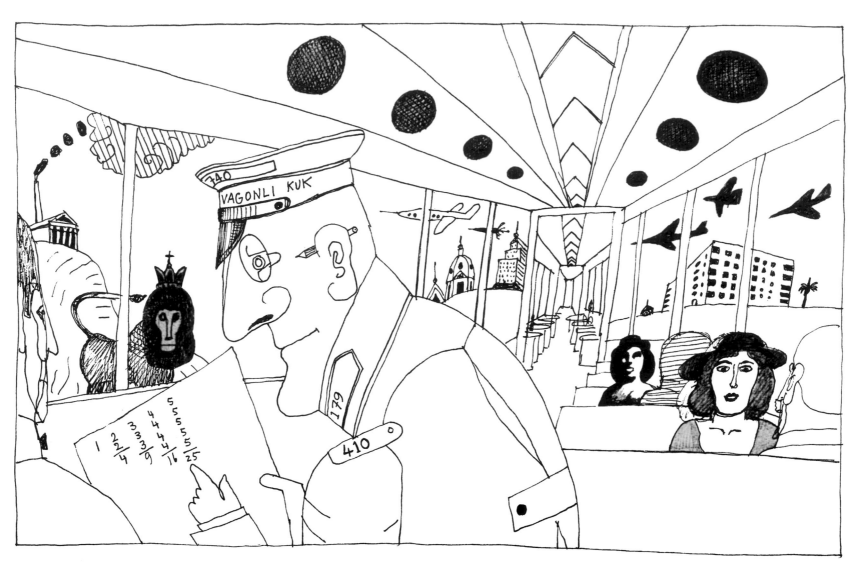

29. From *Dreams*, May 23, 1983

In the same year, Steinberg turned in the first "roughs" of a new genre of work for which he wanted feedback from Lorenz and Shawn. The drawings, spare pencil sketches accompanied by text captions, addressed a range of subjects so diverse that their cumulative theme could only be called autobiography. Having considered his "Postcard" images (pp. 110, 112) "the equivalent of short stories,"[71] Steinberg now described himself as "the illustrator" of his own texts,[72] which varied in length from single sentences to long paragraphs. The pieces range in genre from *flâneur* miniatures (the path of a wind-blown newspaper as it follows him on a walk) to Proustian vignettes (a red candy rabbit on a Bucharest neighbor's shelf), and from odd intersections with history (De Gaulle's entourage passes his taxi on the road to Orly in 1962) to reflections on the sources of the artist's own pessimism ("In Europe West is North and East is South—The Western culture of the North is based on maintenance—The Eastern culture of the south is fatalistic"). There is even homely advice:

> One becomes, with age, a Teacher. I learned from older friends. From Barney Newman—when photographed dress well, necktie etc. And don't smile or god forbid laugh. From Duchamp, answer your mail at once as it arrives. Pounce on it. Don't let it fester—If not answered—Out! My teaching today is—Never accept change from a fishmarket, it will stink your clothing forever. Go to Fish Market with a variety of change.[73]

Despite Lorenz's and Shawn's enthusiasm for the work, Steinberg made somewhat lame excuses—such as misgivings about his English (idiosyncratic and casual, but flawless)—and withheld consent to publish any of the drawings. His resistance seemed to reflect a growing conviction that an aging artist's truest angel was the one who stays his hand (fig. 30). He would hold out until 1994, when Lorenz's successor, Françoise Mouly, finally ran color versions of seven of the drawings under the title "Notebook" (pp. 194, 195).

In 1982, Steinberg ended his thirty years of dual representation by Sidney Janis and Betty Parsons for a more remunerative arrangement at the Pace Gallery, which left him less reliant than ever on *The New Yorker* for income and a viewing public. Following S.I. Newhouse's controversial replacement of William Shawn with editor Robert Gottlieb early in 1988, Steinberg was one of a few longstanding contributors who withheld work from the magazine in protest; he would publish only three illustrations over the next four years. One, his first inside color work, came from *Canal Street*, a collaborative limited-edition book undertaken with his friend, the *New Yorker* writer Ian Frazier (p. 214); another was a variant on his defiant little fencer (fig. 24) that ran, wordlessly, in a special section of contributors' salutes to Shawn following the editor's death in 1992.[74]

Steinberg's unplanned leave of absence from the magazine in the Gottlieb years happened to coincide with the collapse of the Eastern bloc. With the surge in news coverage of his native "fatalistic" half of Europe, the artist found himself pulled ever more deeply into hidden chapters of his own past. Some of the history that came rushing back to him now had once seemed not only distant but dead: while compulsively rerunning videotaped coverage of Nicolae Ceausescu's violent downfall in Romania, he wrote to Buzzi, "I have what they call phantom pain, that is, strong and specific pain in the big toe of a leg amputated years before. It's the pain of the Romanian patriot I was until the age

30. July 29, 1985

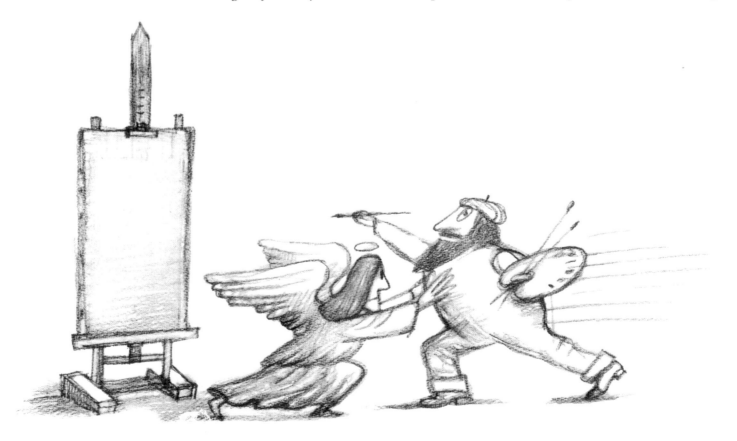

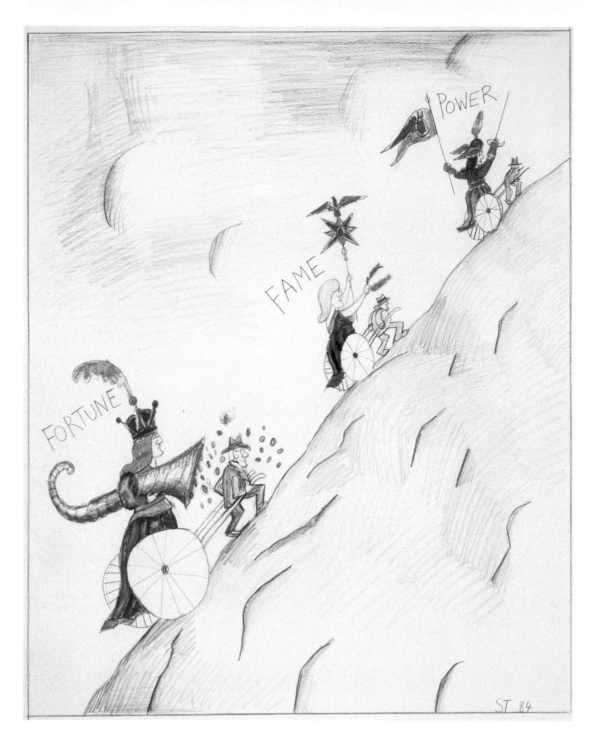

31. From "Onward," March 14, 1994

of 8 or 10, when the anti-Semitism of the place made me renounce that fucking nation forever, remaining faithful only to the landscape, the smell, the house on Strada Palas."[75] Youth now returned to him in the form of intense physical memories—his aging body having become, in his metaphor, a house where his senses occupied various rooms, uncoordinated by central intelligence.[76]

Picasso, in his final years, had found his art's last great theme in the Aging of Picasso. Steinberg, too, visibly aged in public, in the color portfolios he published in the pages of *The New Yorker* from 1994 until his death in 1999. His felt-tip marker line now manifested indifference to traditional notions of draftsmanly elegance.[77] But his powers of self-inquiry and geographic invention were as strong as ever, and his absorption in the love-hate that bound the sexes had only deepened with time (p. 151).

When Brown made Françoise Mouly art editor in mid-1993, she gave Mouly personal charge of Steinberg, warning that he could be "heavy furniture."[78] Mouly embraced

the assignment, feeling that anything from the artist was well worth having, as long as it turned up a new wrinkle in his imagination—by this time a public entity, like the virtuosity of a great athlete or actor nearing retirement. Steinberg never visited the editorial offices in the 1990s; he remained deeply skeptical about the topical territories of fame, fashion, and money which, under Brown's tenure, were seamlessly annexed to the magazine's cultural coverage (fig. 31). He had serious doubts about whether a role remained for him at *The New Yorker* at all. But he took evident pleasure in working with Mouly, a fellow European to whom he could speak in a shared émigré spirit of mingled fascination, fondness, and horror about current events—baseball, movies, the O.J. Simpson trial. At semi-regular intervals, he would summon her to his home on the Upper East Side for ritualized afternoon-long meetings. Leisurely conversation over double espressos led, at last, to careful, piece-by-piece consideration of those drawings he considered worth showing, a blend of the new and the newly excavated.

As Mouly looked at the work, Steinberg looked at Mouly. She recalls realizing, all at once, that a great deal depended upon her response, and that the slightest hint of theatricality would amount to an affront. Steinberg was watching for the kind of involuntary responses which would reveal what a drawing really meant to her. These private meetings with the art editor, on his own turf, were more than just a means of keeping his work in the magazine. If they began as pleasant personal encounters, they became something more crucial. Steinberg grew depressed and withdrawn after Sigrid Spaeth committed suicide in 1996 and his own health declined by degrees. He took no comfort in contemplating the magazine's future, or his own, in a fast-changing culture. Without either a give-and-take with the chief editor, such as he'd known with Shawn, or a sense of rapport with the magazine's readers, his meetings with Mouly now stood in for many of the satisfactions once afforded him by his work for *The New Yorker*.[79]

In 1978, Steinberg remarked: "I am on the edge of the art world. I'm not sure that being in the center is the proper place for an artist. An artist has to have a precarious situation."[80] His was a major oeuvre of postwar art that reached viewers via the printed page—a page it shared with the written word, while seldom entering into partnership with it. That situation must be called unusual, if not unique, in the artist's time, and art criticism has not found a suitable language for handling it. Still, how precarious was it? It would be equally accurate to say that Steinberg's catbird perch, up within the humming machinery of mass communication, brought him into a deeper engagement with the culture of his era than any canonized contemporary artist.

Mechanical reproduction and popular culture presented complex and absorbing issues for modern artists as different as Marcel Duchamp, Andy Warhol, and Philip Guston. But for Steinberg mechanically reproduced popular culture provided both medium and milieu, and what he called the "center" of the art world or, more wryly, the "Academy of the Avant-Garde," looked like a strange place for an artist to want to be (fig. 32). As for his fellow cartoonists and illustrators, a few twentieth-century names—Disney, Rockwell, Schulz, Seuss—won audiences many times the size of his. And yet

by sticking with the singular magazine he called "my refuge, *patria*, and safety net,"[81] Steinberg had found ample compensation for not pushing the popular and commercial limits of his art. In *The New Yorker*, where the mark of his pen was the signature of the unconstrained mind at work, he freely explored ideas and idioms that no other commercial artist was at liberty to try—until they had been proven viably Steinbergian.

The New Yorker at mid-century defined the apex of an upper-middlebrow popular culture founded on the educated curiosity of its public. "Books figured in more homes," John Updike has remarked of the magazine's formative decades, the twenties and thirties; "Your piano teacher read Steinbeck." [82] As the years passed and books lost out to television in the daily habits of millions, *The New Yorker* found itself playing an ever-lonelier role in sustaining the culture of reading from which it had arisen. Steinberg's art came to mean all it did because it appeared amid the words of Perelman, and Updike, and Barthelme, and because it was absorbed along with them by "your piano teacher"—that is, by the kind of ordinary intelligent reader whose search for enlightening diversion began, as a matter of course, on the printed page. What *The New Yorker* gave Steinberg was more like a magazine writer's readership than a fine artist's audience: his readers looked forward to seeing what he would do next, insisted that he not repeat himself, and saw his drawings in relation to a broad spectrum of subject matter and opinions, rather than in splendid isolation. In any given week Steinberg's contributions might cast him in the role of poet, historian, streetscape observer, short story writer, or metaphysical essayist. Whatever part he played, addressing the magazine's readership imposed discipline in the form of a compellingly strange challenge: do for us, here, what an avant-garde does—think and work beyond the limits of convention and métier—but whatever you do, fit it on the coffee table, bring us into it, make it matter.

Steinberg might have rendered *The New Yorker* reader's challenge as a combined trophy and cudgel, a device borne aloft, perhaps, by a delegation of rubber-stamp angels, prepared either to pay him tribute when he spoke their collective mind or to knock him flat as soon as he grew obscure. Working through the weeks and years on the receiving end of such attention honed Steinberg's gift for subtlety, if not subterfuge; late in life, speaking to a fellow *New Yorker* contributor, he recalled realizing "that in order to express certain things I had to transform them into jokes, into plays on words, into strangeness. . . . In order to clothe reality so that it might be 'forgiven.'" Yet even as he adopted a strategic humility demanded by his genre, by his audience, and by his role in the art world, Steinberg never lost the hunger for risk and change that made him what he was. Minutes later in the same conversation, he laid claim to something more ambitious and more unsettling than a humorist's legacy when he aligned himself with the tribe of "the self-made man, also known as the artist—half disaster, half something never seen before."[83]

At War

Between January 1944 and April 1945, *The New Yorker* published ten spreads of drawings chronicling Steinberg's military travels in China, India, North Africa, and Italy—out of sequence, at the military censor's insistence (pp. 52–57). As war chronicles, the portfolios are notable for their peacefulness. The Steinberg soldier dreams of mail in Kunming, strolls in the dust of military convoys in Algiers, is ogled by war widows in Naples, and sits for a tin-type in Calcutta. He sees everything but battle and suffers more from waiting than any other wartime affliction. To combat his own boredom, Steinberg inked murals onto billet walls and sent Christmas gift packs of exotic headgear he had gathered to *The New Yorker* offices.[84]

In the summer of 1946, Steinberg returned to Europe as a pictorial reporter for *The New Yorker* at the Nuremberg trials. His courtroom sketches never took published form, but in 1947 the magazine ran two portfolios on life in occupied Berlin (right), in which Steinberg gave equal attention to vivid emblems of Allied victory, such as the exhaustively defaced walls of Hitler's bunker, and the misery of ordinary civilians. His view of the country remained even-handed; when asked, three decades later, whether he felt ambivalent about showing his work in German museums, he commented: "I participated in the war fully, I saw all the theaters of war. . . . Those who participated in the war are left with less [need for] revenge than those who didn't participate in it. I have noticed that the people who were in concentration camps are able to drive Volkswagens easily, while those who played the black market during the war are still anti-German, even anti-Mercedes."[85]

Hitler's Bunker

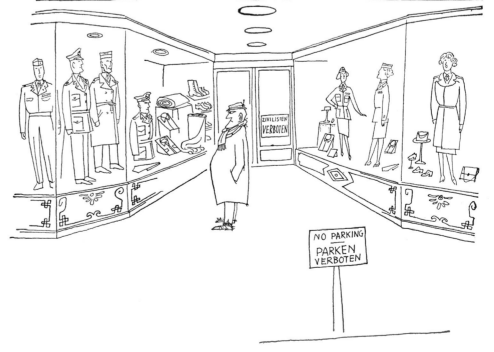

From "Berlin," March 29, 1947

50

Jan. 13, 1945 The NEW YORKER Price 15 cents

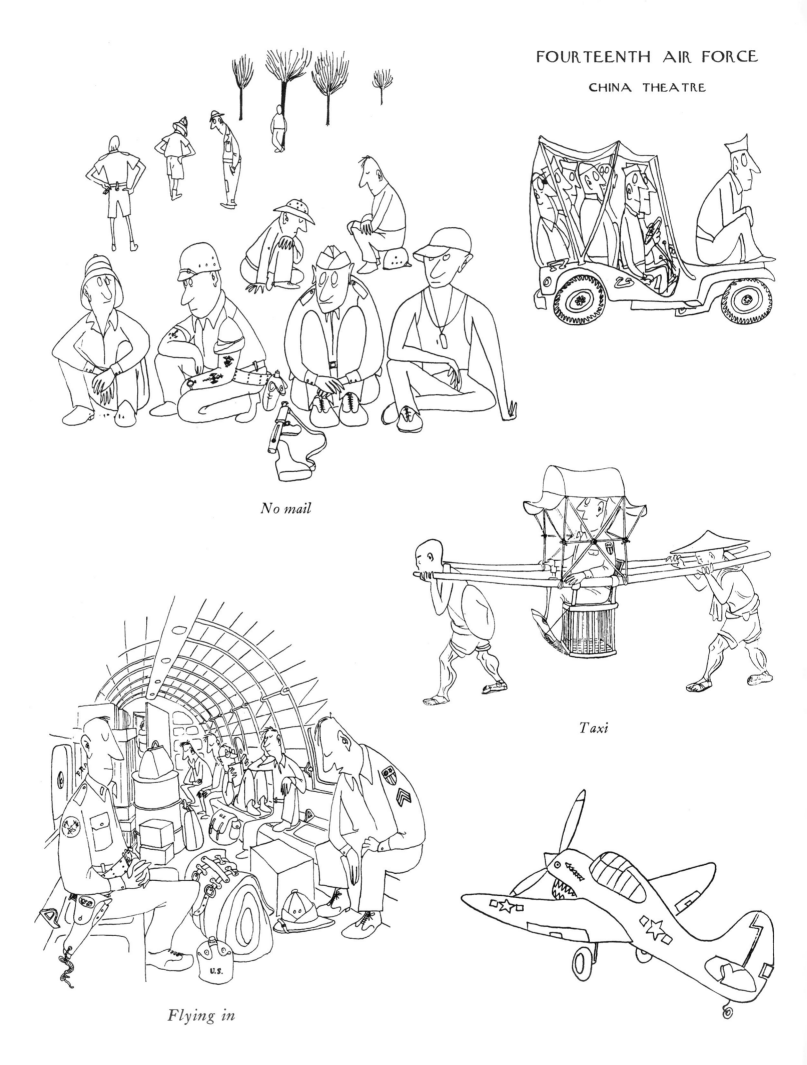

No mail

Taxi

Flying in

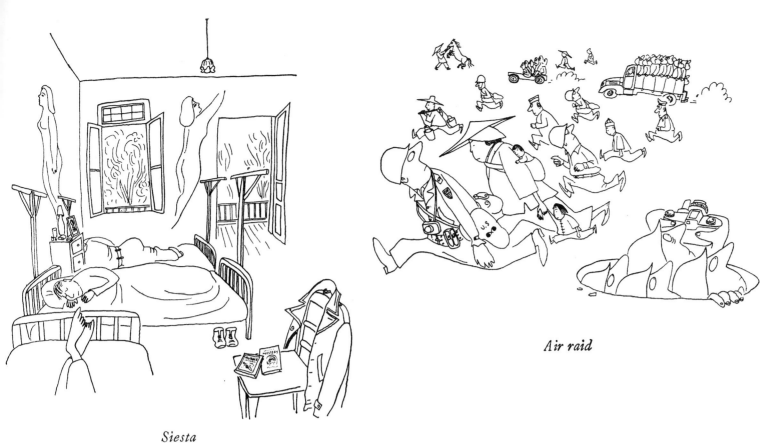

Air raid

Siesta

Main Street

From "North Africa," April 29, 1944

INDIA

From "India," April 28, 1945

Billet

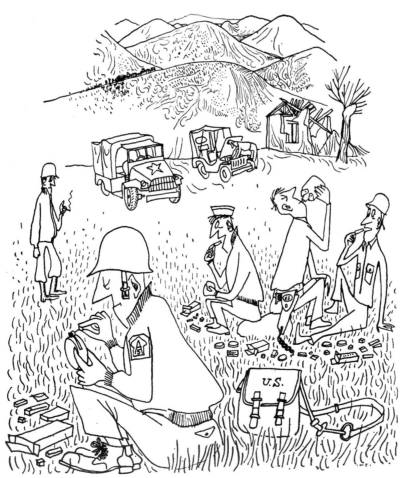

K Ration

V-mail

ITALY

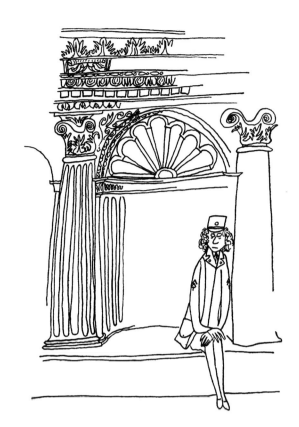

Ack-ack through open window

Discovering a City

One of the more pointed Steinberg drawings *The New Yorker* used to illustrate A.J. Liebling's three-part 1952 Profile of Chicago (right) portrayed the city as a one-horse pioneer town fronted by Potemkin-village high-rise facades. Steinberg's Manhattan, by contrast, was a skyscraping city through and through, its past and future chronicled in lofty stylistic conversations lining the avenues (p. 59).

New York supplied the young artist with no end of raw material for cartoons: ranks of drinkers in the bars of Third Avenue; antiques shops hard under the el, stuffed with ornate Old World gimcracks; the precocious obsessions of cooped-up city children (pp. 60–61). Matching lines and voids to the rhythm of the city's profusion, Steinberg packed his images with detail—sometimes for the sheer visual pleasure of it, sometimes for the sake of comic timing: one's eye can wander at length through his lunch-hour drugstore before finding the psychoanalyst's concession at the back (p. 62).

For a series of spots published in 1957 (p. 63), Steinberg used Manhattan's window jambs as picture frames through which he peered into the interiors of brownstones, hard-edged postwar apartments, the dusty sitting rooms of widows and pensioners: the countless private worlds that add up to New York, silently eyeing one another across the public streets.

Drawing accompanying A.J. Liebling, "Chicago," part III, January 26, 1952

November 3, 1945

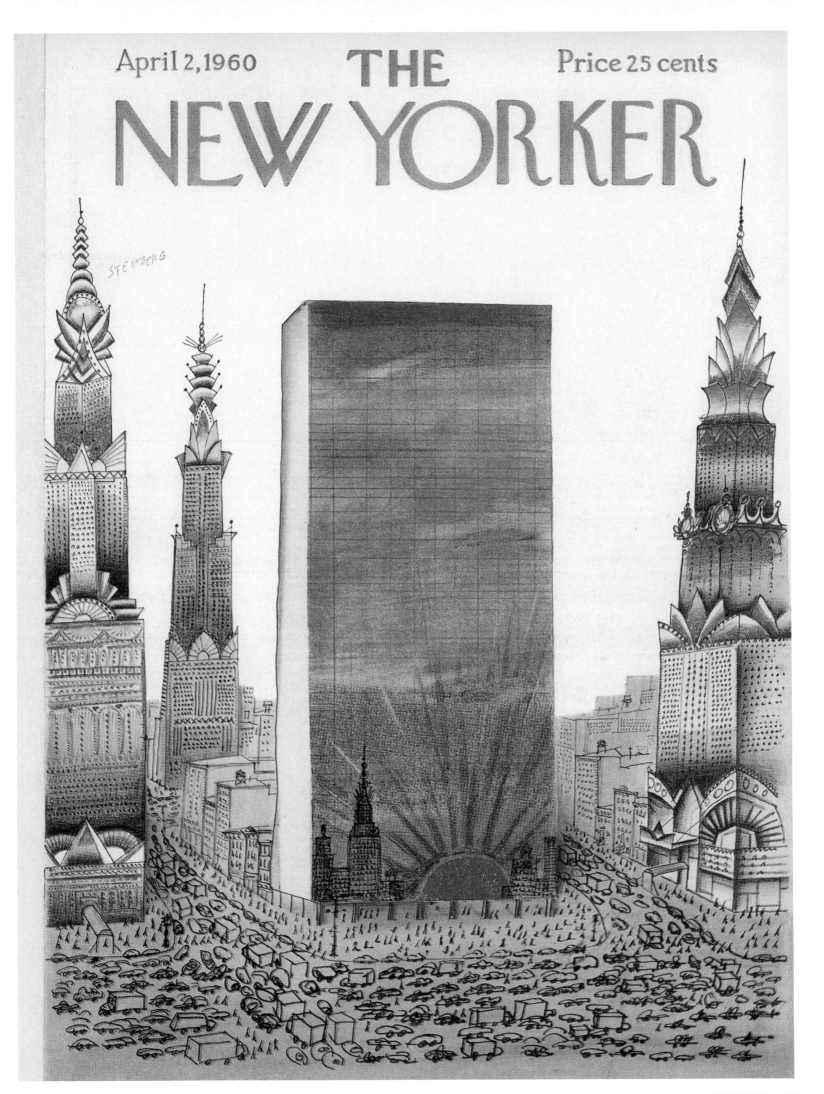

April 2, 1960 THE Price 25 cents

NEW YORKER

STEINBERG

January 3, 1948

January 18, 1947

Three spot drawings, September 14, May 18, and
October 5, 1957

American Allegories

In Steinberg's covers, America is a stage set, as heraldic and unreal as the world pictured on a dollar bill.[86] His USA is by turns a pageant stage, a parade ground, and a tableau vivant modeled archly on such earnest Gilded Age allegories as the Pantheon of Prosperity (p. 65). Inside the magazine, "Sam," as Steinberg called him, was most often seen as Don Quixote (the archetype of the dreamy-eyed idealist), while his protector, Sancho Panza, was

played by that guarantor of material comfort, Santa Claus. Sam appears on eight covers (his near-twin, Abe Lincoln, on two more), filling roles that range from the Ship of State's Ahab to a quixotic matador (below left, p. 205).

For Independence Day, 1964—seven months after John F. Kennedy's assassination—Steinberg pictured the Vox Populi as an ambiguous sphinx, spouting an oracular rebus about harmony and brotherhood before

city-father Sam and a ladies' auxiliary composed of Law, Plenty, Peace, and Liberty (p. 66). A year later, Sam climbed onstage to accompany a dancing Liberty in song, his talk balloon vaguely mapping the country: Alaskan place names at upper left, the Rockies running down the center, private colleges dotting the northeast, and Key West on the panhandle emerging from the singer's mouth (p. 67).

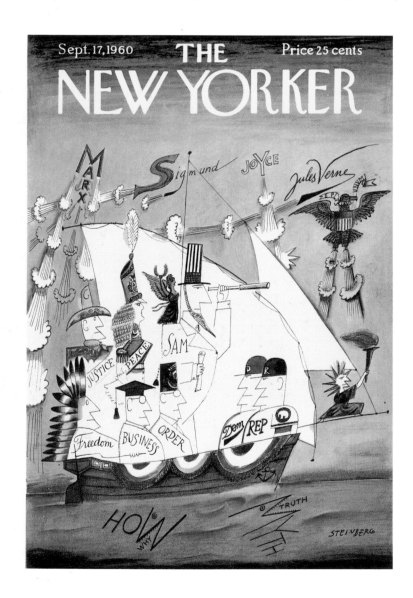

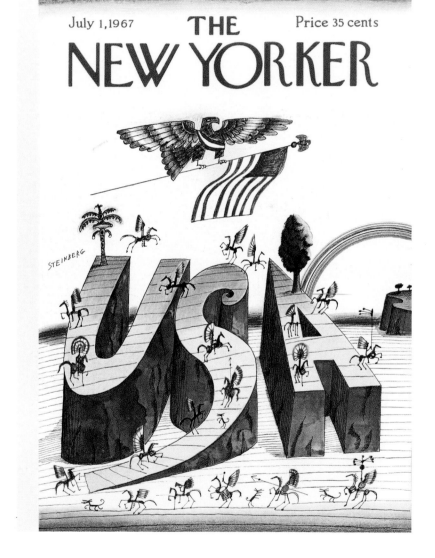

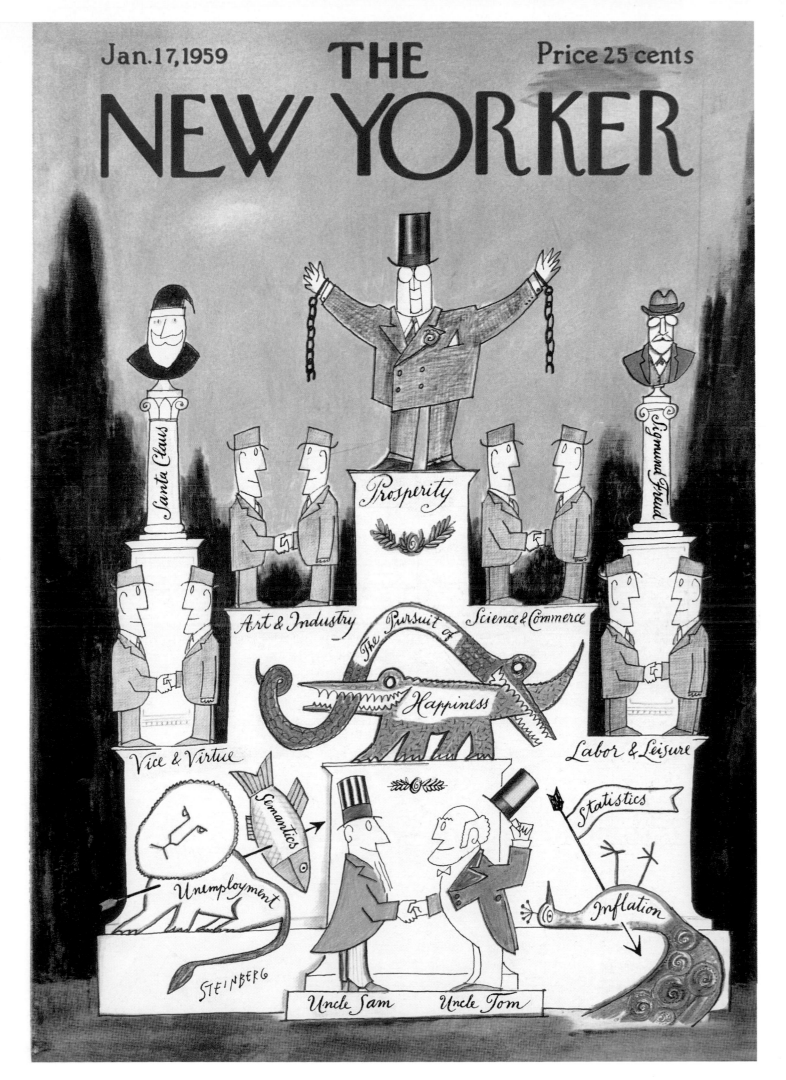

Travelogue

A grim-jawed couple, contrails streaming and cameras at the ready, swoops down onto the Continent in a summertime cover of 1961 (p. 69). Steinberg had returned to Europe nearly annually since the war, usually sailing on "the Queens": ocean liners of luxury rank, on which a costly passage of several days encouraged stays of at least a few weeks. But since the early 1950s, the face of tourism had been changing, as airlines condensed the crossing into a long day's trial. Venice and Vesuvius, Paris and London opened to a rushing class of traveler, and efficiency became the keynote of itineraries that exercised bourgeois rationality as much as they offered respite from it (below). By 1964, Steinberg's single tourist couple had become many, redoubled in the waters of the Grand Canal (p. 71).

Steinberg called his journey to Moscow and Samarkand in 1956 "a trip for my nose, a voyage to the odors of Eastern Europe and my childhood."[87] For him the Soviet realm represented a fate he had been spared by leaving Bucharest in 1933; to *New Yorker* readers his drawings unveiled a hidden world, a twentieth century in which all the parts had been jumbled (pp. 72–75). Recycled checker cabs pass truck-wheeled donkey carts. Crumbling Bauhaus-era apartment towers languish amid blocks of Neoclassical masonry and fretworked log cabins. And, in what looks like a distant parody of American consumerism, bundled passersby carry unadorned packages and the odd homely object (gas lantern, clothes hanger) down the crowded streets.

July 14, 1962

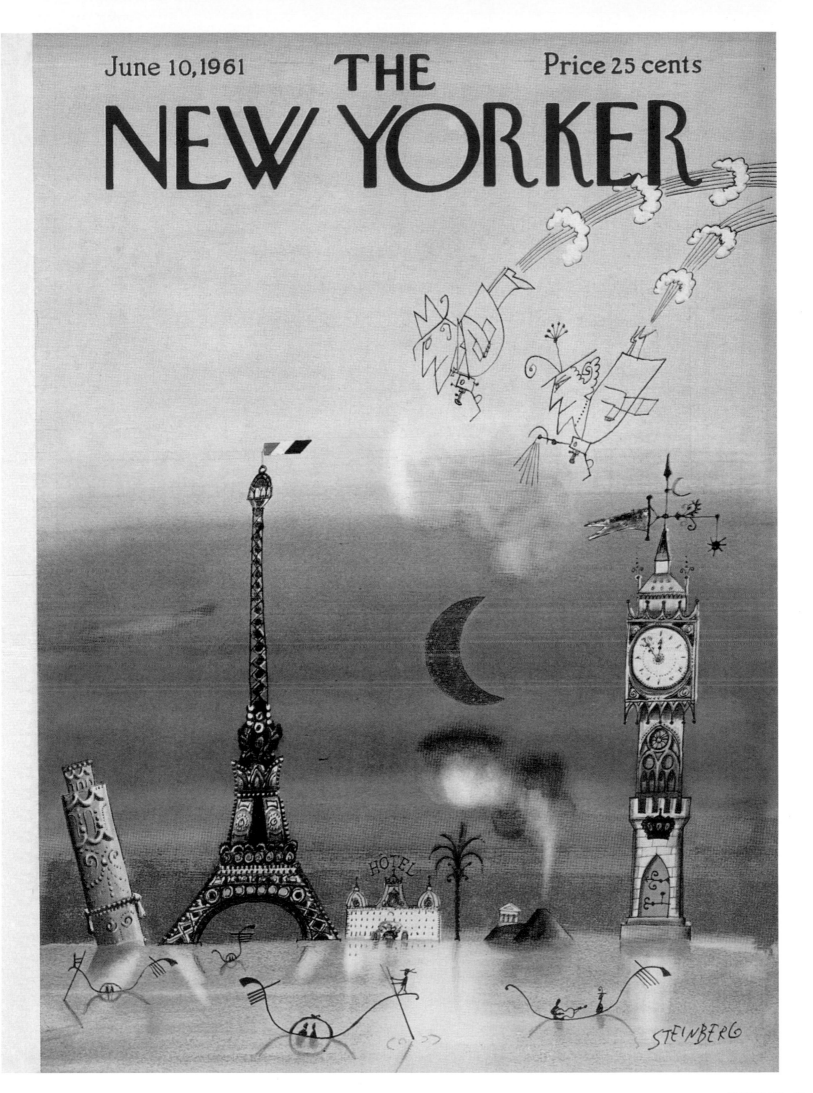

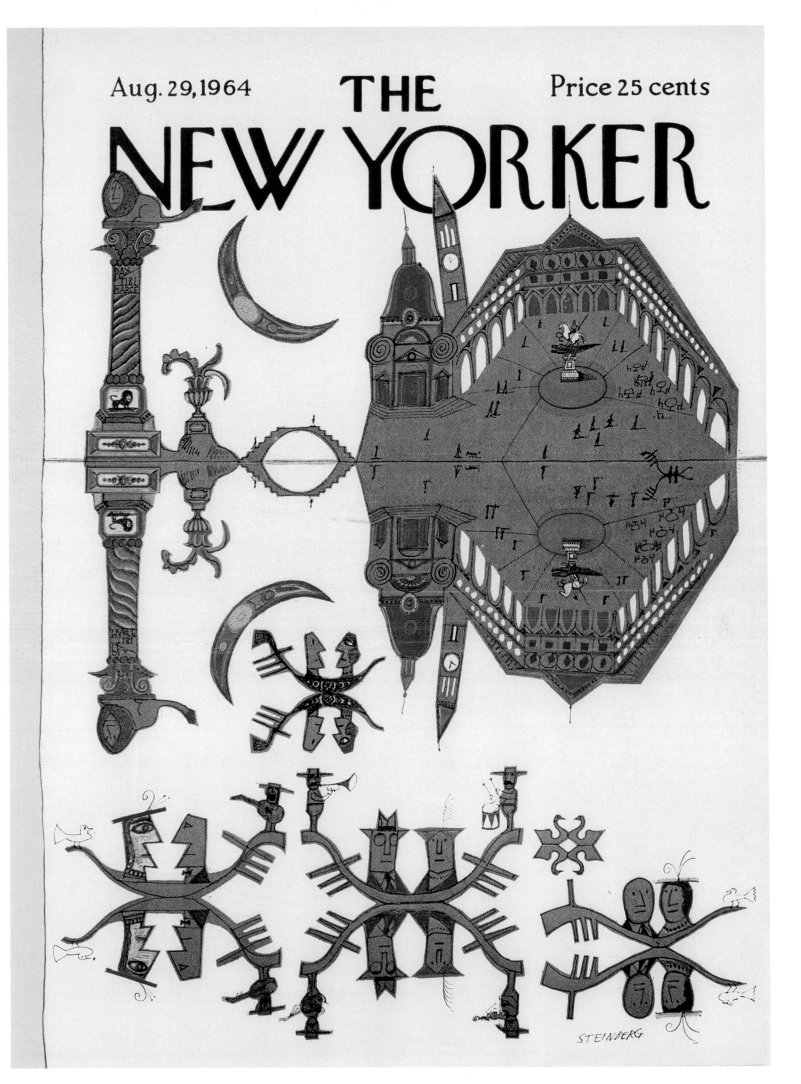

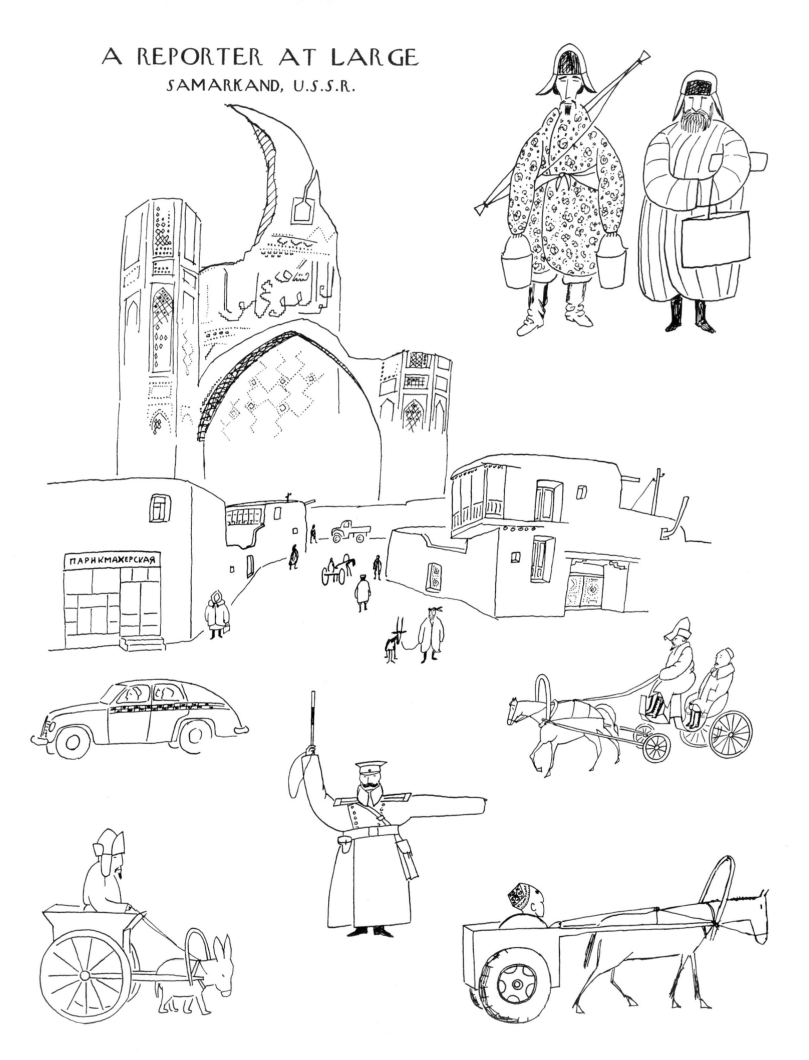

A REPORTER AT LARGE
SAMARKAND, U.S.S.R.

ПАРИКМАХЕРСКАЯ

Two pages from "Samarkand, USSR," May 12, 1956

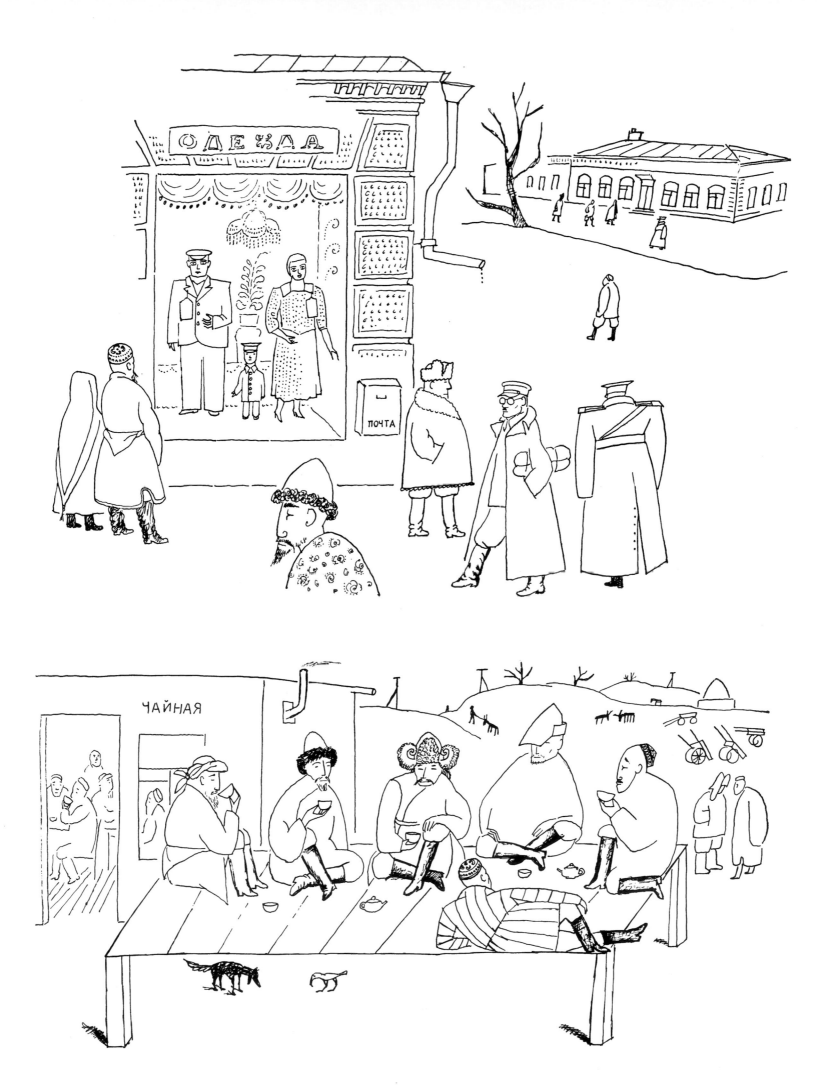

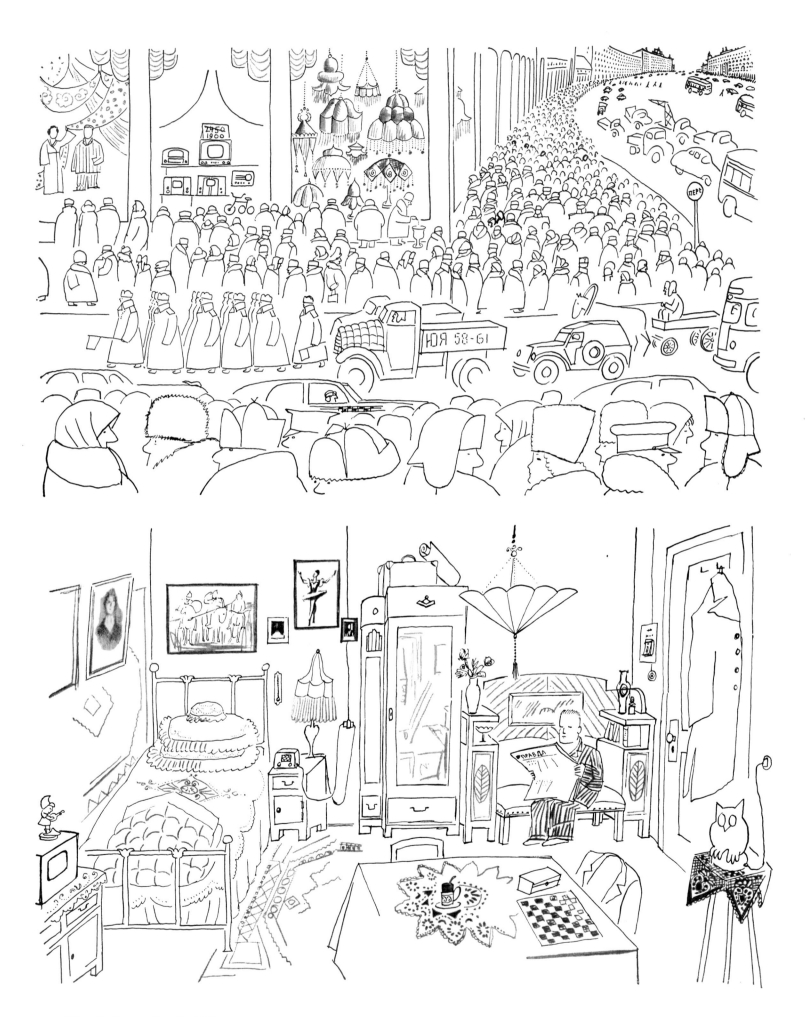

Two pages from "Winter in Moscow," June 9, 1956

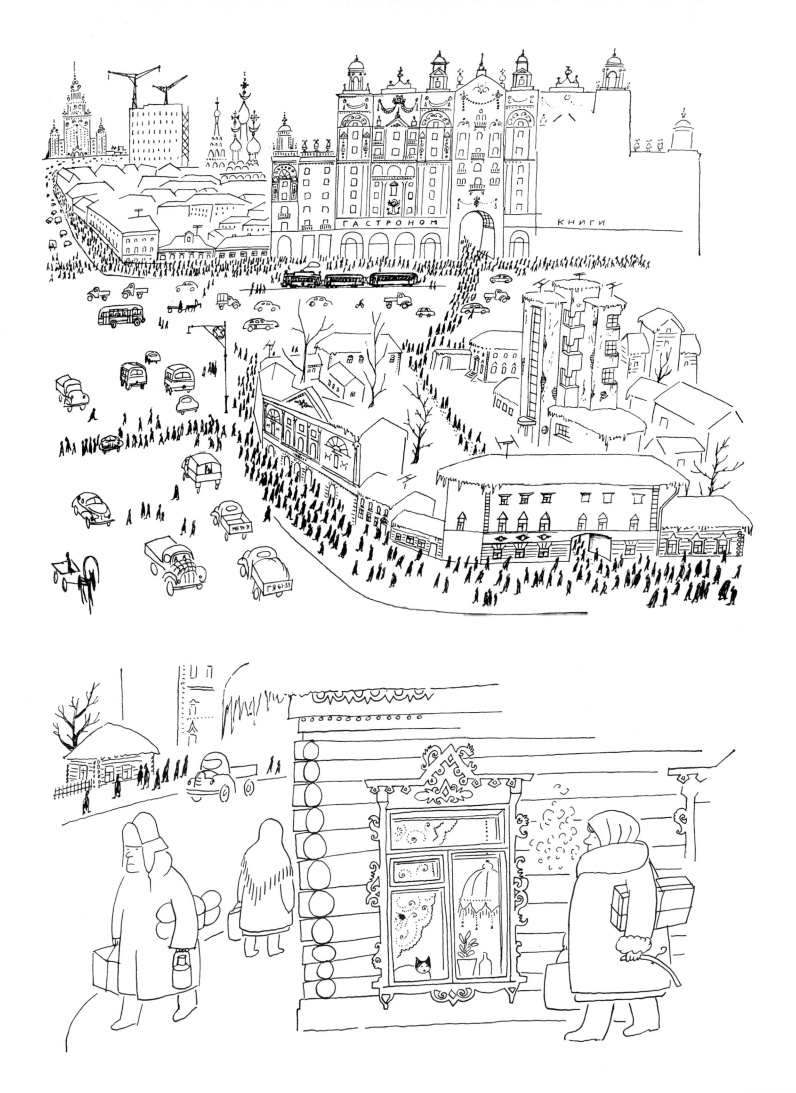

Playland USA

1

In the summer of 1950, Steinberg was summoned to Hollywood to supply the drawing hand of Gene Kelly's artist character in *An American in Paris*. He argued with director Vincente Minnelli on the first day of shooting and quit, but he and his wife, Hedda Sterne, stayed the full three months in a Brentwood house they had sublet. The result for *The New Yorker* was a five-page portfolio, "The Coast" (pp. 78–79), picturing Southern California as a mix-and-match paradise where tamales could be had from drive-in Chinese pagodas, and churches came housed in Spanish-colonial Quonset huts. In this collage world, Steinberg saw hints of things to come. As the magazine containing "The Coast" went to press in January 1951, he noted in his diary: "Am. looks to Calif. the way Eur. looks to Am."[88]

2

Twelve years later, Steinberg visited Florida and found "very beautiful and hot places almost all ruined by trashy architecture and amusements of the rich, as on the Riviera."[89] In the foreground of his Florida cover (p. 77), a Steinbergian family strolls on the beach: a crusty crocodile and his flamingo trophy-wife led by a leashed pelican who is either a boy or a pet ("children look more & more like dogs," the artist observed in 1952).[90] The palm trees behind them are *fin-de-siècle* confections, seemingly caught in mid-evolution from Victorian doilies to Jazz Age showgirls. The setting is the moonlit paradise seen in chromolithographic postcards of the early 1920s, when real estate speculation invented Miami.

3

Right: January 26, 1952

Overleaf: Two pages from "The Coast," January 27, 1951

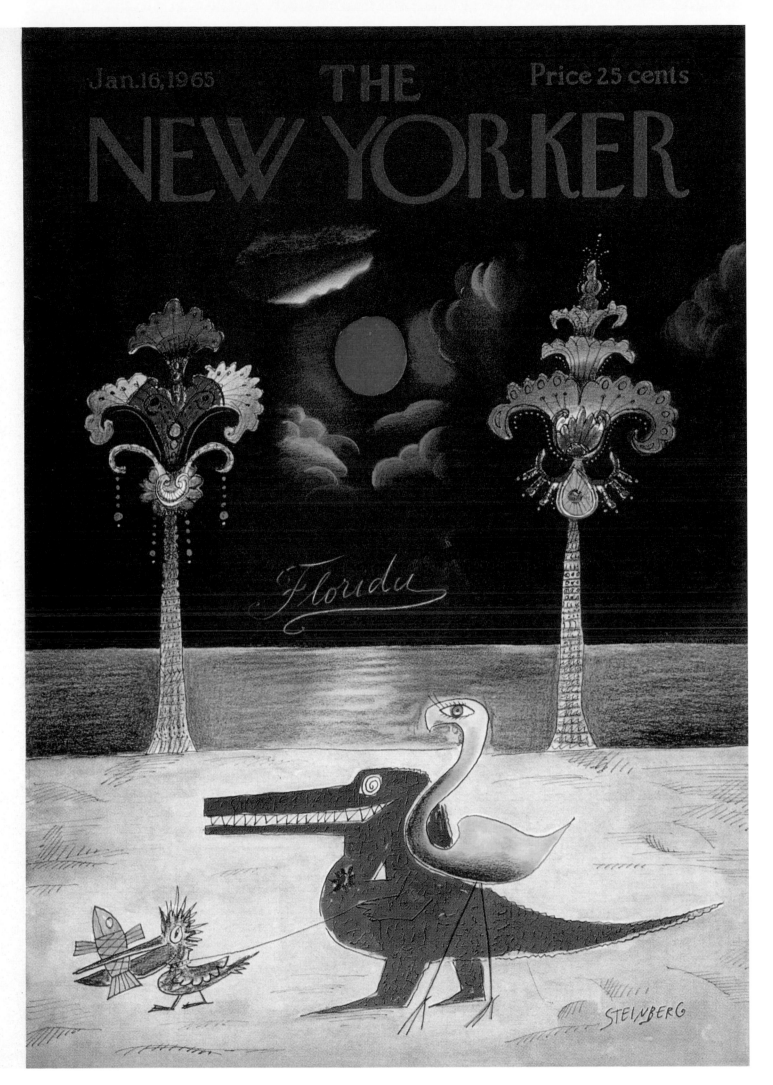

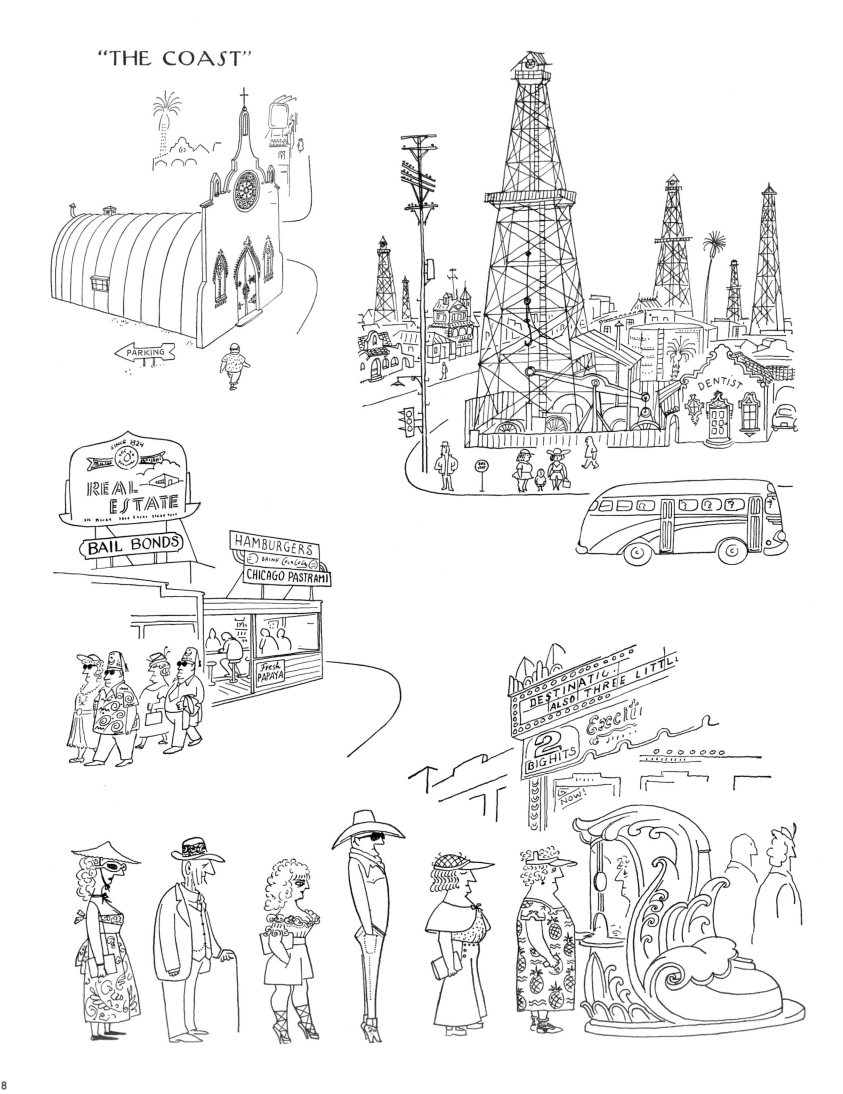

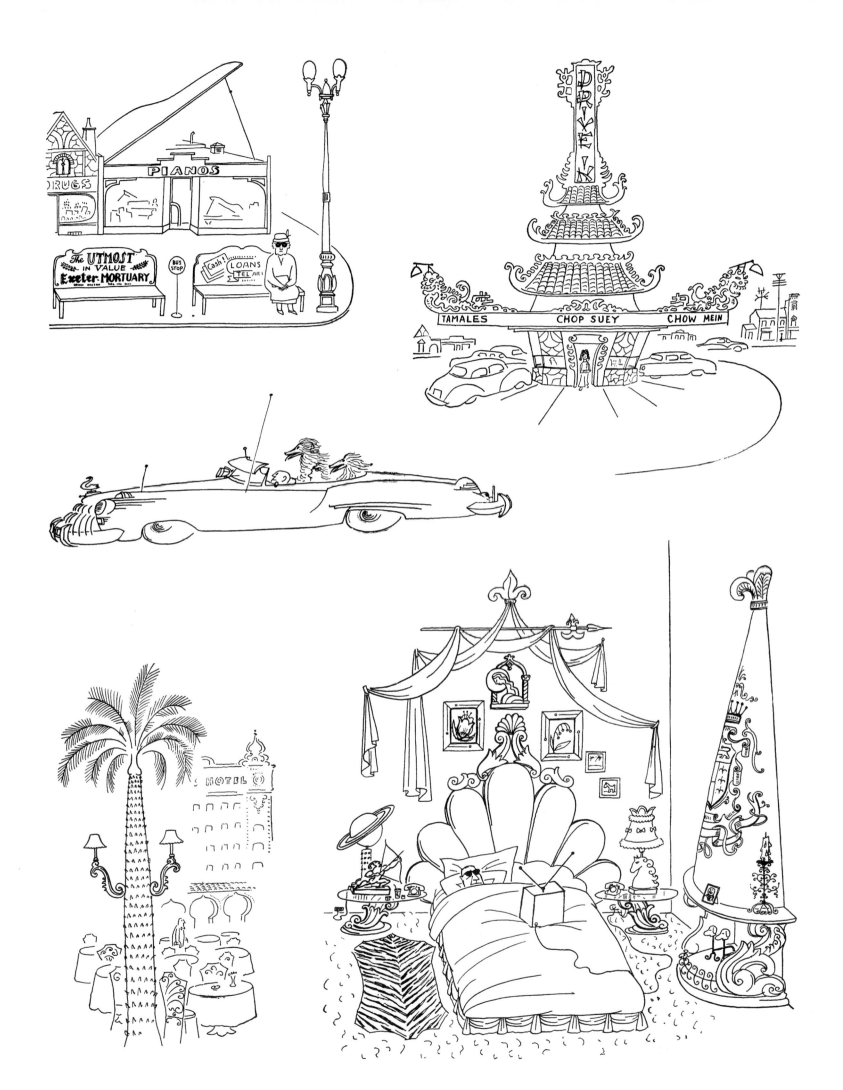

October 17, 1953

Natural History

"Visual games belong to the playfulness of art," Steinberg once commented. "Playfulness is one of the great qualities of man. Animals are playful; nature is playful. Changes in the weather are jokes. Reflections in the water are puns. Birds! They stand out in the country and sing! And mockingbirds imitate the other birds. More confusion. The countryside: It's all very rich."[91] "I can't draw a landscape," he admitted, "but I draw manmade situations: architecture, roads. For nature and for

whatever is untouched by people, I use a series of clichés."[92] An equally remote appreciation inspires a well-to-do papa to help his daughter get closer to the moon, evidently an SRO attraction (above). Another Steinberg Man regards the bucolic greenery around him from within a cubic bubble of rationalized space from which he will never emerge (p. 87).

Steinberg was an amused connoisseur of the civilized urge to systematize, quantify, and control nature—an urge perpetually

inspired and outwitted by the weather (pp. 82–85). In a sequence of compositions after Andō Hiroshige's woodcut *Sudden Shower at Atake* (1857), the artist saw an opportunity to run variations on rain, a picturesque and notably linear climatic condition (p. 86).

Sept. 9, 1961

THE NEW YORKER

Price 25 cents

STEINBERG

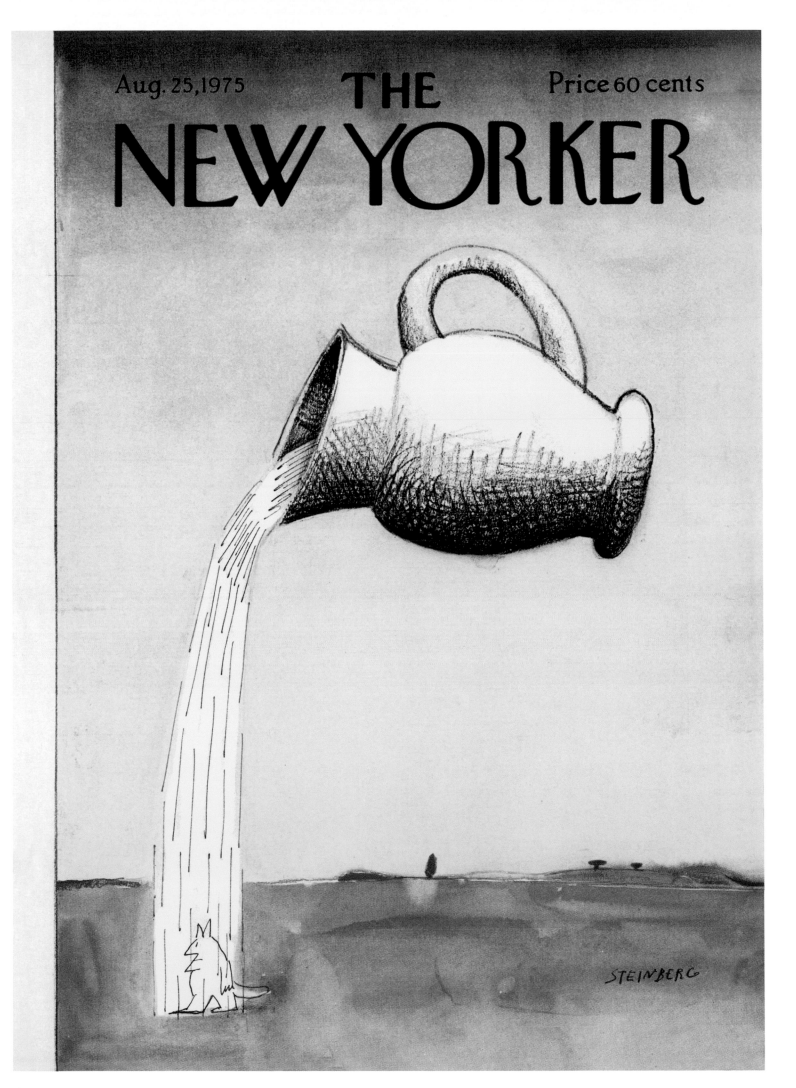

THE WEATHER

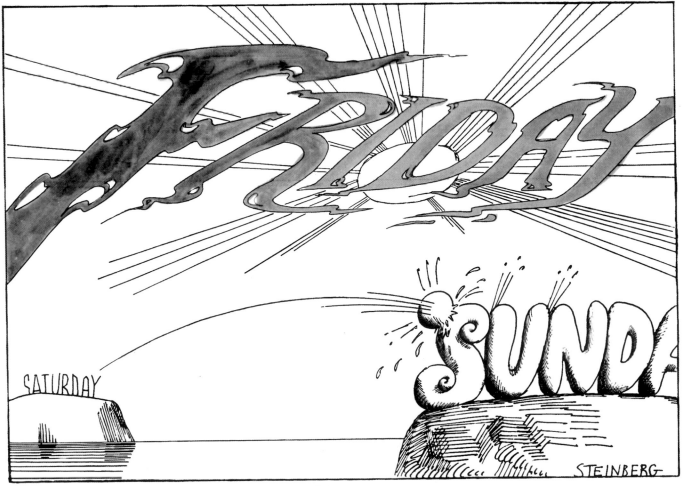

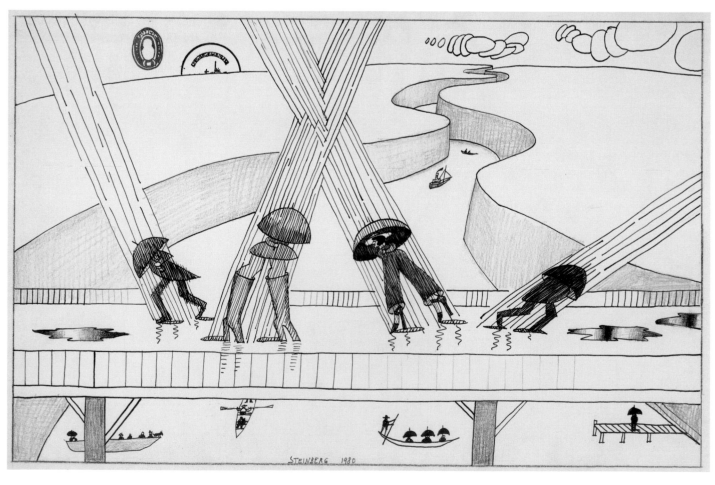

Two drawings from "Rain on Hiroshige Bridge,"
November 2, 1981 (published in black-and-white)

September 10, 1960

Art World

Steinberg's artist on a cliff (p. 89) is a man occupying two simultaneous realities. Bodily, he sits under a tree beside flowering grasses, a loyal dog nearby. But his eye and brush are fixed upon abstract picture-problems—spatial diminution, the horizon, the circularity of the sun—about which "nature" knows nothing.

Art, for Steinberg, is a series of creative mistakes. "Here," he once explained of an image such as his January 1969 cover (p. 90), "is a drawing of a painter in front of a landscape. The landscape contains every cliché in the history of painting. Different textures—oil, crayon, ink. The artist in this drawing thinks he's painting a pure landscape. He isn't. He's making post-cards."[93] The artwork, in turn, will undergo willful interpretation by viewers, dealers, critics, curators, historians. The tables are turned in a painting's-eye-view of museum-goers (below), and in a July 1966 cover in which reflections paint a picture of an artist as she tries to paint nature (p. 91).

Steinberg was quick to see that in postwar America—where the eagle of the New York School was sinking its talons into the guitar of the École de Paris (p. 93)—art had less to do with ideas or traditions than with power, intimidation, and prestige. "Everything has a message," he noted, "even the smell of museums. In Europe, museums smell of town halls and grade schools; in America they smell like banks."[94]

March 8, 1958

Aug. 14, 1965

THE NEW YORKER

Price 25 cents

STEINBERG

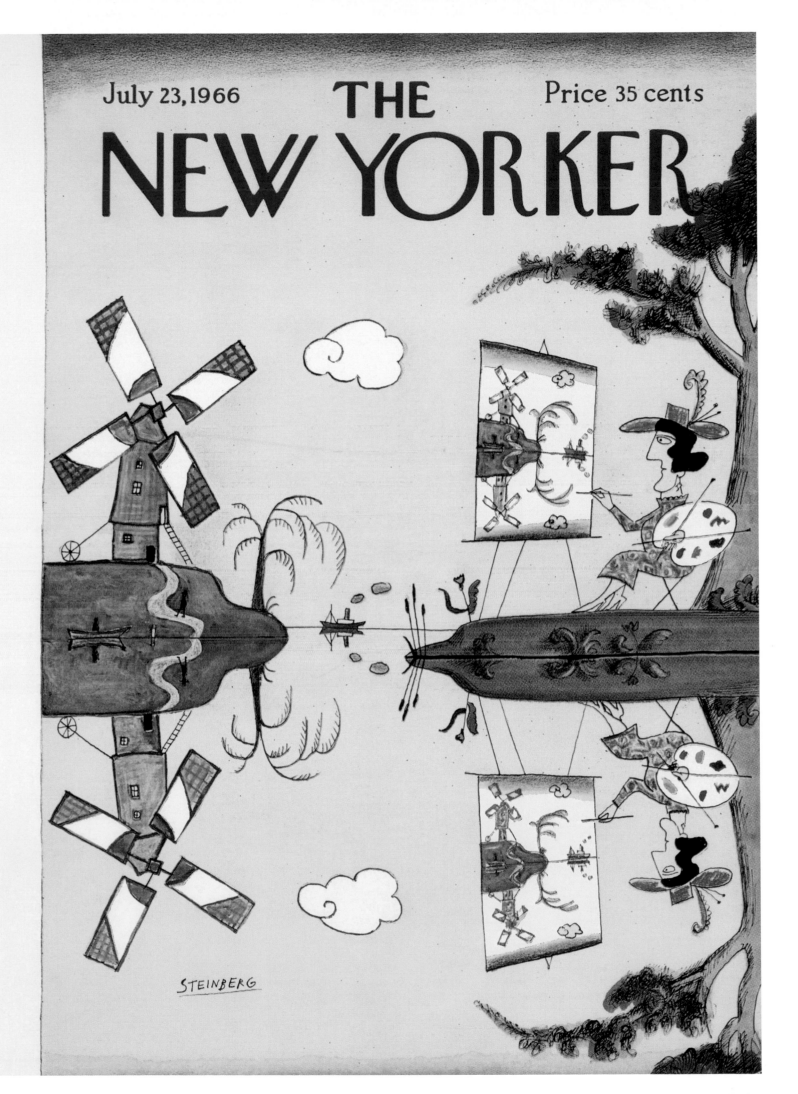

July 23, 1966

THE NEW YORKER

Price 35 cents

STEINBERG

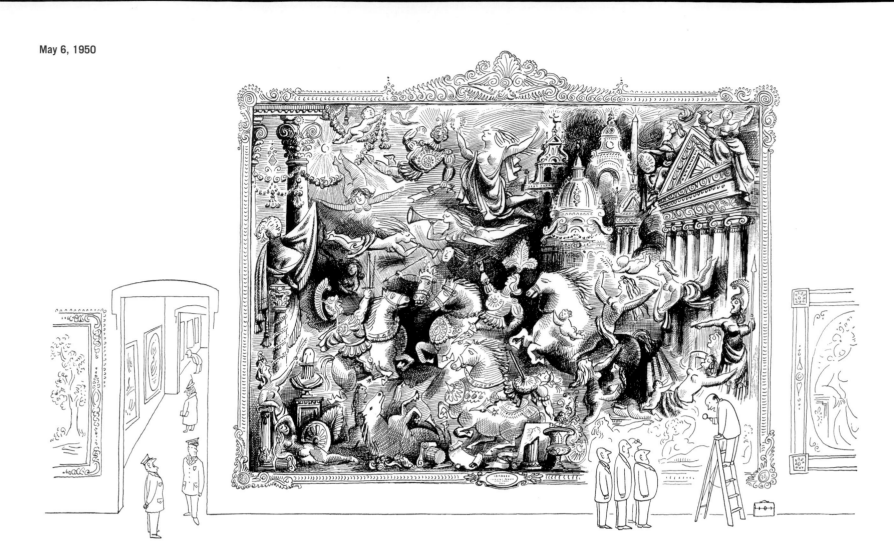

"Gentlemen, it's a fake."

November 1, 1952

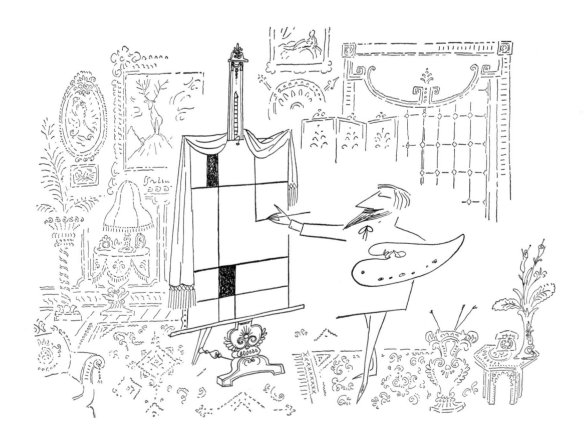

Cat People

"I am a cat," Steinberg replied, when asked why his cats resembled his people as well as himself.[95] In his art, the feline is no animal but humanity discreetly masked, with all the confident self-absorption of a dignified species. The cat tends its own garden—a garden of the mind that is composed, in Steinberg's 1964 cover (p. 95), of printer's dingbats and decorations punctuated by consorting songbirds.

The Steinberg cat can embody qualities as different as motherly devotion (pp. 96, 97) and sensuality (below left, p. 98 top), or bring theories to life. The idea that aesthetic taste is grounded in appetite, for example, finds support in an artist cat who paints canvas after canvas exploring that paragon of earthly beauty, the fish (p. 98 bottom). The cat's implacability and focus make it an apt figure for the onward push

of time, as on a cover published in the spring of 1966 (p. 99). February is an iceberg melting on the forgotten horizon, summer only a vague promise on the page ahead, but here and now March passes vividly into April as a cat rides a bicycle over a wandering stream.

May 16, 1964

THE NEW YORKER

Price 25 cents

Mar. 20, 1954 THE Price 20 cents

NEW YORKER

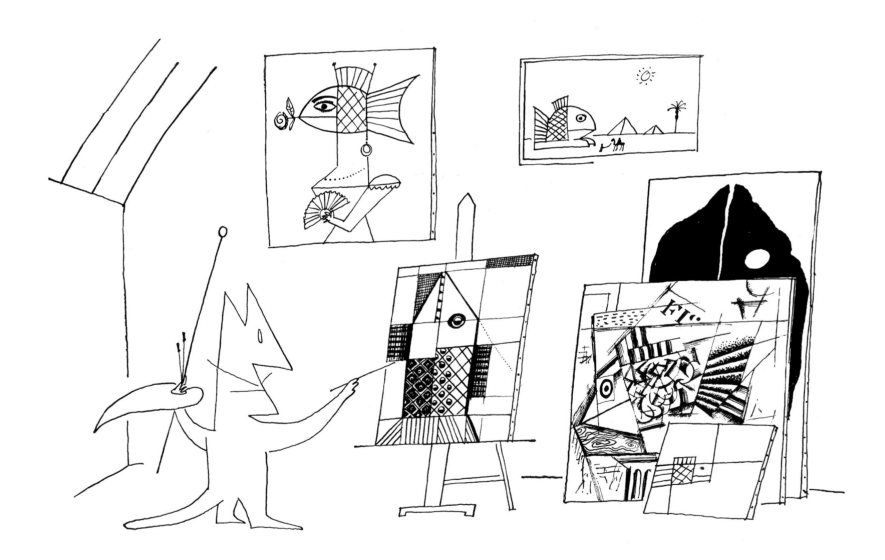

Thought and Spoken

Steinberg was not flattered at seeing his innovations become public property. Among the many he came to consider cheapened by widespread imitation was his graphic transformation of thought and speech balloons "into symbols,"[96] meaning any kind of allusive visual form (pp. 101, 104). But emulation and one-upmanship were deep-rooted traditions among *New Yorker* artists; Steinberg's own earliest drawing of a thought popping visibly to life portrayed a sleeper with a customized manner of counting sheep (above) —a tested company classic that Otto Soglow and others were constantly reinventing.

In his famous spread diagramming several "lines of talk" (pp. 102–03), Steinberg's caricatural targets are not merely vocal sounds but the mindsets that animate, for example, vapid chatter, bloodless technicality, flowery circumlocution, or political gas. At the serious core of this wordless comedy is an intimation of every speaker's or thinker's solitude: the E who would be É (p. 105); a triangle infatuated with his part in the Pythagorean theorem (p. 106); a man dreaming of a woman who dreams of him (p. 107 top). The gap will never close between Paris and Sardinia in the respective mind-maps of Steinberg's two gossiping vacationers (p. 108), nor will his fish (p. 107 bottom— his figure, he said, for the one-idea artist) ever graduate from the tedious tautology of "expressing itself."[97]

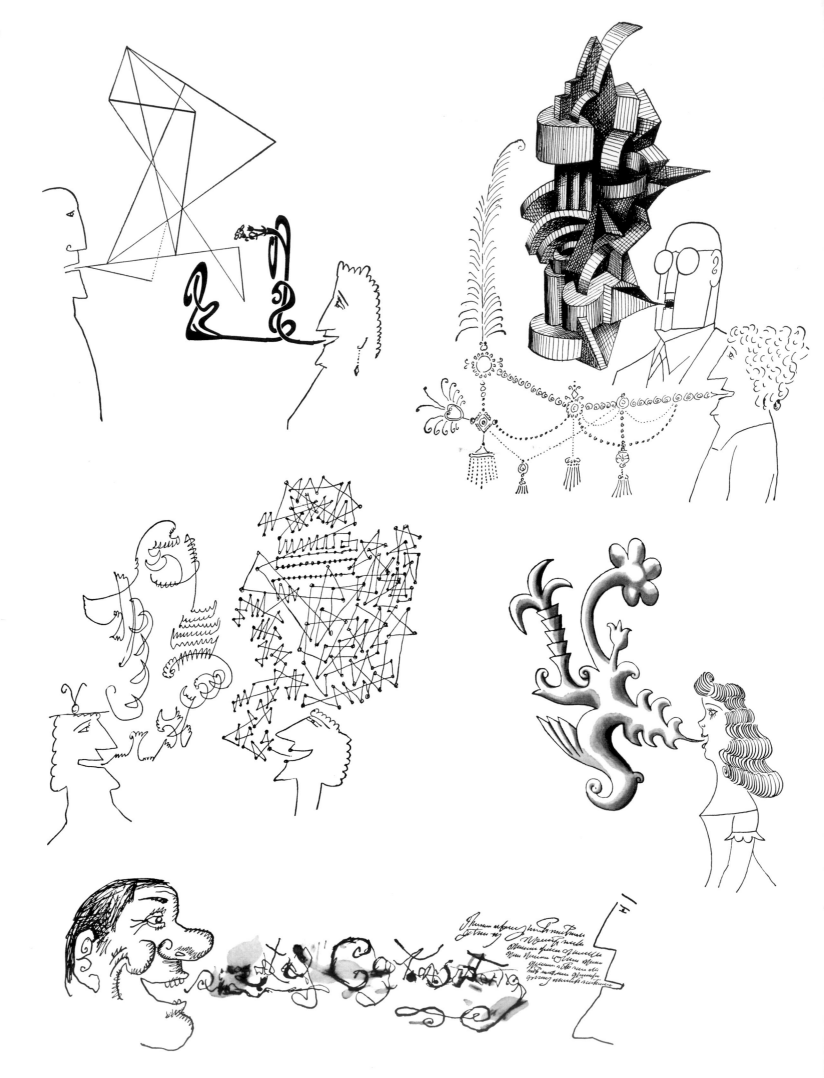

June 30, 1962

February 24, 1962

In the Mail

Mail, for Steinberg, presented one of the minor perfections of twentieth-century life. For a few pennies and a walk to the mailbox, thoughts on paper could be sent around the globe. In handwritten letters, human relationships assumed the obliquely erotic form of dialogues conducted in minute manual gestures. Through the civic church of the Post Office, the state's massive machinery knelt to serve the needs of private life, meanwhile supplying Steinberg with the stamps, seals, and insignia by which he represented the public realm of officialdom.

In two portfolios, Steinberg saluted the picture postcard as a modest form of conceptual art by which locales in the real world are schematized, reduced, sold, and transported: Milan and the Garden State Parkway rendered equal and exchangeable (below, p. 112). For the artist, a collector of hotel receipts, brochures, and stationery, ephemera comprised a universe unto itself, and the postal service was its transportation system, art world, and space program rolled into one. In a floral still-life cover of 1987 (p. 113), Steinberg posited a Cubist kind of kinship between the flower vase—a real-world vessel of romance—and the airmail envelope, confidential conveyor of secrets and sentiments in the flatland of paper.

GARDEN STATE PKWY TOLL PLAZA, ASBURY, N.J.

STEINBERG 1977

From "Postcards," January 16, 1978
(published in black-and-white)

MILAN ITALY

STEINBERG 1976

From "Postcards," February 25, 1980
(published in black-and-white)

Jan. 12, 1987

Price $1.50

THE NEW YORKER

PER VIA AEREA
PAR AVION

ST

Action Writing

The look of letters and the smell of ink sent Steinberg back to his childhood; his feeling for written language as a "reality," he reflected, "must have come from holding in my hands those wooden question marks or numbers that my father used for printing."[98] Every letter, for him, was civilization writ small: "There is no writing without the hand and everything that lies beyond the hand, all the architecture that weighs on it, moves it—biology, geology, man's history. Writing is the tip of an enormous inverted pyramid."[99]

If letters meant serious business for Steinberg, they were also "characters" in a cartoonist's sense: drawn figures optimally designed to express themselves in pantomime. 5, a cipher, inspires a curious cat to look into it—but it proves to contain only the "fiveness" of two apples and three pears (p. 116 right). The apostrophe in DON'T (a suspect foreign body among the letters) is inadvisability itself (p. 118). In the classic cover of 1971, I DO blazes in the sky over grubby I HAVE, a travesty teetering precariously atop a deeply grounded I AM (p. 119).

In Steinberg's world, numbers celebrate their independence, words map out the future, letters stage parades, and pedestrians are dogged by question marks. In mock-literal affirmation that some words were truly human, Steinberg pulled up an armchair for them in a punning series of riffs on modern culture's prime movers (right). For DARWIN, the chair defines the endpoint of evolution, where N takes its well-earned rest. MARX's X angrily crosses it out as the throne of the despised bourgeoisie. Finally, the chair becomes the seat of the ego, played by FREUD's initial letter. For all his sitting-room self-assurance, F is incomplete without his four fellow-letters, who are variously at home down in the depths and up in the idealist ether.

From an untitled portfolio, November 7, 1964

Opposite: from an untitled portfolio, November 17, 1962

BOX OFFICE

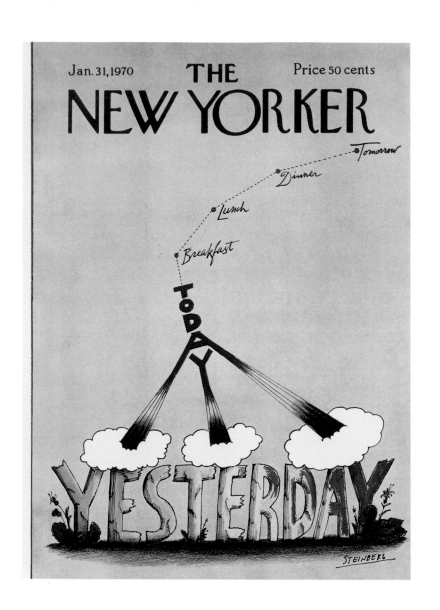

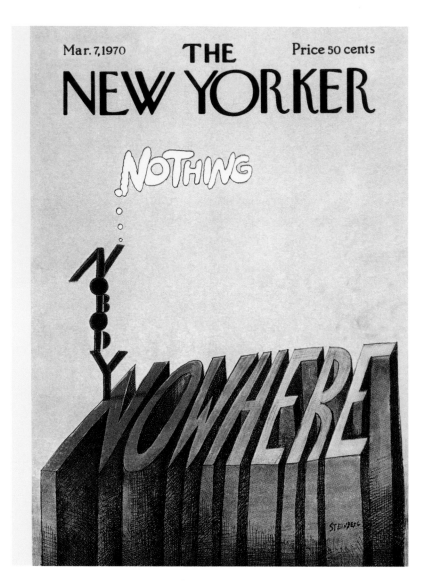

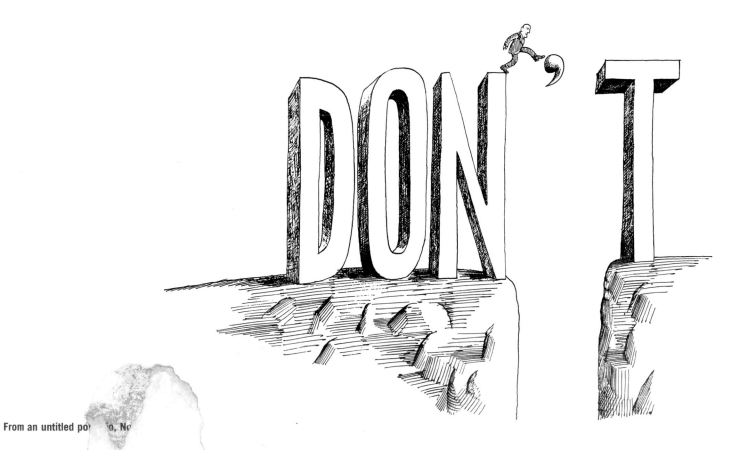

From an untitled po██o, No

118

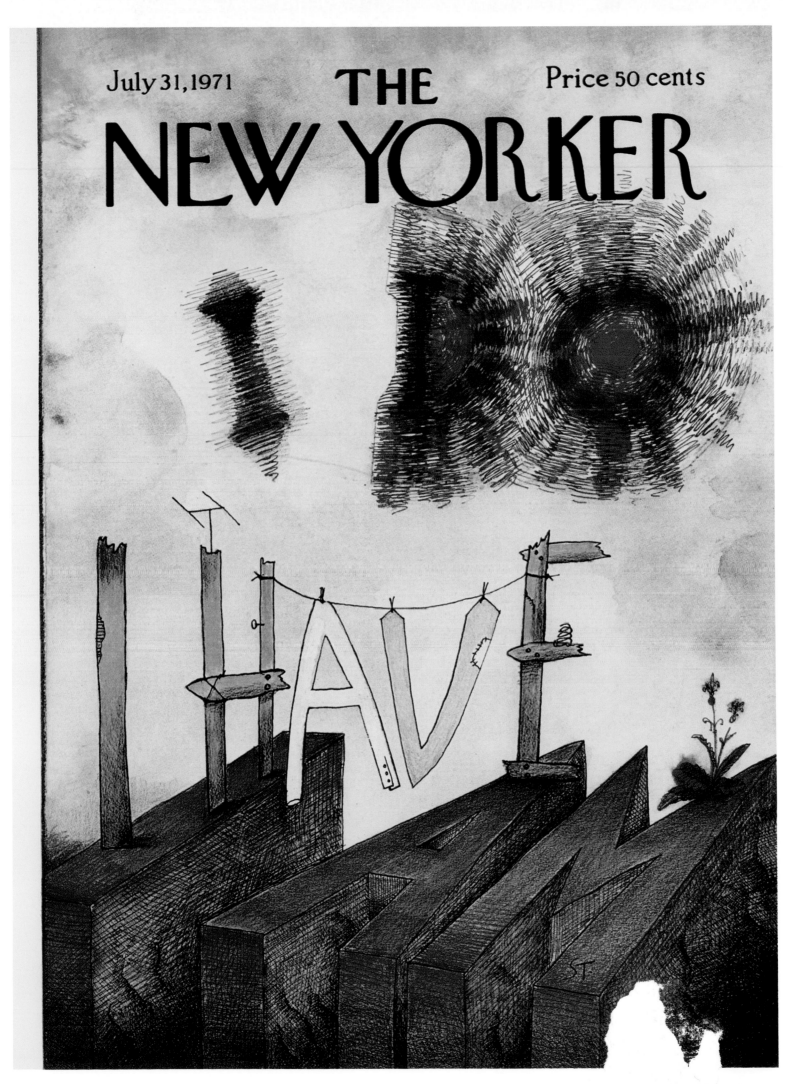

The Good Life

For the postwar generations that grew up reading *The New Yorker*, the magazine embodied a Good Life defined not by mere material luxury, but by the pleasurable rigor of "recreation" as a cultural duty. While other artists at the magazine such as Charles Saxon lampooned the comfortable life in Larchmont and Rye, Steinberg pictured the life of the learned eye, ear, and mind. The Steinberg man of leisure is constantly re-creating the world through cultivated pursuits such as gardening or literate and creative (even if quickly distracted) contemplation of the arts (pp. 124, 125).

The orchestra pit in Steinberg's opera house (p. 123) is a white-on-black photostat of his trademark false handwriting. Here, florid squiggles evoke a full symphonic arsenal (string and brass sections, a harp and double bass) as well as the physical motions of musicians. Indeed, on a third punning level, Steinberg's notation calls to mind a composer's hand at work, inking clefs, bars, and notes onto a staff.

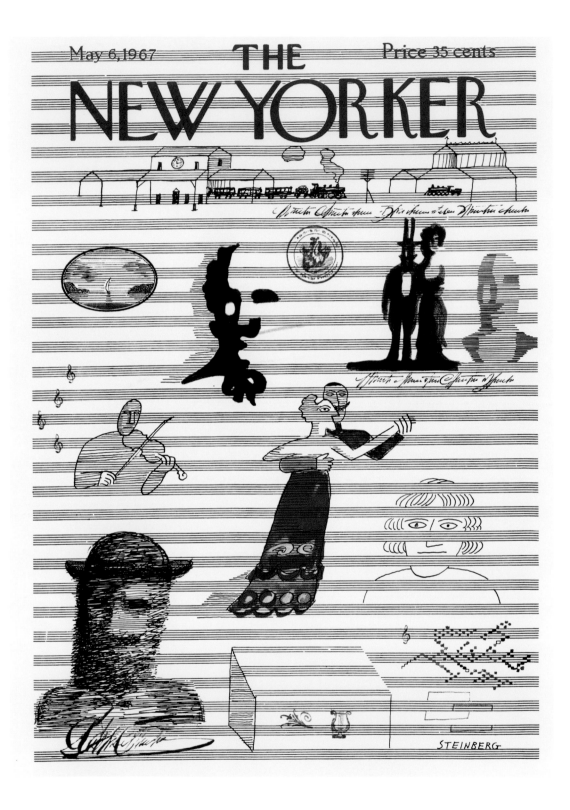

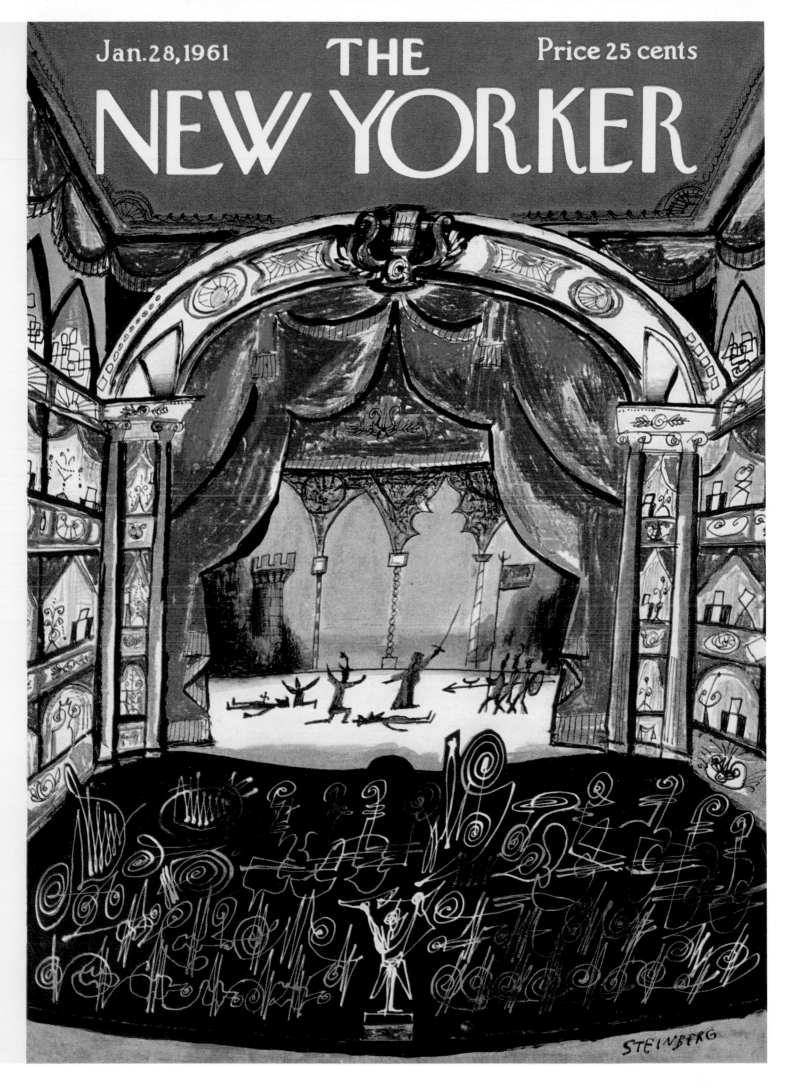

Jan. 28, 1961

Price 25 cents

THE NEW YORKER

STEINBERG

Aug. 26, 1967 — Price 35 cents — THE NEW YORKER

STEINBERG

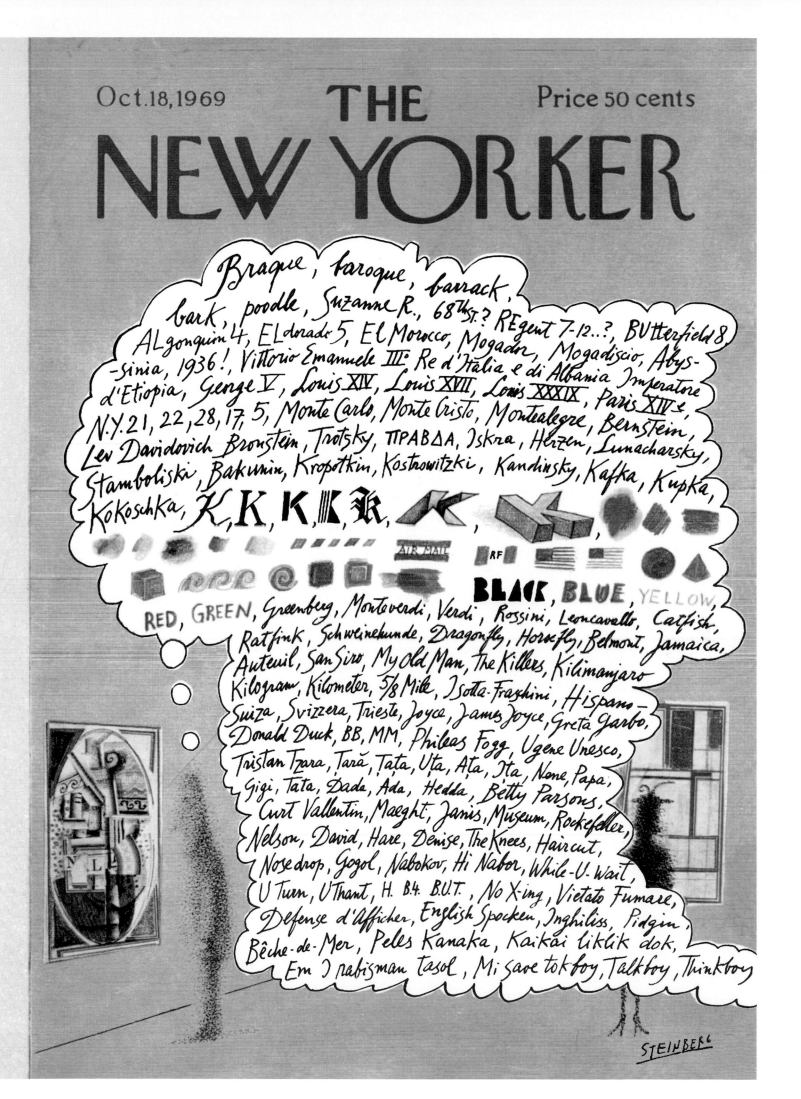

Certified Landscapes

Like a landless peasant wandering through royal domains, Steinberg Man lives in a landscape he can never control or escape: a place marked off in coordinates denoting time and location (below) and stamped and signed off on by unseen planners, scientists, bureaucrats, and diplomats (pp. 127, 128). Steinberg's tiny people in abstract settings made ideal (and ideally oblique) companions to *New Yorker* features that bridged the genres of the scientific or political "thought piece" and investigative reportage, such as Jeremy Bernstein's 1963 two-part piece on computers, Christopher Rand's series on education and power at Harvard and M.I.T., or Horace Freeland Judson's study of genetic science and its far-reaching implications (pp. 129, 130). The one time Steinberg's rubber-stamp-over-watercolor "postcard" style appeared independent of editorial content, on a 1971 cover (p. 131), it occasioned dozens of queries ("*10* people in Larchmont can't understand September 25 cover—Please give them *the answer*"). The confused correspondents might have seen the magazine's form-letter response merely as a reiteration of the cover's gnomic demeanor: "There is no special sequence," the note read, "and so far as we know, no hidden meaning in the six panels that make up Saul Steinberg's cover drawing for our September 25th issue. They simply represent various aspects of official seals (of Mr. Steinberg's own concoction) viewed as natural phenomena."[100]

February 24, 1968

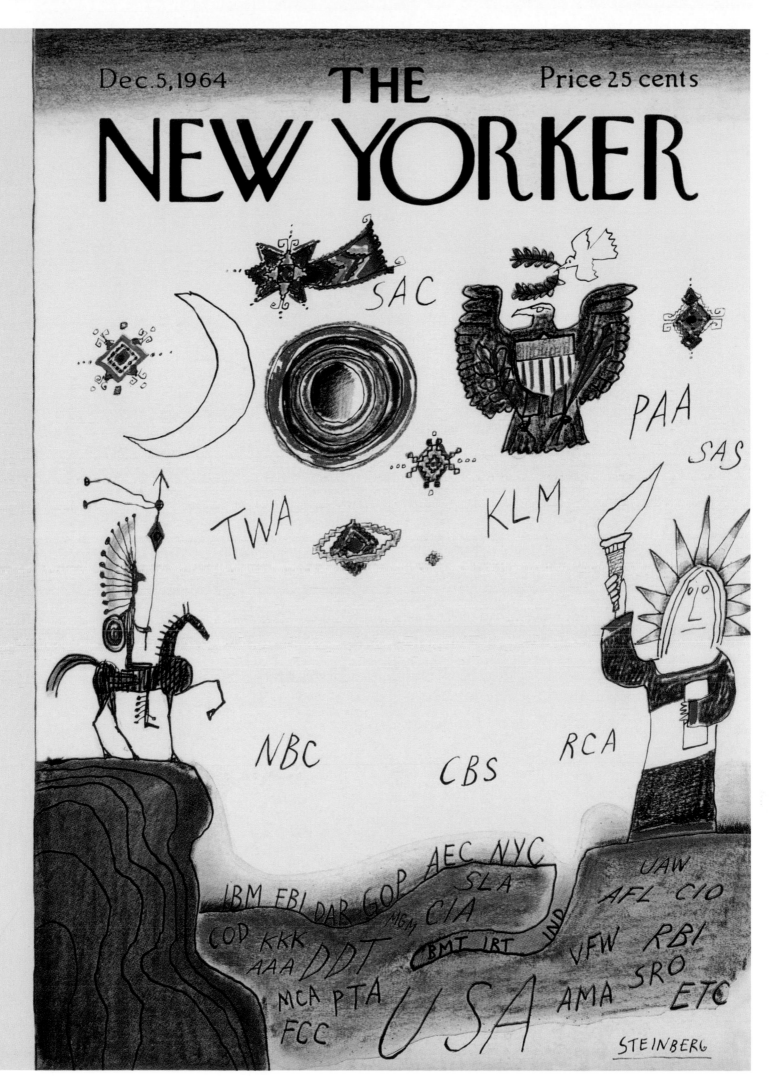

Drawing accompanying Jeremy Bernstein,
"The Analytical Engine," part I, October 19, 1963

Drawing accompanying Christopher Rand,
"Center of a New World," part III, April 25, 1964

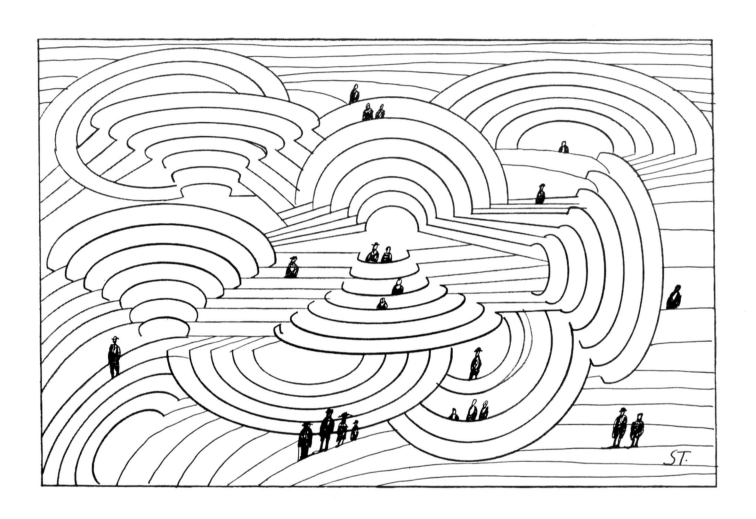

Drawing accompanying Horace Freeland Judson,
"DNA," part III, December 11, 1978

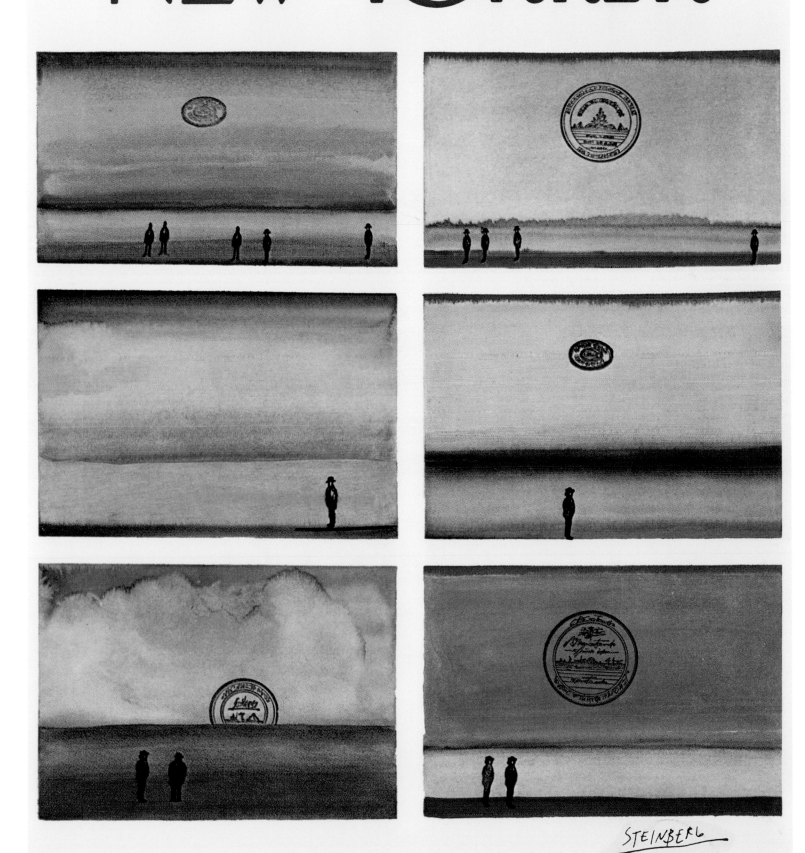

Reality Stamped Out

The rubber stamp—its very name signifying rote bureaucratic reflex—served Steinberg as a parody of the gestural expressions of a draftsman. "I don't want my hand to over-power my brain," he explained. "Work is a trap that keeps people from thinking—it's therapy. I avoid it by making these simple elements and then arranging them. With about 50 rubber stamps I can do everything necessary to render space, nature, tech-nology, and so on. It's a computerized form of art."[101]

The first rubber stamps Steinberg used in his drawings, in the late 1940s, came straight from the stationer, but by 1965 he was ordering stamps after his own designs: cyclists, Indians on horseback, painters at their easels. Ultimately he had stamps made that broke drawing down into elemental fragments such as lines or hatching, and others that allowed him to construct and populate a world using found images, such as the pious peasants in Jean-François Millet's *Angelus* (p. 35). His print-drawings marry the handmade and the mechanical, an ideal graphic language for exploring con-formism, mass experience, inauthenticity, and the seductiveness of the iconic image.

March 8, 1969

Drawing accompanying John Newhouse,
"SALT," part IV, May 26, 1973

From "Rubber Stamps," December 3, 1966

On a Pedestal

In a younger, simpler world, the hero vanquished his allotted dragon and earned earthly immortality as a public monument. Steinberg's paper monuments suit an era richly supplied with fear and ambition but short on conquerable dragons. He generously conferred heroic stature upon Executive Class drabs, liberated music students, and even the classic bottle of *vin rouge* (below, pp. 144, 145). Of his Don Quixote cover (p. 137), the artist wrote to a young friend: "The feathered hat of the pineapple proves my old theory that dragon & hero are one—This is one of the very rare times when a real incident gave me the idea." The writer Dorothy Norman, he went on, had recently called him to discuss her book *The Heroic Encounter* (1958); Steinberg had then visited his close friend, the *New Yorker* art critic Harold Rosenberg, whom he found "sitting at the table with a big knife, butchering a pineapple—Voilà!, I said, The Heroic Encounter. Harold had on his face a crocodilian expression—a sinister smile. The fruit wasn't by [any] means helpless— putting on a fine fight. I don't remember who won."[102]

June 27, 1959

"His wife poisons him in the third act."

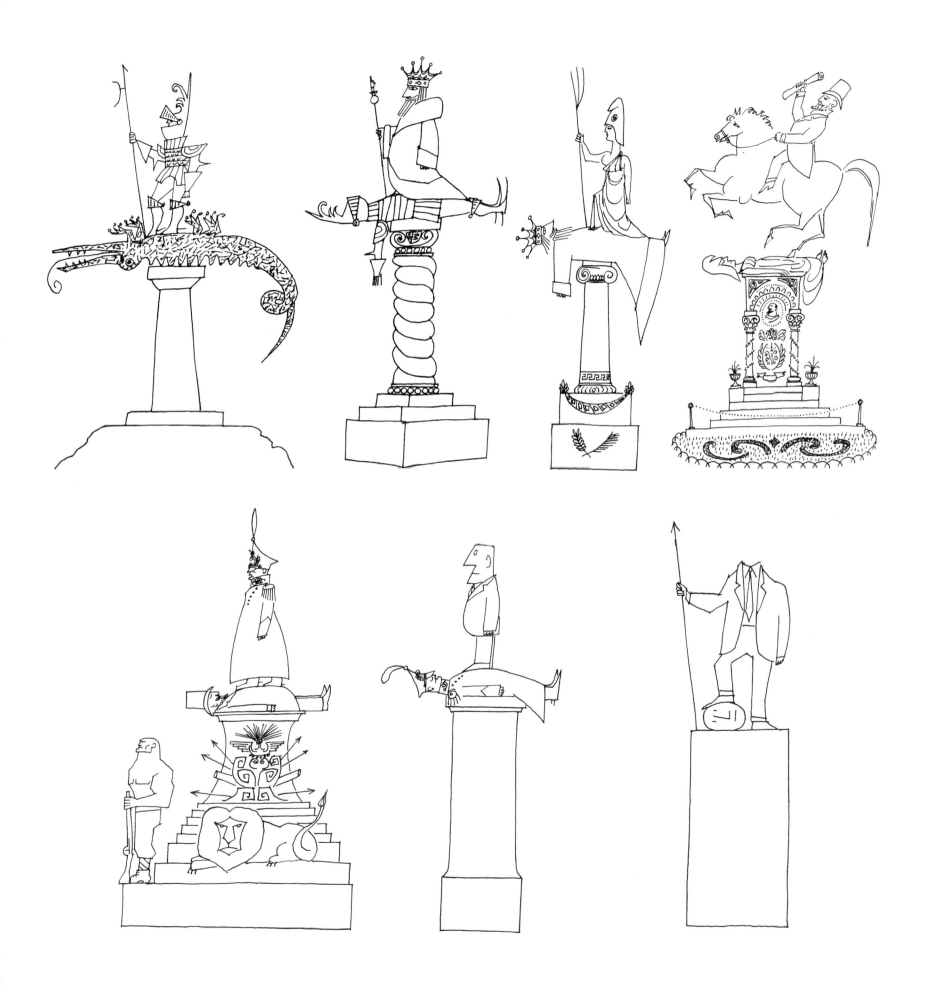

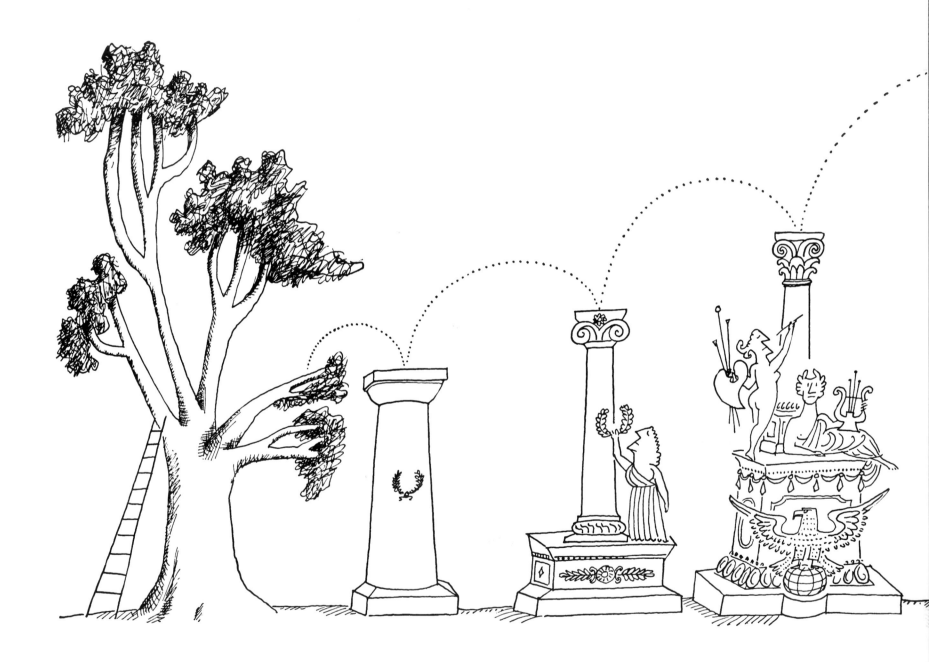

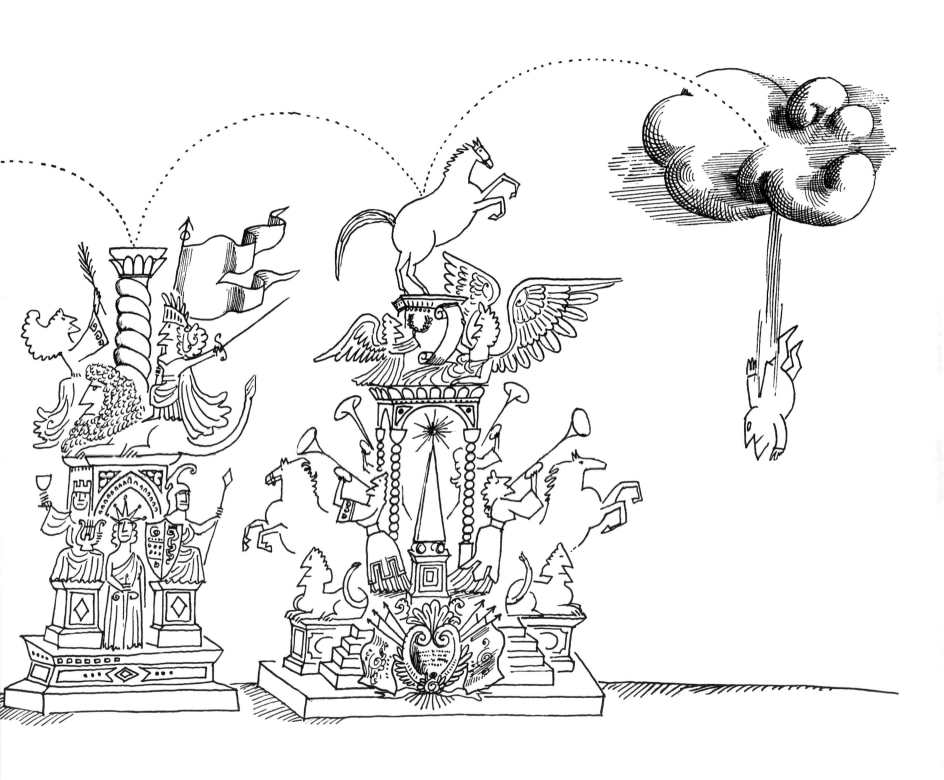

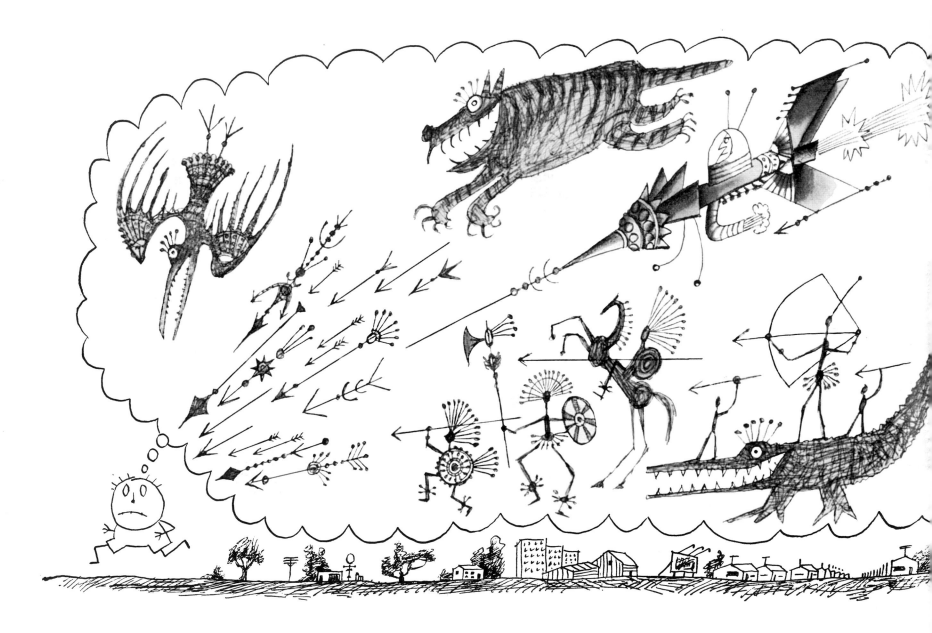

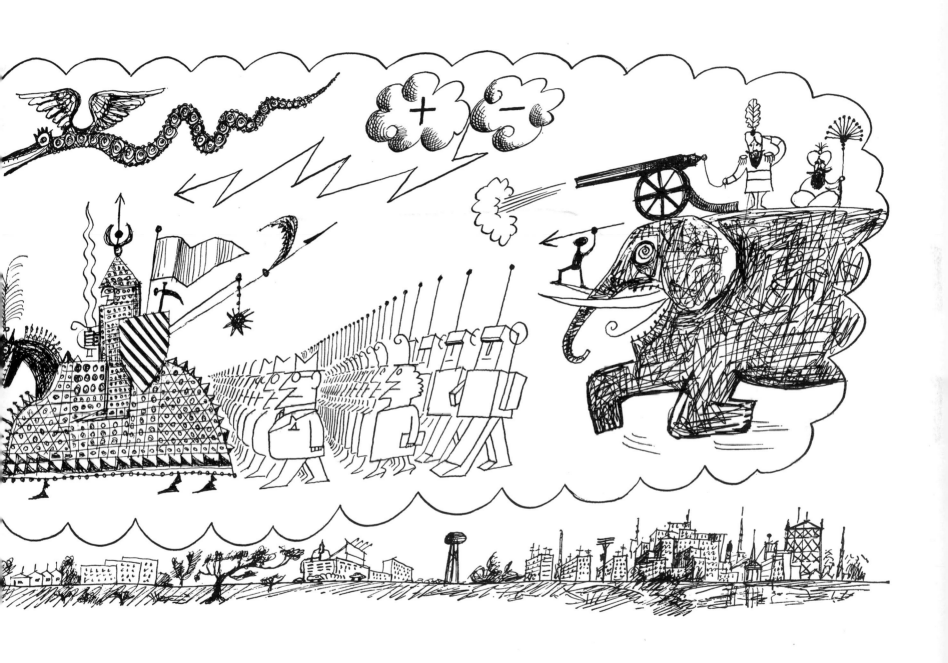

Price $3.00

Aug. 16, 1999

THE NEW YORKER

VIN ROVGE

ST

The Sexes

Men and women, in their mutual mystery and dependence, are a Steinbergian pair as elemental as black and white, round and square. The archetypal man's life is monumentalized on a 1967 cover (p. 149). After rising from crayon-scrawled infant to company dog to triumphant eagle, he descends to crocodile (all power and corruption), fish, and cockroach, before ending as a snail, coiled around his mute memories. In the woman's life (p. 148), mantelpiece photographs recount a smoother progress through stations: student, debutante, bride, mother, widow—and, finally, faux-child in Florida, beyond the age of dignity and shame.

Steinberg was fascinated by American social dress, a workaday street party enlivened by the many forms of female disguise. "When I came to America, I was impressed by those great armies of women with flowers and feathers in their hats. It struck me that women were dressed and painted like prostitutes. I understood this later: in America, there is no tradition of professional prostitution as in Europe, where honest women have to dress like honest women, and where a sexy outfit denotes a profession."[103] By the artist's later years, the varieties of masquerade he had once delighted in cataloguing (p. 150) no longer added up to a coherent code, and his interest shifted to what was left in the relations between the sexes: expectation and tension, pleasure and power, and the ritual fetishism of dress and grooming (below, pp. 151–53).

From "Kiss," December 2, 1985

May 1, 1978

THE NEW YORKER

One Dollar

STEINBERG

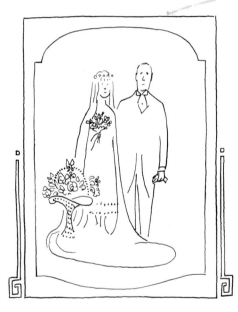

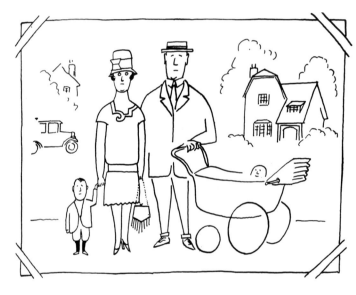

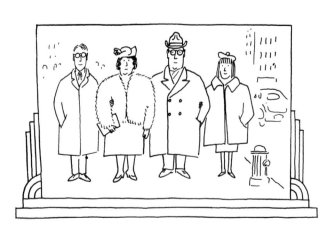

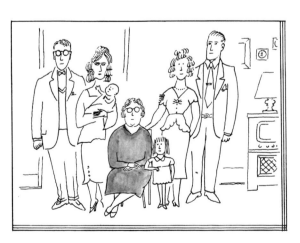

March 28, 1953

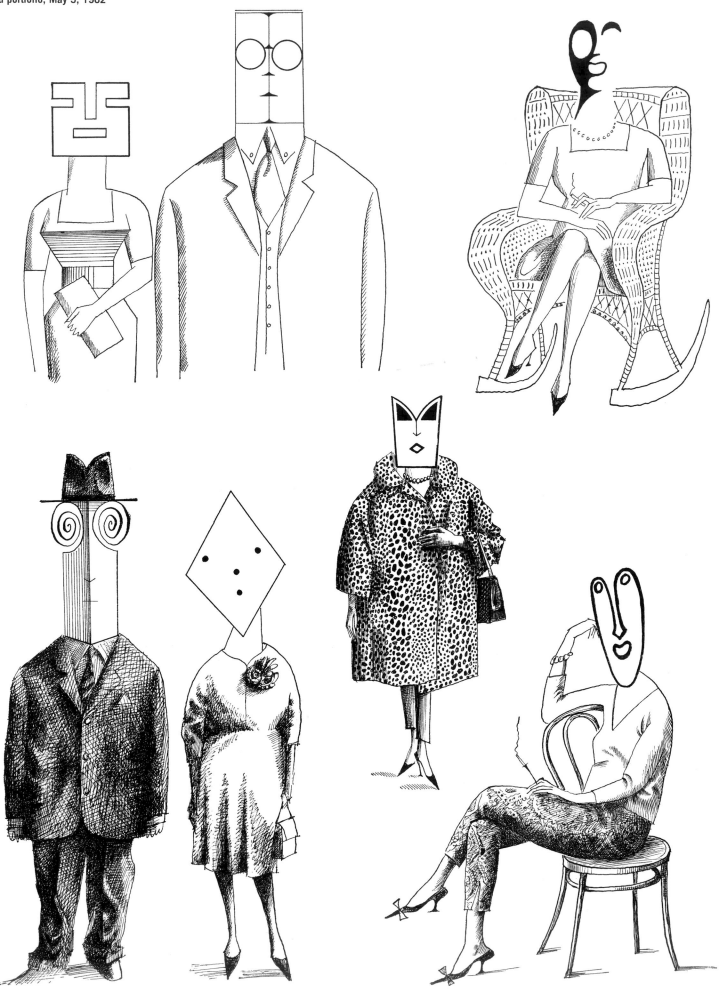

From "Onward," March 14, 1994

From "Couples," February 27, 1995

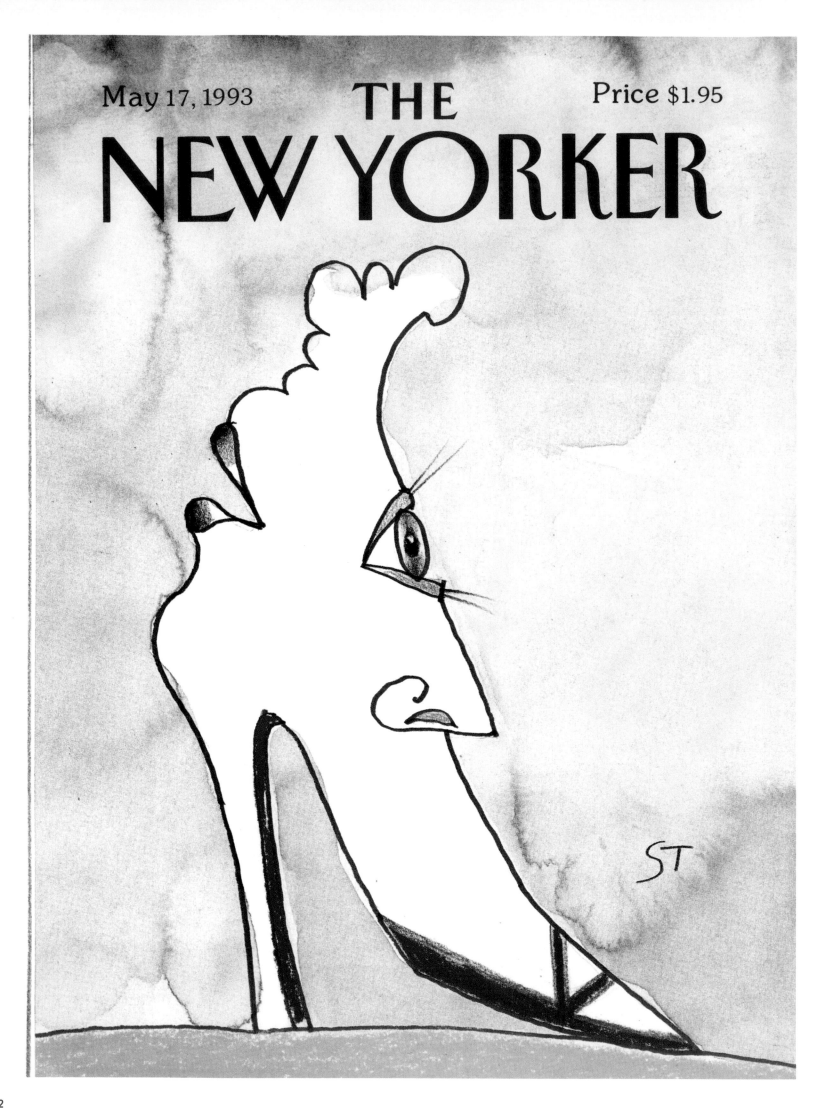

Jan. 12, 1998

THE NEW YORKER

Price $3.00

Mean Streets

"New York is degenerating," Steinberg told a visitor in 1972. "I go to some of the saloons around here where the young artists come out at night. They are brutalized—coated by a thin layer of plastic."[104] In his first decades at the magazine, New York had served as a rich if generic backdrop for Steinberg's narrative vignettes (pp. 58–62). The city he drew in the later 1960s and 1970s was a mesmerizing hell on earth, populated by a taxonomic catalogue of grotesques. Steinberg's bright-eyed terrorists, robots, junkies, and dog-faced functionaries, his abandoned popped-hood cars and acid-toned closeout storefronts reflected changes he saw in New York itself, changes emblematic of a nation in moral and fiscal freefall. But one detects, too, the influence of underground cartoonists such as R. Crumb, of the nightmare civics lessons in Philip Guston's figural paintings, and of Steinberg's occasional experiments, since the early 1960s, with mescaline, LSD, and marijuana.

Drawing accompanying Joseph Mitchell,
"Joe Gould's Secret," part I, September 19, 1964

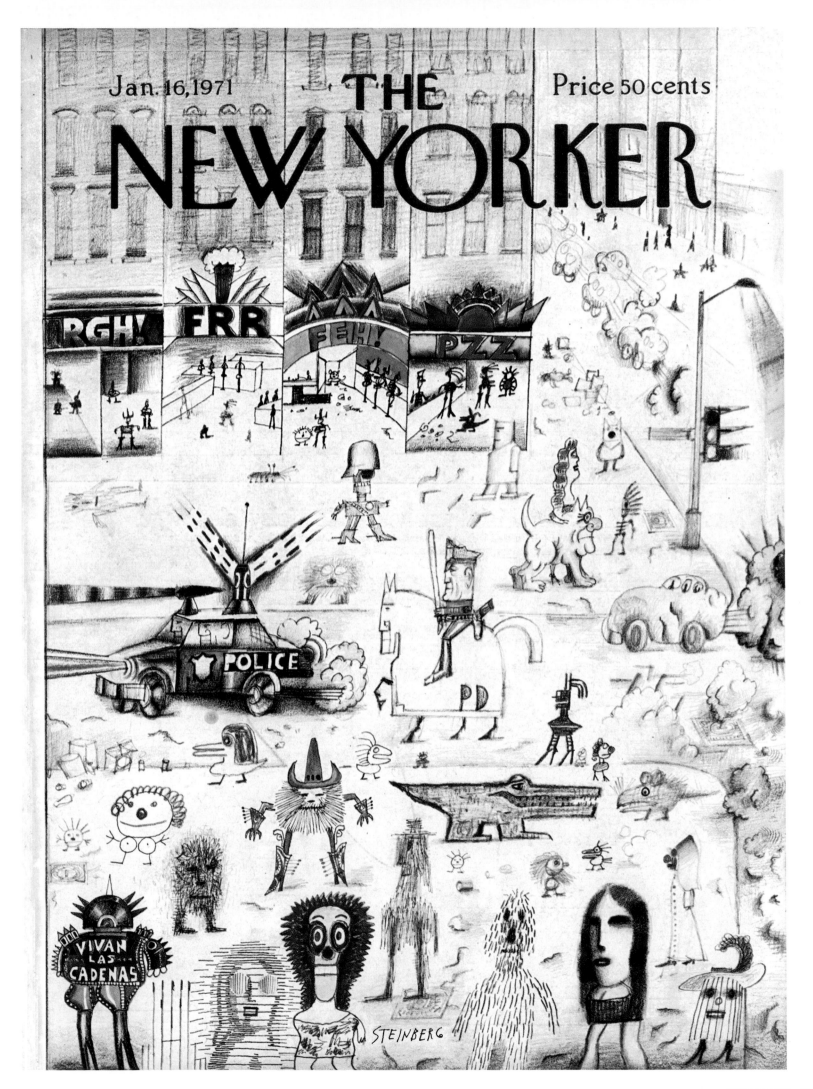

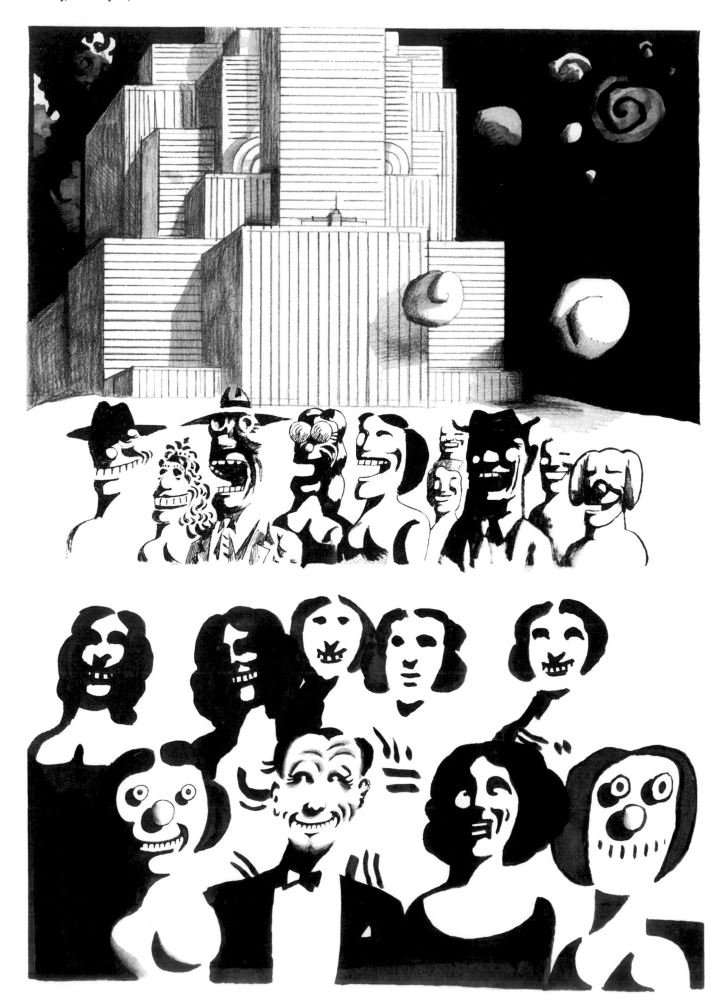

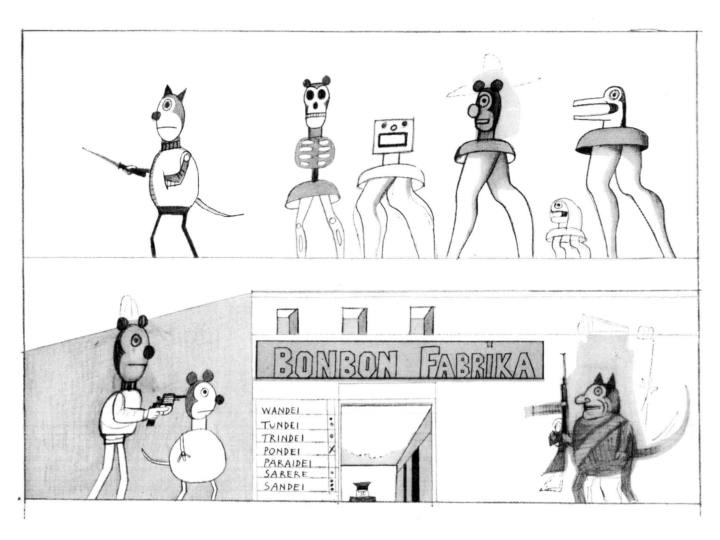

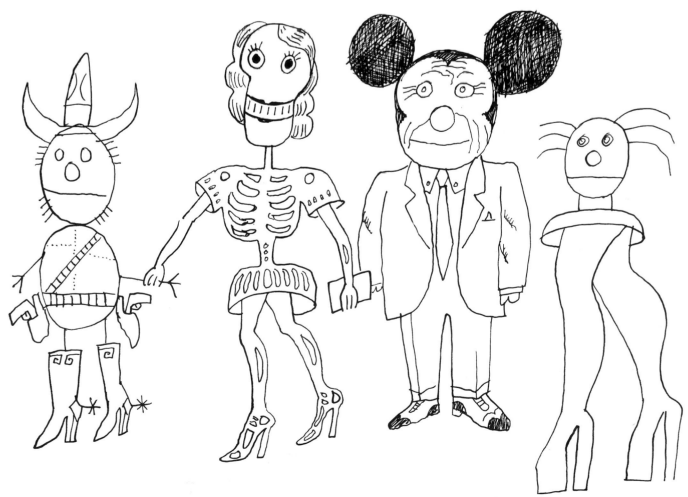

From an untitled portfolio, December 7, 1968

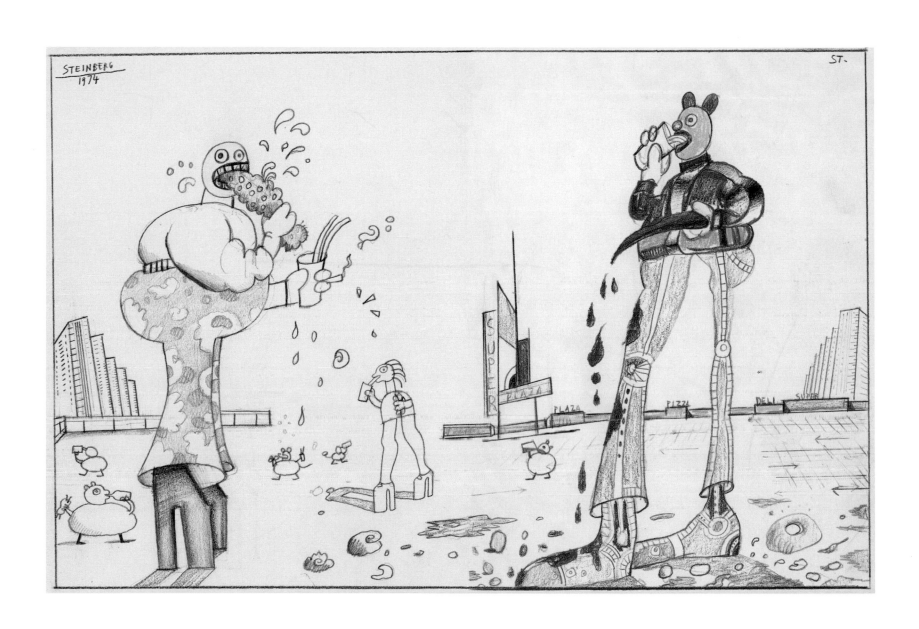

From "Fast Food," February 23, 1976
(published in black-and-white)

Feb. 26, 1979

One Dollar

THE NEW YORKER

Domestic Animals

A menagerie of animal regulars—dogs, cats, birds, fish, rabbits—supplied Steinberg with readymade caricatures of common human qualities. His dogs (pp. 165–67) are sweating, striving counterparts to his effortless cat-artists, cat-muses, cat-thinkers. A violinist in his youth, Steinberg drew a dog sawing rude noises out of the instrument after one of his many abortive returns to the discipline (p. 165). (He enjoyed practicing "loudly, out in the country, with no neighbors nearby."[105])

Birds for Steinberg were angelic figures of the imagination, keeping a flame of fantasy alive in the city's midst (right, p. 168 bottom). His fish are dumb plodders whose mindlessness makes the world mechanical (p. 169 top). His rabbits are all vulnerability; the camouflaged fall hare on his 1983 cover (p. 171) could be *The New Yorker* itself in Shawn's late years, nearly disappearing into the media landscape in its determination to be what the editor called "the gentlest of magazines." The rabbit's opposite is the leering crocodile (p. 168 top)—which, in a typical inversion, Steinberg described as his "symbol for dragons": power at once evil and invincible, setting the terms for a world it aims only to devour.

May 18, 1963

March 7, 1959

February 17, 1968

December 10, 1960

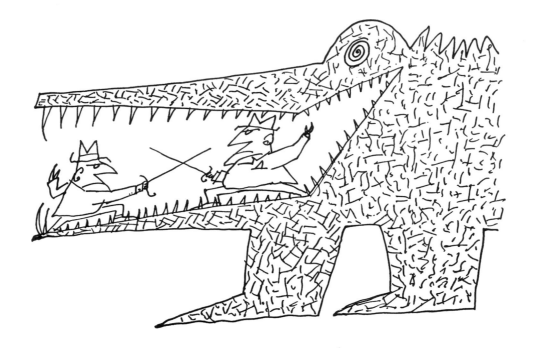

April 16, 1955

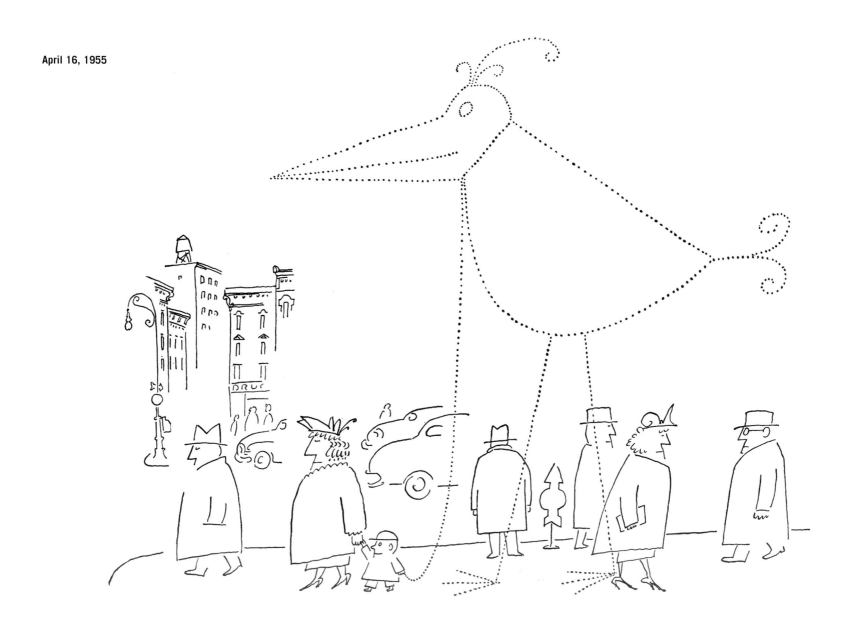

December 20, 1958

Oct. 3, 1983

THE NEW YORKER

Price $1.50

ST

Seeing Through Metaphors

Besides being acutely alert to the workings of the five standard senses (below), Steinberg enjoyed an extra one: a sense of metaphor, through which everything became, in his experience, something else.[106] He occasionally used this sense to trace natural genealogies: "Architecture first imitated trees, then the trees imitated architecture. Campaniles and minarets were invented by cypress trees."[107] More often, and more remarkably, he drew indelible associations between utterly unlike things. He diagrammed the seasons of the year as (among other things) a pyramidal tomb, the nations of Mediterranean Europe, and a highway interchange (pp. 176–77); he turned a page of typographic border samples into a field guide to noises heard at his country house (p. 181).

Like a synesthete, who literally hears colors and tastes sounds, Steinberg employed a mental filing system that was his alone. In what he called his "stenographic" or "hieroglyphic" drawings, stylistic variations in line might serve to define distinctions among ideas, sounds, personalities, or frames of mind (pp. 173–75). "For me, seeing a work of art is, to some extent, a matter of graphology," he noted; "All good pictures are based on a script, a handwriting."[108] In fact, literary precedents, such as a novelist who used "dialect to describe a person—not in the dialogue," helped to inspire Steinberg's practice of devising "handwriting" appropriate to each new subject he drew.[109]

IL CHA-CHA DELL'AMOR

December 30, 1961

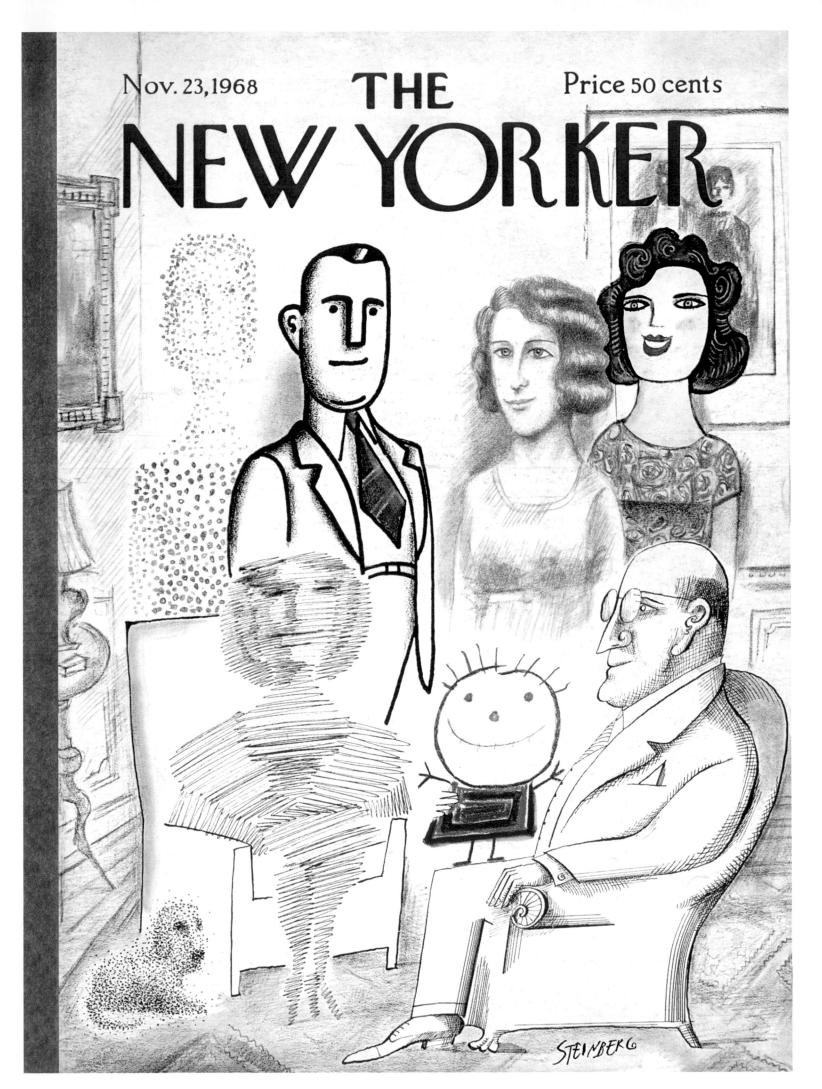

Nov. 23, 1968

THE NEW YORKER

Price 50 cents

STEINBERG

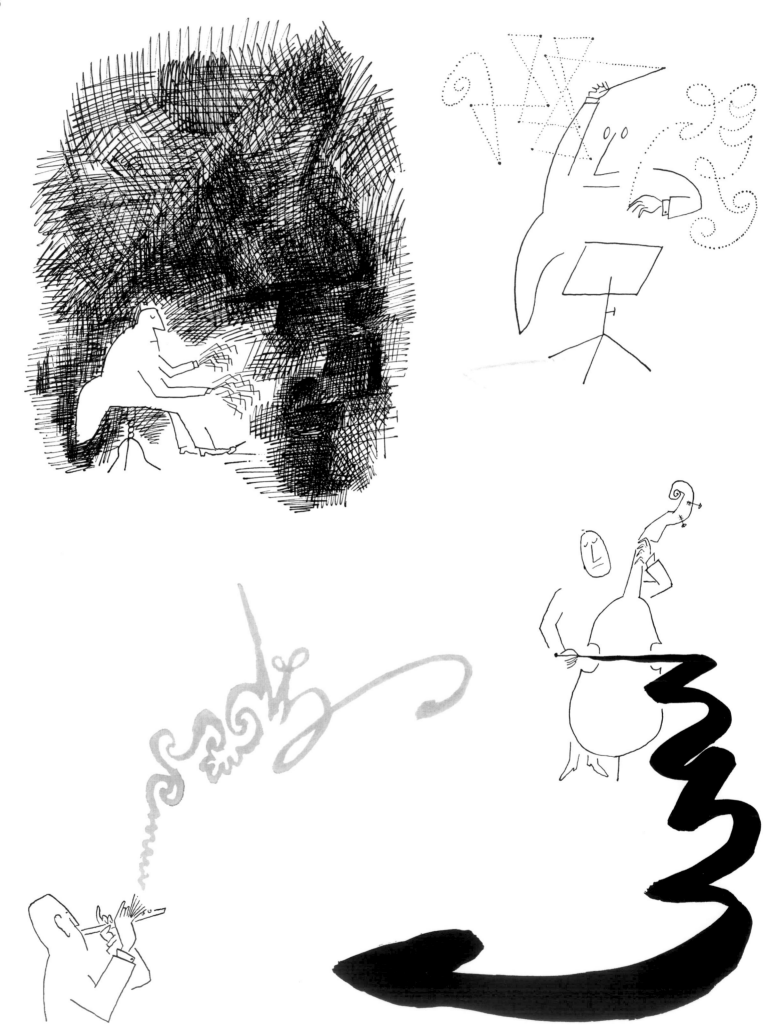

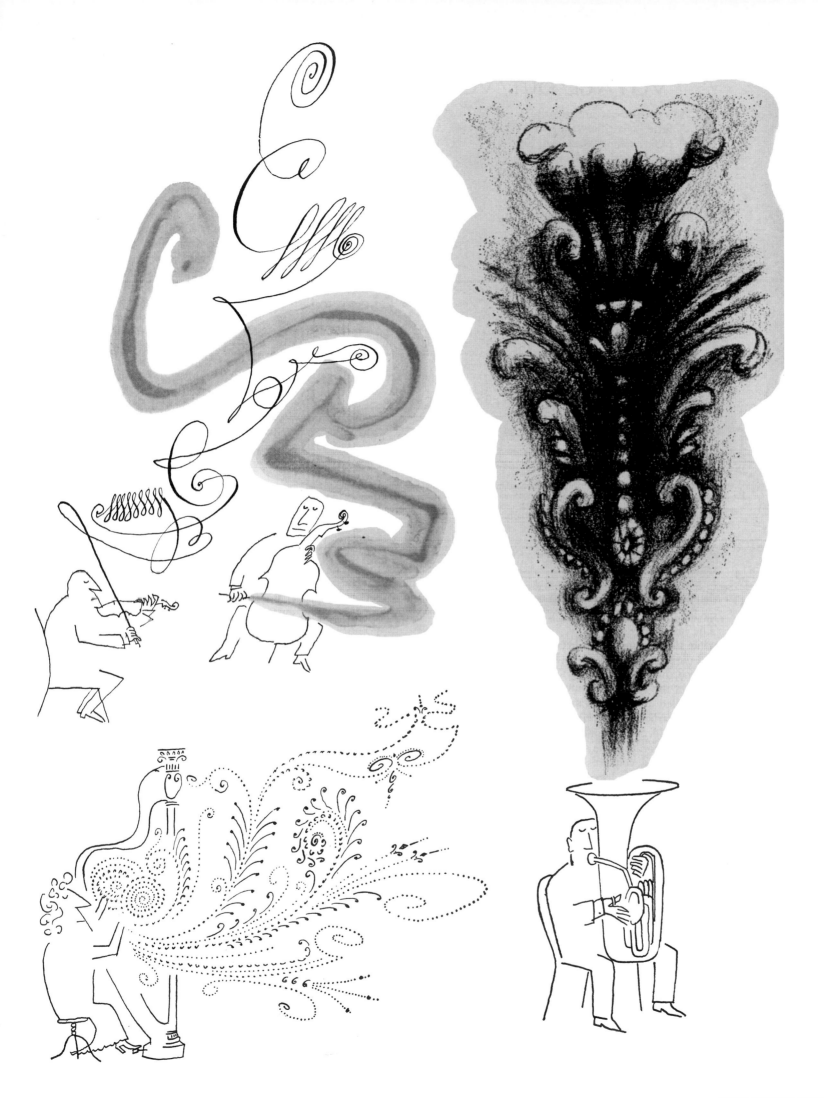

12 VARIATIONS

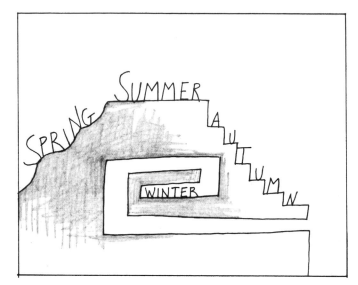

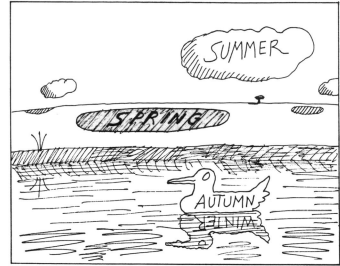

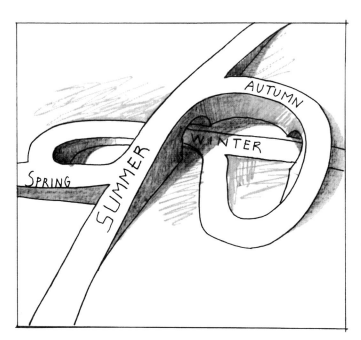

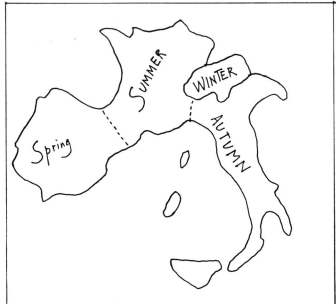

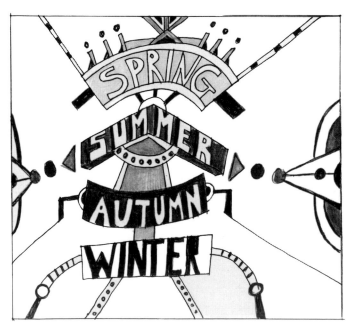

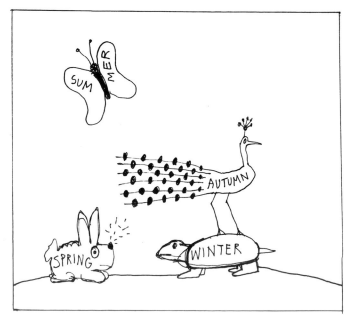

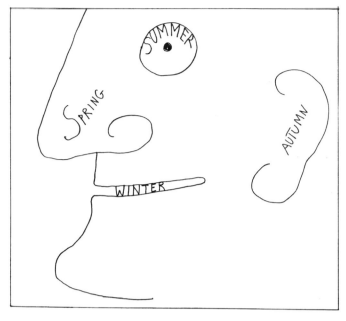

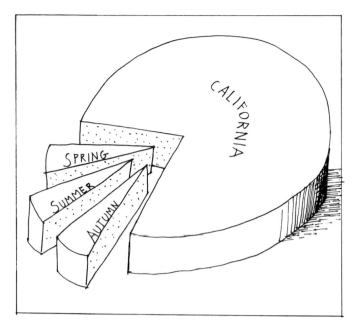

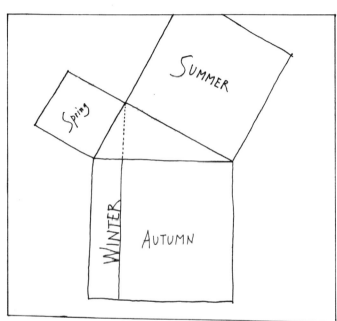

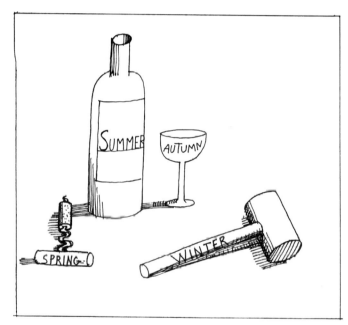

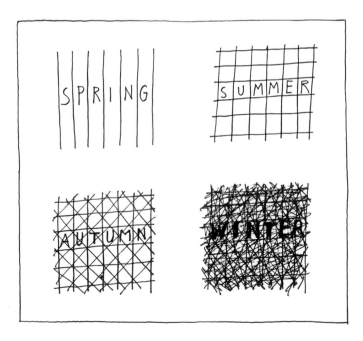

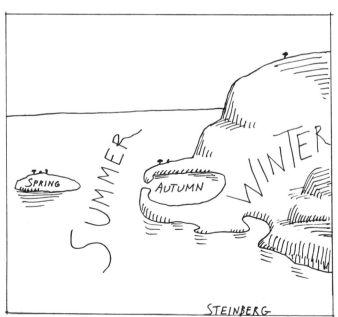

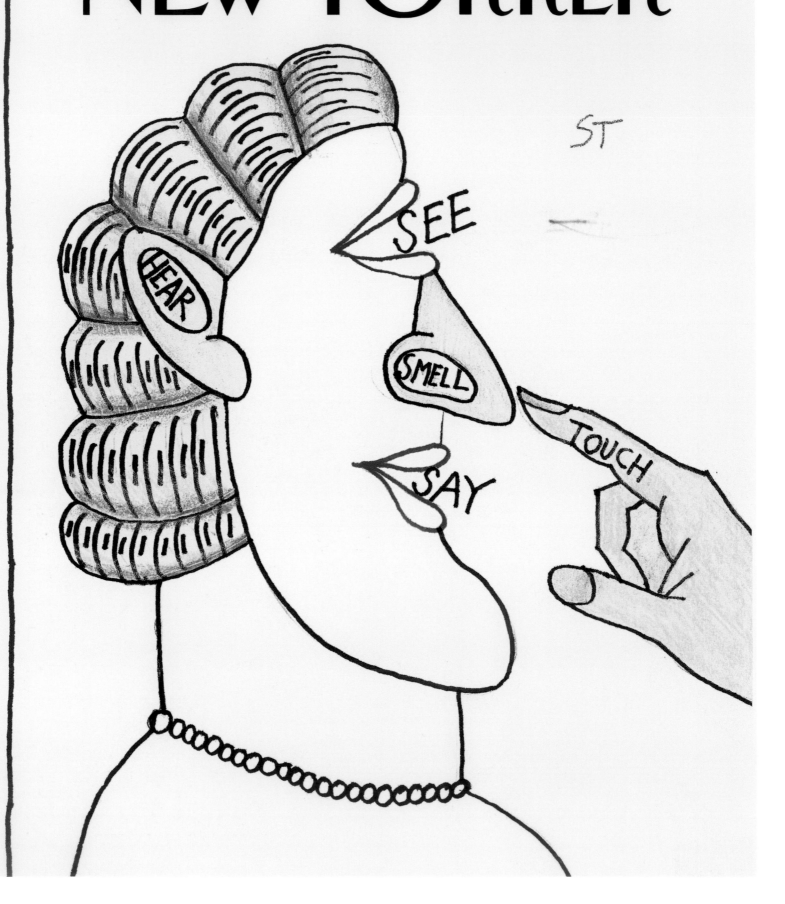

Two drawings from "Statistics," February 21, 1983
(published in black-and-white)

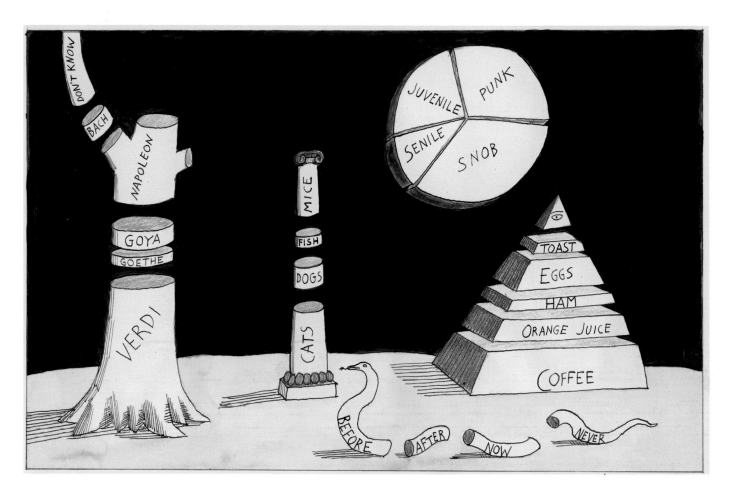

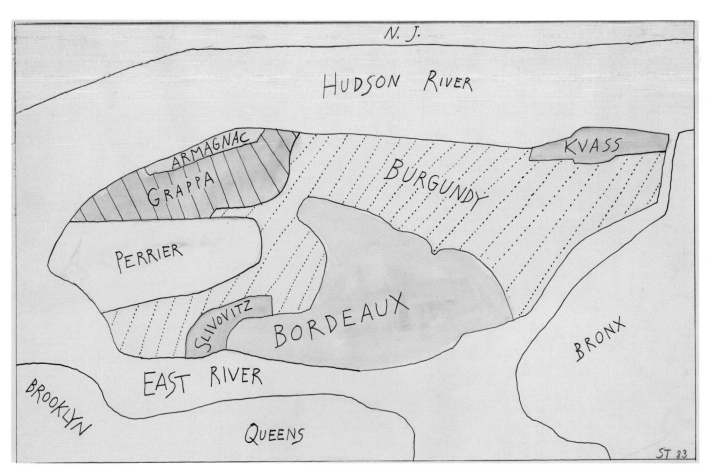

COUNTRY NOISES

Phone rings

Phone rings in TV drama

Phone rings in house across the road

Furnace

Refrigerator

Lawnmower

Small plane

T.W.A. from Paris to Kennedy

Dishwasher

Cricket

Electric clock

Car

Truck

Dead leaves cross the road

Mosquito

Paper uncrumples in wastebasket

Willow

Raccoon?

Chest of drawers creaks

Frog

Woodpecker

Rain on roof

Rain on deck

Blue jay

Catbird

Unidentified

—SAUL STEINBERG

A Self-Made World

Steinberg, a self-identified self-made man, took pride not only in the singularity of his art but in the self-reinvention he had achieved through emigration. He saw an implicit "satire of autobiography" in a recurring theme of his drawings, namely "an object that reproduces itself: a man who draws himself, a pencil that draws a pencil (p. 183), the word 'red' written in red (although sometimes I have written it in blue—I have written 'red' in blue and 'yellow' in green, as much as to say: we can joke about this)" (p. 184).[110] Some of his self-reflexive images indicate not self-sufficiency but its opposite, such as his 1982 stencil drawing of a stencil-artist spouting stencil-talk (p. 185): "What is a stencil but a cliché? So she's an artist who speaks in clichés. . . . The cliché is the expression of the culture of a period. Most artists are not original, but their use of clichés defines the generation. We judge a period by its clichés, by the quality of its lousy art."[111]

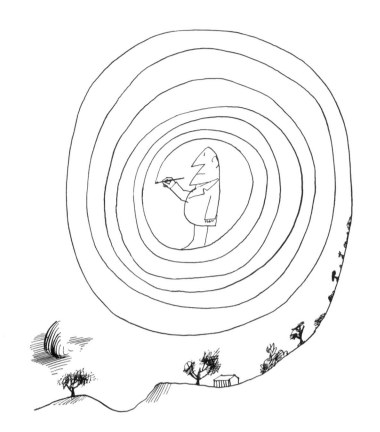

February 23, 1963

February 12, 1949

Jan. 6, 1975

THE NEW YORKER

Price 50 cents

STEINBERG

April 26, 1982

The

NEW YORKER

Price $1.25

ST

Drawn from Life

The idea of drawing what lay before him struck Steinberg late in his career. Early training in architectural design and decades of cartooning had taught him to rely on his imagination for subject matter and on a vocabulary of graphic conventions to ensure maximum legibility. For Steinberg, drawing *dal vero* (he preferred the Italian phrase, meaning "from life"—literally, "from the truth") came both as a technical challenge and a means of relaxing his idea muscles between the "calisthenic" work of cartooning. The four desktop still life covers *The New Yorker* published between 1976 and 1983 are muted anecdotal outtakes, fragments and traces of untold autobiography: a key on a Blue Willow platter, a gathering of Central European Easter toys (below left and right), a sketch of the Chrysler Building and a Mexican postcard (p. 189).

The low status of still life as a genre is taken to its logical end in Steinberg's 1983 cover (p. 187). Here only the most abject categories are represented: things from between the sofa cushions (used match, pennies); things that could prove useful, but won't (violin bridge, untorn movie ticket, screen door hook-and-eye); things that would be less work to replace than to save (tiny lock and key, bobby pin). That such an image of modest oddments, or Steinberg's studious "Inventory" of microphenomena (p. 188), should prove as pleasant to behold as they were satisfying to create affirms the artist's suspicion of a natural symbiosis between accuracy and acuteness: "when a drawing from life tells the truth," he maintained, "it automatically turns out to be a good drawing."[112]

Jan. 17, 1983

THE NEW YORKER

Price $1.50

INVENTORY

DOTS

LINES

FIVES

CORKS

Born	BAUDELAIRE	1821 – 1867
	DOSTOYEVSKI	1821 – 1881
	FLAUBERT	1821 – 1880
Died	NAPOLEON	1769 – 1821
1821		

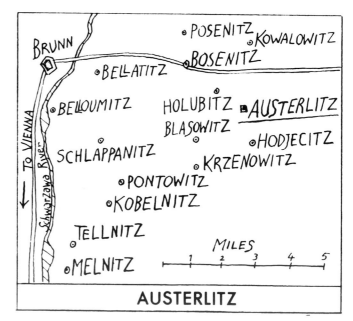

AUSTERLITZ

Steinberg's Century

Most readers seeing *The New Yorker*'s July 22, 1972 cover (p. 191) probably took it for a portrait of a man turning forty. But its inverted pyramid of time begins with 1933, the year Steinberg left Bucharest for Milan, on his way to becoming what he called "a western man." He regarded his evolution from Romanian provincial to Manhattanite as a graduation from savagery to modernity. The change, he said, left him "addicted" to emigrations,[113] and made his origins strange enough that his past became a topic as exotic to him as it was intimate.

In the time-travel portfolios "Cousins" and "Uncles" (p. 193), he resurrected relatives in Romania whose trades (sign painter, bookseller, watchmaker, croupier) had provided his boyhood catalogue of possible futures. In "Italy—1938" (p. 192), he relived the jittery paranoia of life as a foreign Jewish student under Mussolini.

The chapters of Steinberg's life— emigration, war, success in New York and flight to the country—had traced a singular but emblematic route into the American Century. He preferred to chronicle his times

not in broad historical strokes but through detached vignettes, unmistakably personal in their observed details. The "Notebook" portfolio, published in 1994, featured only a fraction of the so-called ex-votos he had been drawing for over ten years, in which he converted dozens of memories and *pensées* into captioned images (pp. 194– 95). In another series, published in part a year after his death, he revisited his wartime experiences in China, retroactively promoting himself to a general's rank (p. 197).

From "Italy—1938," October 7, 1974
(published in black-and-white)

From "Cousins," May 28, 1979
(published in black-and-white)

From "Uncles," December 25, 1978

I spend three days at a Zen retreat. I sleep in a sleeping bag on the floor.
I wake up early one morning. Upside-down eyes are looking at me: my roommate doing his yoga.

*Driving on a Boston bypass, I listen to "La Clemenza di Tito" until
the reception becomes faint. I make an illegal U-turn and head back toward "Clemenza."*

Feb. 5, 1972

Price 50 cents

THE NEW YORKER

STEINBERG

AFTER

BEFORE

From an untitled portfolio of late drawings revisiting
Steinberg's service in wartime China, July 10, 2000

American Scenes

From the late 1960s, Steinberg's image of America in *The New Yorker* was by turns loving and sardonic. His fondest tributes took the form of object studies that symbolized the country's simple idealism: the Lincoln penny, the Liberty tree, the bicycle that he considered an apt emblem of democracy in its achievement of balance based on forward momentum (below, pp. 200, 201). A more critical view of the nation came out in catalogues of types such as the 1975 cover where Sam and Liberty join a lineup with the gangster, the riot cop, and the lost astronaut (p. 199), or the wordless parade of 1968, in which endless ranks of the heroic and dubious march across six pages (p. 202). Some of Steinberg's most ominous Americans (soldier in desert fatigues, banshee hostess, klansman, death's-head cowboy) become roadside sphinxes in his highway scene of 1992 (p. 203), a darker rendition of a vernacular America that he more often celebrated for its informal energy or its B-movie bombast (pp. 206–09).

Thanksgiving, the prime holiday in American civil religion, was a favorite of Steinberg's, and he produced two covers on the theme. In his 1976 design (p. 204), a roster of secular saints gathers for the ritual consumption of their host, who has strutted in but not yet sat down on his central platter. In a 1992 design called *The American Corrida* (p. 205), Steinberg wed two different cultural systems, throwing each into meaningful relief: within the tragic ritual theater of the Latin bullfight, the roles are filled by a tossed-salad pantheon of American pop culture, with Uncle Sam as matador, Santa his picador, and the turkey as the bull, fantailed for battle and swelled to taurine scale—a measure that prevents Sam from coming off as a bully.

Sept. 7, 1992

Price $1.95

THE NEW YORKER

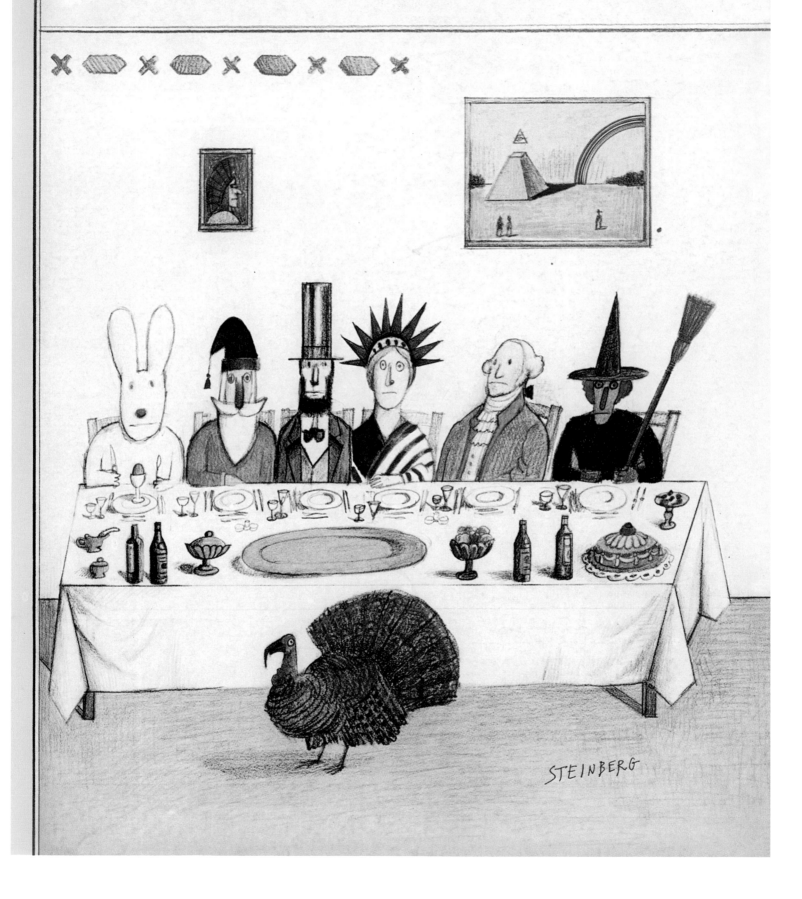

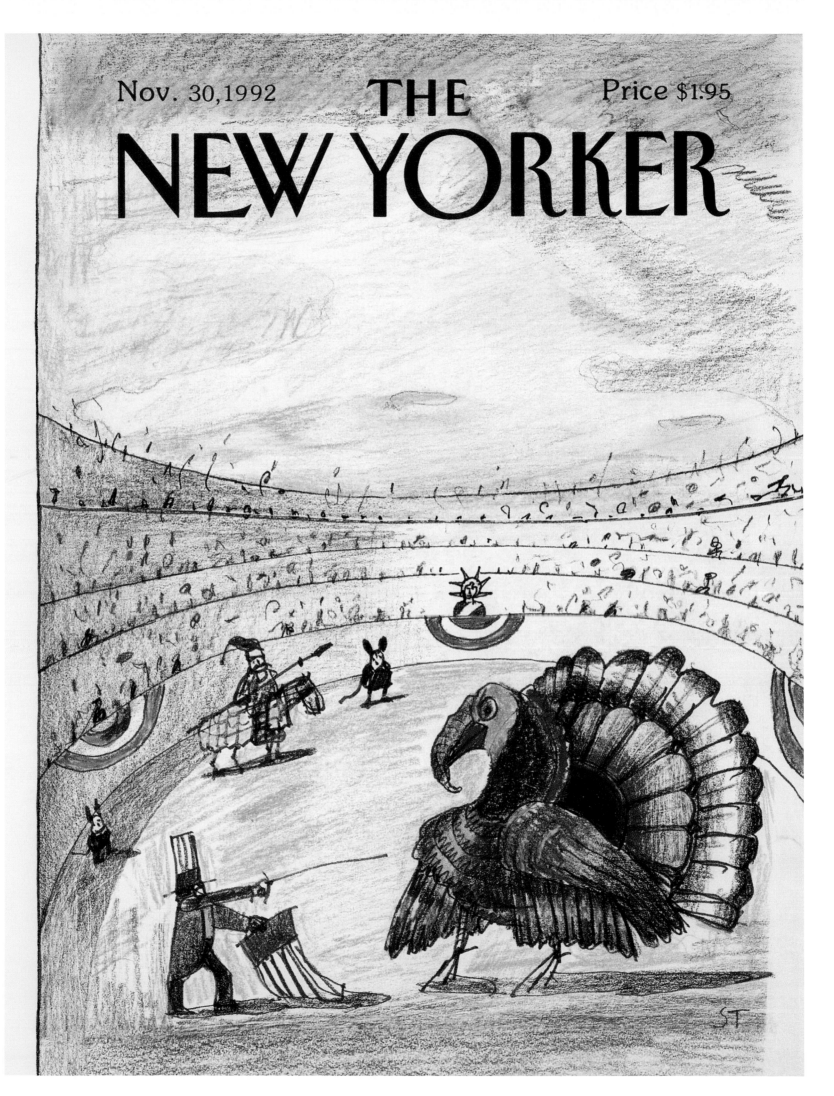

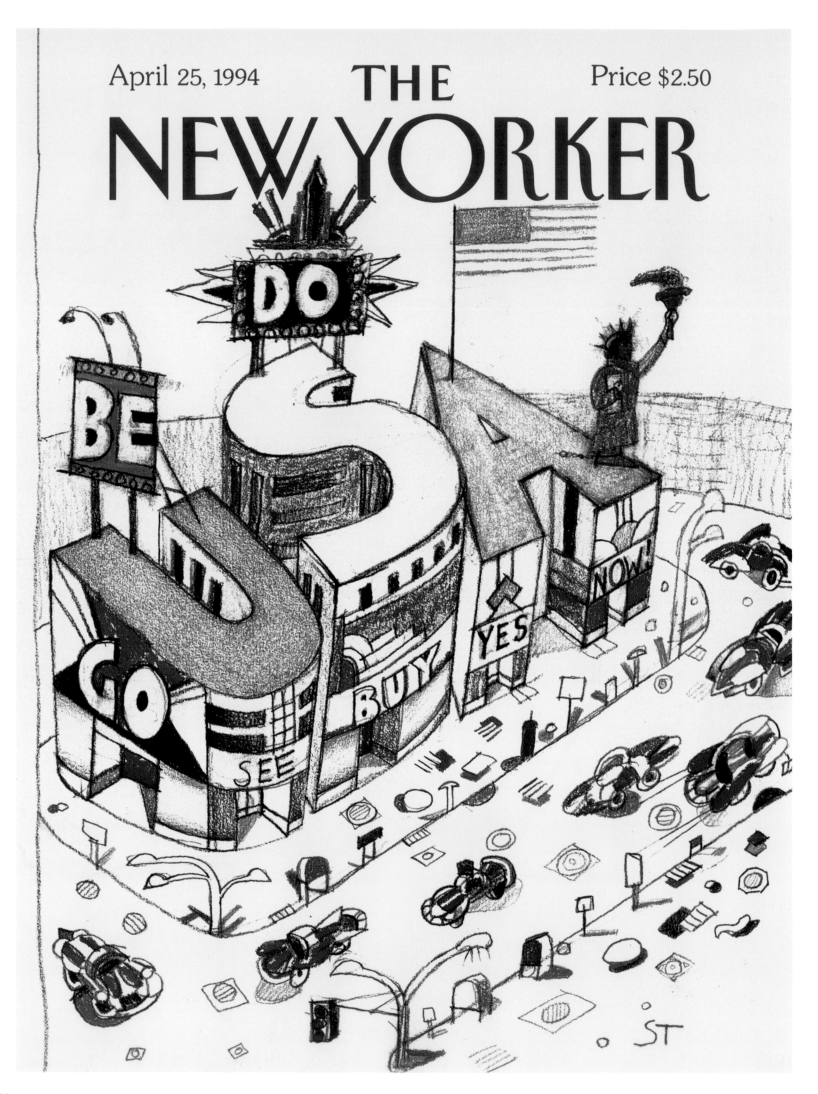

May 11, 1987

THE
NEW YORKER

Price $1.75

STEINBERG

Below: from "Country Traffic," December 1, 1980

Opposite, top: from "Architecture: Housing," April 4, 1983 (published in black-and-white)

Opposite, bottom: from "Bank," May 19, 1986 (published in black-and-white)

Inner City

New York had first served Steinberg as a
backdrop for comic scenarios (pp. 58–62);
in time, his focus shifted to the city itself,
a cosmos in imbalance (pp. 154–63).
By the 1980s and 1990s, New York had
become virtually a part of the artist: its
history and geography were private stories
he changed at will (pp. 212, 213), the
bridges and avenues extensions of his body
(right), the borough map a template by
which he made sense of the outlying world
(p. 218). The later drawings document the
frank self-absorption of an artist certain
that his most promising source of material
was himself. But this did not mean pushing
Manhattan off center stage. On the con-
trary, there was no separating the city that
lived inside him from the instants of insight
that moved him to draw. He envisioned
how the city appeared to a cat looking
down from a high window (p. 211), felt
the movement of traffic like a throbbing
pulse (pp. 214, 215), stared down Death
as it charged him on a messenger's bicycle
(p. 216), and imagined his movements
mapped, as though watched over from
above, when he took a walk around his
neighborhood (p. 217). His *Wilshire and
Lex* cover (p. 219), in which East and West
meet at last, updates his *View of the World
from 9th Avenue* (p. 42) to an age of big
media and big deals, starring Hollywood
and Manhattan as the sister capitals of
American unreality.

February 22–March 1, 1999

Feb. 28, 1994

THE NEW YORKER

Price $2.50

BOOXS

ST

Indian totem erected on Bedloe's Island in 1584, replaced in 1886 by the Statue of Liberty

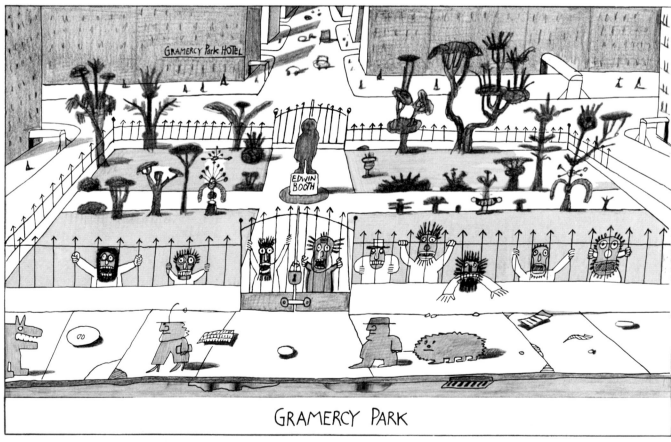

GRAMERCY PARK

From "Manhattan," May 2, 1983 (published in black-and-white)

From "Lexington Avenue," July 4, 1983

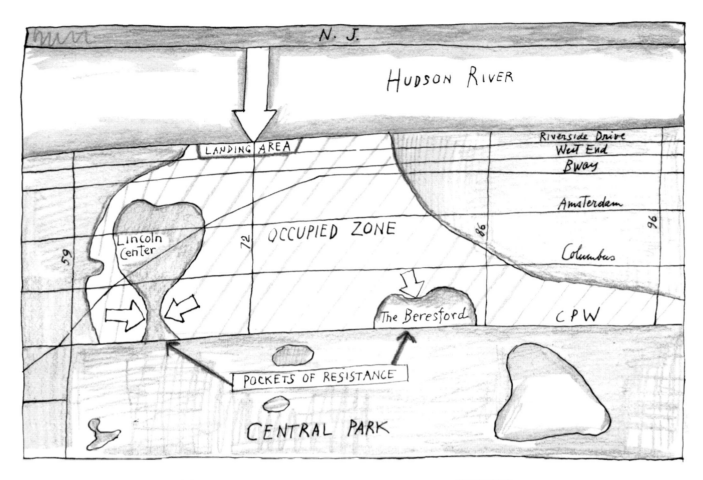

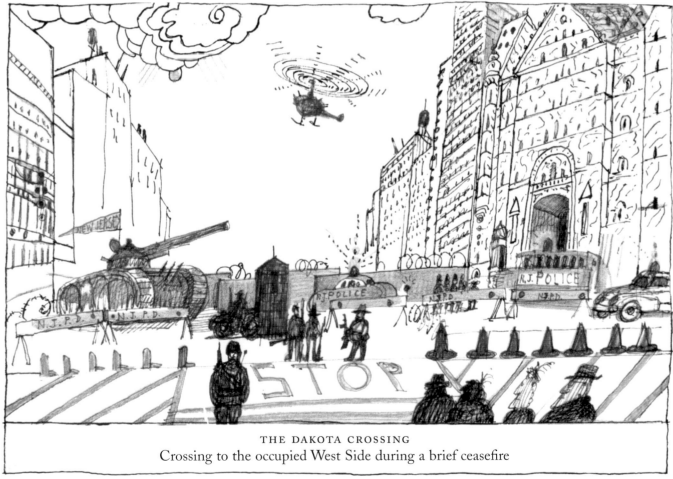

THE DAKOTA CROSSING
Crossing to the occupied West Side during a brief ceasefire

From "The War with New Jersey," February 23, 1987

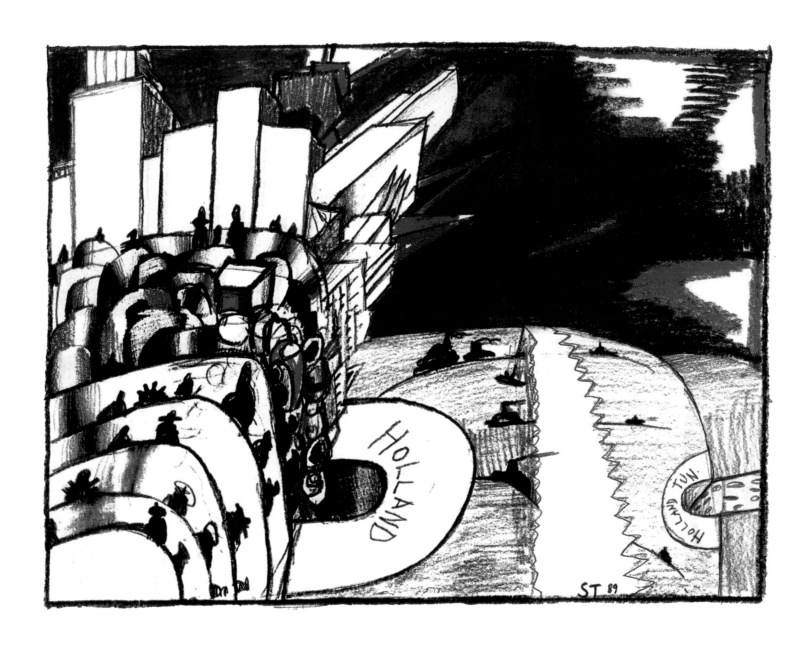

Drawing accompanying Ian Frazier, "Canal Street,"
April 30, 1990

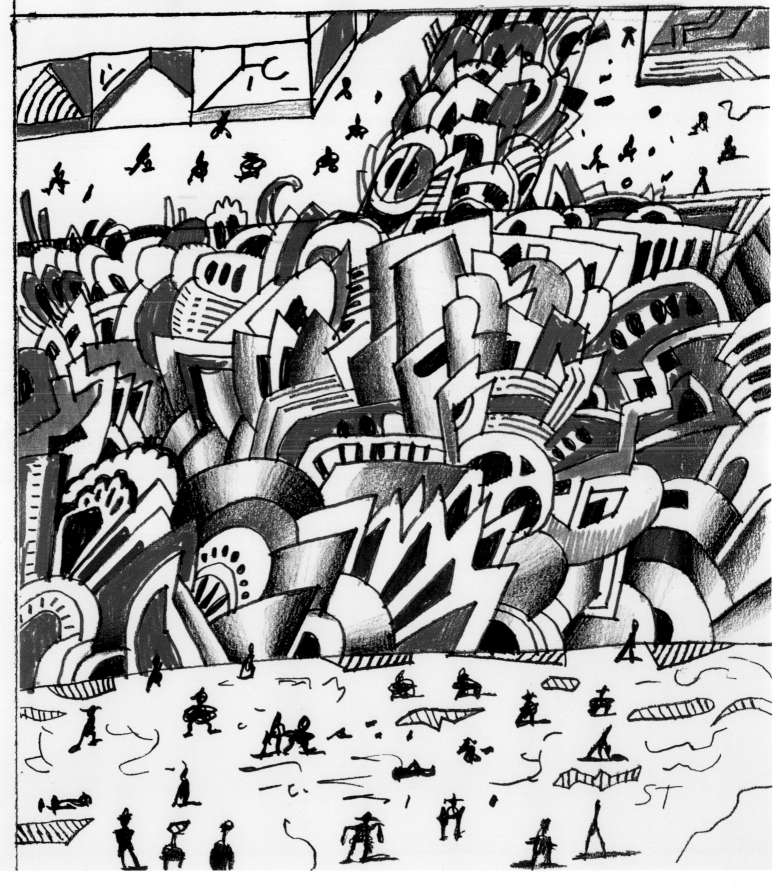

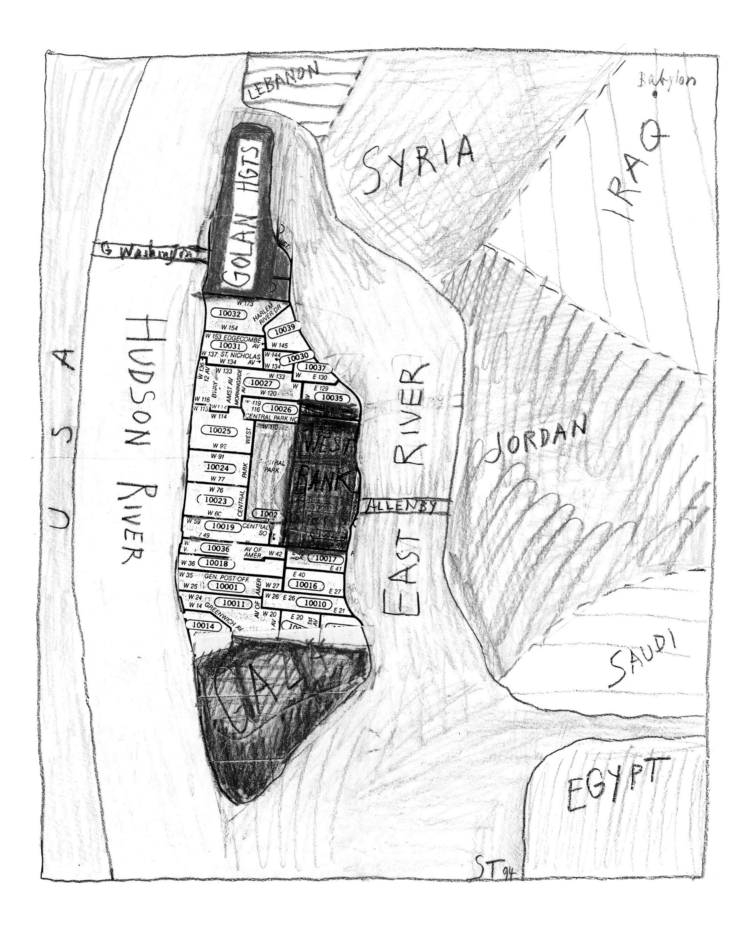

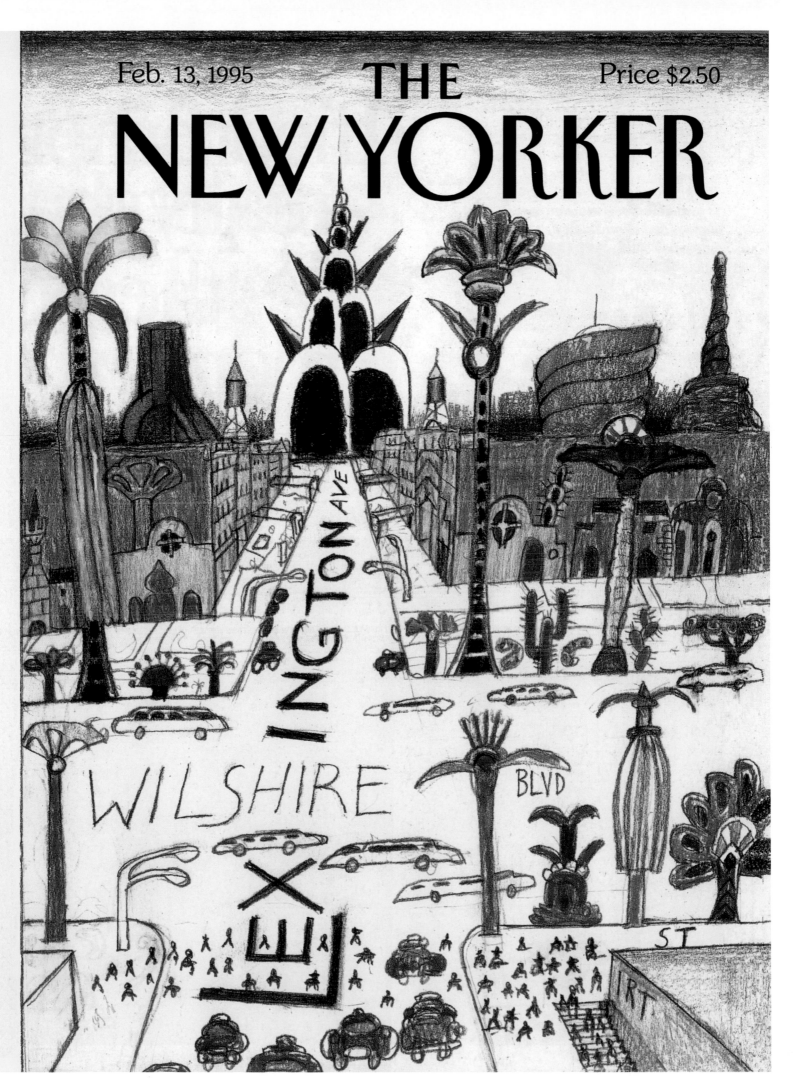

Mapping Time

The map was an ideal format for Steinberg's imagination: a three-way marriage of diagram, picture, and text, loaded with covert opinions and irrefutable trivia. He found maps well suited to charting time, whether in speculation (on the future of Europe, p. 222, and on time itself, p. 224) or in a microdocumentary mode (below). In a cover that ran the month he died, Steinberg observed that every fixed location on the map bears, in its own mind, the label HERE, while every vehicle on every road knows only the eternal NOW of movement (p. 225). He had applied such an idea to his own life, pictured as a hybrid landscape-map, in a 1966 drawing titled *Autogeography* (p. 221) that never appeared on a *New Yorker* cover, though its vertical format and degree of finish leave no question that it was intended for that purpose. Over a plain meanders the river of Steinberg's life, weaving among dozens of place names sized and sited according to the vagaries of fond or bitter memory: Râmnicul Sărat ("a place invented for me to be born in"); Tashkent and Tuba City ("where I bought a hat"), Riverhead and Calcutta, Milan and New York. Here, as so often in a career spanning six decades, Steinberg used a language of his own devising to re-create the world in his own image.

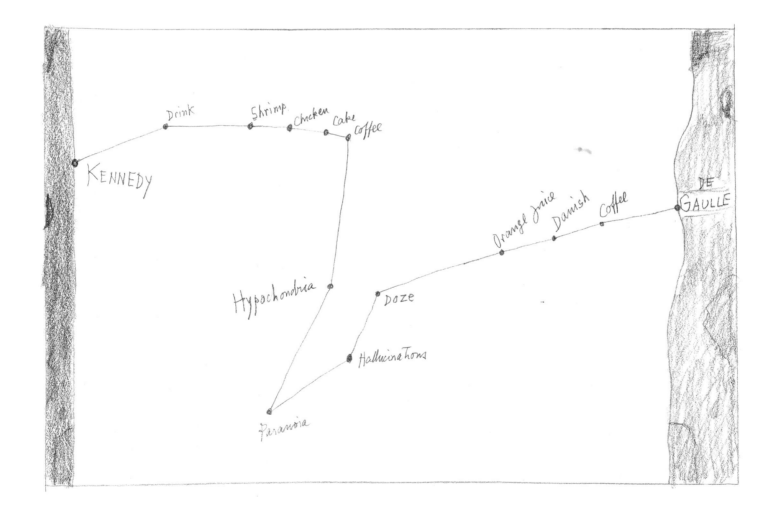

From "Maps," February 21–28, 2000

Opposite: *Autogeography*, 1966, an unpublished cover drawing

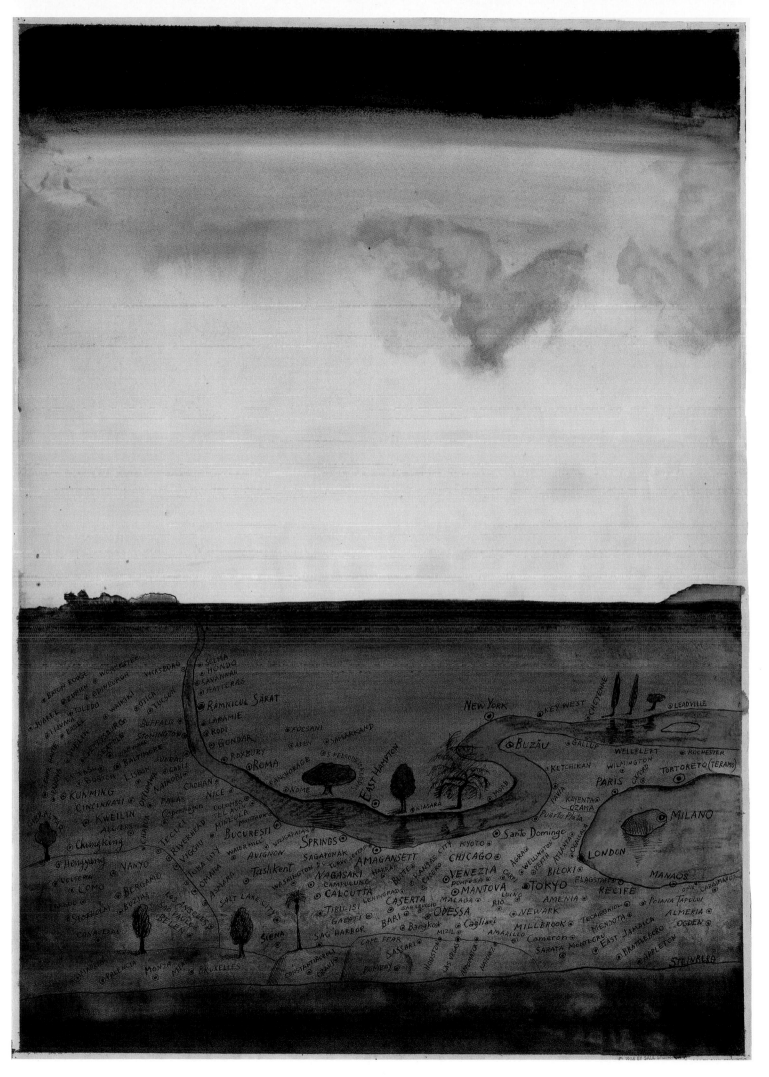

From "Maps," February 21–28, 2000

Jan. 6, 1997

THE
NEW YORKER

Price $2.95

Price $3.00

The

NEW YORKER

May 24, 1999

Endnotes

Saul Steinberg's papers are on deposit at the Yale Collection of American Literature, Beinecke Rare Book and Manuscript Library, Yale University (henceforth YCAL). The papers, uncatalogued at the time of writing, are classified as Uncat. Mss. 126. References are given to the present box numbers whenever possible. In many cases, however, there is no single document or source for information given about Steinberg. Much of it has been extrapolated in the course of the author's research from papers scattered throughout the Beinecke boxes as well as those in *The New Yorker* Records, Manuscripts Division, The New York Public Library (henceforth TNYR).

1. See Saul Steinberg with Aldo Buzzi, *Reflections and Shadows*, trans. John Shepley (New York: Random House, 2002), pp. 22–36, and Lawrence Danson, "An Heroic Decision," *Ontario Review* 53 (Winter 2000–01), pp. 57–68.

2. Fig. 5 and "Life in the 'Guativir' Line," *Life*, May 23, 1940, pp. 14–15, 17.

3. Geraghty's memo on Steinberg is reproduced in Ben Yagoda, *About Town: The New Yorker and the World It Made* (New York: Scribner, 2000), p. 178.

4. Quoted in Danson, "An Heroic Decision," p. 64.

5. Ik Shuman to Harold Ross and James Geraghty, November 21, 1941, TNYR, box 366.

6. Harold Ross to Robert E. Sherwood, October 23, 1942, TNYR, box 62; Ross to Elmer Davis, November 5, 1942, in Thomas Kunkel, ed., *Letters from the Editor: The New Yorker's Harold Ross* (New York: Modern Library, 2000), p. 191.

7. Hedda Sterne, in conversation with the author, May 16, 2002. Hedda had married Ben Sterne, an Austrian, in Vienna in the late 1930s. The couple soon separated and he emigrated to Boston, but as conditions worsened in Europe he worked to ensure her safe passage to the United States. Hedda proceeded with a divorce after Steinberg was sent overseas. Her wartime letters to Steinberg (YCAL, box 57) document a period of several weeks she spent at a Reno hotel under the name Hedda Stafford, the name by which she was known to Geraghty.

8. Ross to Steinberg at General Delivery, Los Angeles, January 6, 1943, TNYR, box 62.

9. "Drawings in Color by Steinberg, Paintings by Nivola," Wakefield Gallery, New York, April 12–24, 1943. Steinberg's departure is mentioned in notices for the exhibition in the *New York Herald Tribune*, April 18, 1943, and *Time*, April 26, 1943, p. 79.

10. On the Happy Valley outpost, see Milton Miles, *A Different Kind of War: The Little-Known Story of the Combined Guerilla Forces Created in China by the U.S. Navy and the Chinese During World War II* (New York: Doubleday & Company, 1967), with drawings by Steinberg, dated August 1943, on illustration pp. 8–9.

11. See Jane Kramer, "Mission to China," *The New Yorker*, July 10, 2000, p. 59.

12. Written orders from M.E. Miles, Office of the U.S. Naval Observer, American Embassy, Chungking, China, dated December 6, 1943, direct Steinberg to proceed from Kunming to Algiers via India and report to the Chief of the Office of Strategic Services for temporary duty, YCAL, box 57.

13. Yagoda, *About Town*, p. 182.

14. Reader responses to Steinberg's war spreads, retyped by *The New Yorker*'s mailroom and sometimes accompanied by annotated tear sheets, YCAL, box 57, and TNYR, box 62.

15. The phrase "Uncle Joe School of realistic illustration," coined by graphic designer Paul Rand, is cited in Steven Heller, *Paul Rand* (London: Phaidon, 1999), p. 13. The gradual postwar demise of literalist illustration was greeted with relief by aspiring young illustrators such as R.O. Blechman, who recalls that, by contrast, "The key word in the Fifties was 'concept'..."; Blechman, *Behind the Lines* (New York: Hudson Hills Press, 1980), p. 22.

16. Quoted in Deborah Allen, "Parlor of a Satirist," *Interiors* 110 (October 1950), p. 175.

17. Like these forms of expression, Steinberg's line was, despite appearances, the product of a planned performance. He would typically execute several complete "rehearsals" of an image before drawing the publishable version, which poured forth (in Hedda Sterne's words) "at the speed of breathing." On the creative and receptive context surrounding Steinberg's first decades in America, see Brooke Kamin Rapaport and Kevin L. Stayton, *Vital Forms: American Art and Design in the Atomic Age, 1940–1960*, exh. cat. (New York: Brooklyn Museum of Art, 2002), and Daniel Belgrad, *The Culture of Spontaneity: Improvisation and the Arts in Postwar America* (Chicago: University of Chicago Press, 1998).

18. Saul Steinberg, "Steinberg at the Bat," *Life*, July 11, 1955, p. 55, and "Saul Steinberg Stamp Collection," *Harper's Bazaar* (June 1959), p. 73.

19. In conversation with the author, March 3, 2004, Lee Lorenz noted that Geraghty and Ross invented the art category "spot-plus" in order to compensate Steinberg for a specific type of drawing. Because many of his drawings were not meant to be funny, they did not qualify as cartoons, but they conveyed idea content, and were therefore more than spots. In the running tabulation of Steinberg's contributions kept in *The New Yorker*'s library, the designation "spot-plus" last appears in 1961.

20. Geraghty to Steinberg, July 13, 1944, YCAL, box 57. Solicited for suitable cover art while he was still in China, Steinberg had obtained the military censor's clearance to submit a colored drawing of an airfield. The drawing was never used: it arrived via Navy packet in New York months late, irreparably damaged in transit, and only after the magazine had printed a black-and-white version of the subject in the January 15, 1944 "Fourteenth Air Force: China Theatre" portfolio; Ross to Steinberg and Geraghty to Steinberg, May 2, 1944, TNYR, box 62.

21. On a full page and on the back of the dust jacket of Steinberg's *The Passport* (1954), the drawing appears without the collage element.

 The absence of Steinberg covers in these years did not reflect a lack of will on either side. When Ross sent Steinberg a note complaining that Steinberg should have created a cover out of one of the drawings that appeared in his 1949 book *The Art of Living*,

Steinberg assured him, "I'm very anxious to do covers for the magazine. . . ." Ross replied: "I, for one, never hold it against an artist when he loses patience, or interest, and sidetracks anything. We're a fussy outfit, God knows. We all hope earnestly that you will do some covers, and my theory is that you will, given time"; Steinberg to Ross, September 19, 1949, and Ross to Steinberg, September 22, 1949, TNYR, box 62.

22. Steinberg to Aldo Buzzi, November 18, 1945 and January 26, 1946, in Steinberg, *Lettere a Aldo Buzzi 1945–1999* (Milan: Adelphi Edizioni, 2002). The translations used in this essay are taken from the English-language version now in preparation under the auspices of The Saul Steinberg Foundation.

23. Steinberg to Ross, April 8, 1947, TNYR, box 62.

24. Quoted in John Gruen, typescript interview with Steinberg (with handwritten amendments by the artist) dated January 19, 1978, p. 14, YCAL, box 67 (henceforth Gruen interview, 1978). Edited and adapted as "Saul Steinberg," in Gruen, *The Artist Observed: 28 Interviews with Contemporary Artists* (New York: A Capella Books, 1991), pp. 161–71.

25. Steinberg to Buzzi, January 26, 1946, in *Lettere a Aldo Buzzi*.

26. Rosalind Constable, "Saul Steinberg: A Profile," *Art Digest* 28 (February 1, 1954), p. 9.

27. On the origins of the type in popular art, see Virginia Smith, *The Funny Little Man: The Biography of a Graphic Image* (New York: Van Nostrand Reinhold, 1993). Smith's account identifies the "FLM" primarily with prewar European advertising, and dates his demise to the war.

28. In writing as in art, Thurber's effect at the magazine was decisive, as Wolcott Gibbs regretted: "[T]he average *New Yorker* writer, unfortunately influenced by Mr. Thurber, has come to believe that the ideal *New Yorker* piece is about a vague, little man helplessly confused by a menacing and complicated civilization"; Wolcott Gibbs, "Theory and Practice of Editing New Yorker Articles" (office memo), 1937, in Thomas Kunkel, *Genius in Disguise: Harold Ross of The New Yorker* (New York: Carroll & Graf, 1995), p. 443.

29. *The New Yorker*, October 29, 1949, p. 78.

30. Steinberg, who regarded Ross as a conventionally casual anti-Semite of his generation, sensed that the editor harbored suspicions about his large-nosed cartoon figures; see Adam Gopnik, typescript interview with Steinberg dated February 1986, p. 10, YCAL, box 67 (henceforth Gopnik interview, 1986). In a wartime letter to Ross, Steinberg voiced regret that in the April 8, 1944 issue the magazine had run one of his old "European" (meaning emptily whimsical) cartoons, which portrayed a little man opening boxes from which further boxes spring up. Ross, misunderstanding Steinberg's point, sought to reassure him that "the man in that picture is completely passable as a North American. In fact, he seems to be a rather high class American, a fellow to be proud of. There are plenty of men in this country that look like him"; Steinberg to Ross, April 27, 1944, and Ross to Steinberg, May 19, 1944, TNYR, box 62.

31. William Steig, preface to *Dreams of Glory: And Other Drawings* (New York: Alfred A. Knopf, 1953).

32. Steinberg to Buzzi, November 29, 1985, in *Lettere a Aldo Buzzi*.

33. "First grade is the shock from which we can never recover. That is the tragedy of our lives, the time when we learned to trust and obey and face forward. If I have a tragedy in my own life, it is going to school, with hours of terror before me. Terror. Obedience. Duty"; quoted in Adam Gopnik, undated typescript interview with Steinberg, c. 1990, pp. 5–6, YCAL, box 67 (henceforth Gopnik interview, c. 1990). The passage is published in Gopnik, "Le Nain de la Maternelle" (interview with Steinberg), *Egoïste* 1, no. 12 (1992), p. 102.

34. Quoted in Pierre Schneider, "Steinberg at the Louvre," *Art in America* 55 (July–August 1967), p. 83.

35. Lee Lorenz, conversation with the author, March 3, 2004.

36. "At home to look at some old drawings from '51–'52, not bad—I should have made large paintings back then—subjects: diners, girls, cars, an America I believe myself the first to have discovered, or at least to have sketched, since photographers like Walker Evans were already making the rounds"; Steinberg to Buzzi, December 15, 1984, in *Lettere a Aldo Buzzi*. On jukeboxes, diners, and Deco Americana, see Steinberg, *Reflections and Shadows*, pp. 56, 67.

Asked which twentieth-century artists he rated most highly, Steinberg named James Joyce, Vladimir Nabokov, Pablo Picasso, Walker Evans, and Andy Warhol; see Grace Glueck, "The 20th-Century Artists Most Admired by Other Artists," *Art News* 76 (November 1977), p. 101.

37. Steinberg often used the word "stenographic" to describe his line, for example, in Jean vanden Heuvel (Jean Stein), "Straight from the Hand and Mouth of Steinberg," *Life*, December 10, 1965, p. 62, and in Gruen interview, 1978, p. 5. In the latter, Steinberg describes "the evolution—the transition from the architectural drawings into the same stenographic architectural quality of the early cartoons. . . . I would say, I came out of architecture."

38. Steinberg applied the designations "primitive," "savage," and "Red Indian" to all levels of American culture. "Recently I think I've discovered the key to understanding the American abstract painters: they're primitives." "I've been back here for a couple of days. I had a very instructive trip. From Los Angeles to Denver by bus with the poor, peasants, Indians, servants. (In America the bus is only for the very poor.) Across deserts that are truly scary, villages of almost savage people"; Steinberg to Buzzi, December 7, 1949 and September 11, 1950, in Steinberg, *Lettere a Aldo Buzzi*.

39. Steinberg, interview with Jacques Dupin, January 13, 1978, typescript, p. 23, The Saul Steinberg Foundation.

40. Gruen, *The Artist Observed*, p. 170.

41. Quoted in Constable, "Saul Steinberg," p. 29.

42. Gopnik interview, 1986, p. 7.

43. Grace Glueck, "The Artist Speaks: Saul Steinberg," *Art in America* 58 (November–December 1970), p. 113.

44. Quoted in vanden Heuvel, "Straight from the Hand and Mouth of Steinberg," p. 59.

45. Quoted in Dore Ashton, "Art: Lecture by Rothko," *The New York Times*, October 31, 1958, p. 26 (notes from a lecture delivered by Mark Rothko at Pratt Institute, Brooklyn, 1958).

46. Despite the dramatic and multifaceted evolution in comics over the past three decades, Steinberg's work has had few heirs in this field. His influence is far more evident, even ubiquitous, in the field of editorial illustration.

Steinberg, an enthusiast of great cartoons and comics art, told Ian Frazier that he had once urged Shawn to publish the work of underground cartoonist R. Crumb, but that Shawn had shuddered at the thought; Frazier, conversation with the author, March 11, 2004. Crumb's debut at the magazine waited until February 21, 1994, when his downscale version of Eustace Tilley graced the anniversary issue.

47. For an early appreciation of Steinberg's art as social commentary, see Heinz Politzer, "The World of Saul Steinberg: A Mirror Reflecting the Forlornness of Modern Man," *Commentary* 4 (October 1947), pp. 319–24.

48. Quoted in vanden Heuvel, "Straight from the Hand and Mouth of Steinberg," p. 66.

49. Gopnik interview, 1986, p. 7.

50. Quoted in vanden Heuvel, "Straight from the Hand and Mouth of Steinberg," p. 66.

51. The only years after 1959 in which no Steinberg covers appeared were 1973, 1974, 1977, 1984, 1986, and the years of Robert Gottlieb's editorship, 1988–91, following Shawn's dismissal from the magazine.

52. For examples of color magazine features by Steinberg, see "Steinberg at the Bat," *Life*, July 11, 1955, pp. 55–61; "Steinberg Field," *Fortune* 53 (February 1956), pp. 96–99; and "Steinberg at the Races," *Sports Illustrated*, November 11, 1963, pp. 40–47. His advertising work of the 1950s included prominent series for Noilly-Pratt Vermouth, Miron Woolens, *House and Garden* magazine, and Simplicity Patterns, all of which ran in *The New Yorker*, in the last instance in color; see Manuel Gasser, "Steinberg as an Advertising Artist," *Graphis*, no. 67 (September–October 1956), pp. 376–85.

53. See *The Complete Book of Covers from The New Yorker: 1925–1989* (New York: Alfred A. Knopf, 1989) and especially John Updike's felicitous foreword, pp. v–vii.

54. For these cem covers, see *The Complete Book of Covers from The New Yorker*, April 2, 1955; September 22, 1956; May 18, 1957; April 19, 1958; February 14, 1959; September 26, 1959; November 7, 1959; and June 6, 1964.

55. Gopnik interview, c. 1990, p. 4.

56. Steinberg to Ross, October 12, 1943, TNYR, box 62.

57. Gruen interview, 1978, p. 5.

58. Cigarette smoke and Art Nouveau: John Jones, "Tape-Recorded Interview with Saul Steinberg," October 12, 1965, typescript, p. 16, in John Jones

interviews with artists, Archives of American Art, Washington, D.C. Cubism and electric light: "Saul Steinberg Interview," unsigned typescript with hand corrections by Steinberg, dated June 1986, p. 4, YCAL, box 67 (henceforth "Saul Steinberg Interview," 1986).

59. Steinberg, *Reflections and Shadows*, p. 86.

60. Steinberg to Buzzi, September 26, 1949, in *Lettere a Aldo Buzzi*.

61. Adam Gopnik, "What Steinberg Saw," *The New Yorker*, November 13, 2000, p. 146.

62. Susan Sontag, "America Seen Through Photographs, Darkly," in Sontag, *On Photography* (New York: Delta, 1977), p. 45.

63. Lee Lorenz, *The Art of The New Yorker 1925–1995* (New York: Alfred A. Knopf, 1995), p. 82.

64. Anton Van Dalen, quoted in Sarah Boxer, "An Assistant Tells All, Finally and Gracefully," *The New York Times*, February 22, 2004, section 2, p. 39.

65. Steinberg, to be sure, sold many artworks through his various dealers. He also sold original drawings that had appeared in *The New Yorker*, but he did so on his own terms—for example, through the double gallery show "Saul Steinberg Cartoons" (Sidney Janis and Betty Parsons galleries, November 17–December 12, 1976)—rather than on the ad hoc basis hoped for by countless fans who wrote to him over the years, care of the magazine. Whenever possible, he sold variant versions of *New Yorker* work, keeping the original of the published drawing for himself.

66. Prudence Crowther, email to the author, January 4, 2004.

67. Lorenz, conversation with the author, March 3, 2004.

68. Steinberg to Buzzi, August 31 and October 28, 1987, in *Lettere a Aldo Buzzi*.

69. Handwritten notation by Steinberg on Gruen interview, 1978, p. 3.

70. Lorenz, conversation with the author, March 3, 2004.

71. Steinberg to Buzzi, August 13, 1979, in *Lettere a Aldo Buzzi*.

72. Ibid., June 25, 1984.

73. Sketches for, and variations on, several dozen of these sketchpad *pensées*, which Steinberg often called "Ex Votos," are among the artist's papers, YCAL, box 117.

74. "Remembering Mr. Shawn," *The New Yorker*, December 28, 1992–January 3, 1993, p. 143.

75. Steinberg to Buzzi, January 4, 1990, in *Lettere a Aldo Buzzi*.

76. Steinberg, in Gopnik, "Le Nain de la Maternelle," p. 102.

77. For some years Steinberg watched the decline of facility in his own work with equanimity, explaining: "I'm reasonably clumsy, but this is no drawback. . . . Even in Picasso it is the clumsy we like, not the use of dexterity. He can be facile, but clumsiness means reasoning, making up your mind, searching. Matisse too

was clumsy. The clumsiness, the hesitations are the parts in the drawing where one sees the emotion and the reasoning"; "Saul Steinberg Interview," 1986, p. 2.

78. Françoise Mouly, conversation with the author, March 3, 2004.

79. In the mid-1990s, Steinberg asked Roger Angell to alert him if it ever seemed that his art was becoming "childish"; Roger Angell, conversation with the author, March 10, 2004. The request may have reflected both self-doubt and hesitancy on Steinberg's part about reconciling his own judgments with the taste of a magazine whose aims and criteria had changed radically.

80. Gruen interview, 1978, p. 13.

81. Steinberg to Buzzi, September 16, 1969, in *Lettere a Aldo Buzzi*.

82. John Updike, interviewed on "Making History with Roger Mudd," The History Channel, March 6, 2004. For the comment's fuller context, see "The Importance of Fiction," collected in Updike, *Odd Jobs: Essays and Criticism* (New York: Alfred A. Knopf, 1991), p. 89.

83. Gopnik interview, c. 1990, pp. 4, 11. The first passage quoted appears, in slightly variant form, in Steinberg, *Reflections and Shadows*, p. 84.

84. Ik Shuman to Steinberg, December 30, 1943, and James Geraghty to Steinberg, January 17, 1944, YCAL, box 57.

85. Gruen interview, 1978.

86. Heraldic devices drawn from American currency appear throughout Steinberg's work, from the elements of the Great Seal to the ubiquitous tufts of vegetation, for example, on pp. 66, 105, 118 top left, and 149, which appear to have been transplanted from the base of the one dollar bill's Masonic pyramid.

87. Steinberg, "Chronology," in Harold Rosenberg, *Saul Steinberg*, exh. cat. (New York: Whitney Museum of American Art, 1978), p. 241.

88. Steinberg, Year Book (pocket diary) entry dated January 21, 1951, YCAL, box 3.

89. Steinberg to Buzzi, March 4, 1963, in *Lettere a Aldo Buzzi*.

90. Steinberg, Year Book (pocket diary) entry dated August 8, 1952, YCAL, box 3.

91. "Saul Steinberg Interview," 1986, p. 3.

92. Quoted in vanden Heuvel, "Straight from the Hand and Mouth of Steinberg," p. 68.

93. Quoted in Harold C. Schonberg, "Artist Behind the Steinbergian Mask," *The New York Times Magazine*, November 13, 1966, p. 164.

94. Quoted in Schneider, "Steinberg at the Louvre," p. 82.

95. Quoted in Meera E. Agarwal (Thompson), "Steinberg's Treatment of the Theme of the Artist: A Collage of Conversations," unpublished manuscript, December 1972, p. 25, YCAL, box 67.

96. Gopnik interview, 1986, p. 7.

97. Quoted in Agarwal, "Steinberg's Treatment of the Theme of the Artist," p. 9.

98. Quoted in vanden Heuvel, "Straight from the Hand and Mouth of Steinberg," p. 64.

99. Quoted in Schneider, "Steinberg at the Louvre," p. 88.

100. The thirty-four transcribed telephone messages and mailed-in queries regarding the September 25, 1971 cover, along with *The New Yorker*'s form-letter response, are in TNYR, box 1009.

101. Quoted in Grace Glueck, "A Way to Stamp Out Art," *The New York Times*, November 9, 1969, p. D28.

102. Steinberg's letter, still in the possession of the recipient, is dated March 6, 1967.

103. Quoted in vanden Heuvel, "Straight from the Hand and Mouth of Steinberg," pp. 64, 66.

104. Quoted in Agarwal, "Steinberg's Treatment of the Theme of the Artist," p. 11.

105. Steinberg to Buzzi, December 9, 1979, in *Lettere a Aldo Buzzi*.

106. See Adam Gopnik, "Steinberg's Gift," in *Saul Steinberg*, exh. cat. (New York: Pace Gallery, 1987).

107. Quoted in Schneider, "Steinberg at the Louvre," p. 84.

108. Ibid., pp. 84 and 87.

109. Steinberg to Buzzi, June 1, 1958, in *Lettere a Aldo Buzzi*. The novel was Carlo Emilio Gadda's *Il pasticciaccio [That Awful Mess on Via Merulana]*.

110. Steinberg, undated typescript, YCAL, box 67, pp. 101–03.

111. "Saul Steinberg Interview," 1986, p. 1.

112. Steinberg, *Reflections and Shadows*, p. 70.

113. Gruen interview, 1978, p. 8.

Selected Bibliography

Archives

Saul Steinberg Papers, Yale Collection of American Literature, Beinecke Rare Book and Manuscript Library, Yale University, Uncat. Mss. 126

The New Yorker Records, Manuscripts Division, The New York Public Library

Art at *The New Yorker*

Gertrud Vowinckel-Textor, "Der New Yorker und seine Bedeutung für die moderne humoristische Zeichnung, den Cartoon," in *Bild als Waffe: Mittel und Motive der Karikatur in fünf Jahrhunderten*. Exhibition catalogue. Hannover: Wilhelm-Busch-Museum, 1985, pp. 441–49

The Complete Book of Covers from The New Yorker: 1925–1989. New York: Alfred A. Knopf, 1989. Foreword by John Updike

Lee Lorenz, *The Art of The New Yorker 1925–1995*. New York: Alfred A. Knopf, 1995

Ben Yagoda, *About Town: The New Yorker and the World It Made*. New York: Scribner, 2000

Großstadtfieber: 75 Jahre The New Yorker. Exhibition catalogue. Edited by Gisela Vetter-Liebenow. Hannover: Wilhelm-Busch-Museum, 2000

The Complete Cartoons of The New Yorker. Edited by Robert Mankoff. New York: Black Dog & Leventhal, 2004. Foreword by David Remnick

Books by Saul Steinberg

All in Line. New York: Duell, Sloan and Pearce, 1945

The Art of Living. New York: Harper & Brothers, 1949

The Passport. New York: Harper & Brothers, 1954

Steinberg's Umgang mit Menschen. Hamburg: Rowohlt, 1954

Dessins. Paris: Gallimard, 1956

The Labyrinth. New York: Harper & Brothers, 1960

The New World. New York: Harper & Row, 1965

Le Masque. Essays by Michel Butor and Harold Rosenberg, photographs by Inge Morath. Paris: Maeght, 1966

The Inspector. New York: Viking, 1973

All Except You. With Roland Barthes. Paris: Repères, 1983

Dal Vero. With John Hollander. New York: The Library Fellows of the Whitney Museum of American Art, 1983

Canal Street. With Ian Frazier. New York: The Library Fellows of the Whitney Museum of American Art, 1990

The Discovery of America. Essay by Arthur C. Danto. New York: Alfred A. Knopf, 1992

Saul Steinberg: Masquerade. Photographs by Inge Morath. New York: Viking Studio, 2000

Reflections and Shadows. With Aldo Buzzi. Translated by John Shepley. New York: Random House, 2002

Lettere a Aldo Buzzi 1945–1999. Edited by Aldo Buzzi. Milan: Adelphi, 2002

Exhibition Catalogues

Saul Steinberg: Zeichnungen, Aquarelle, Collagen, Gemälde, Reliefs, 1963–1974. Essays by Tilman Osterwald, Wilhelm Salber, and Gertrud Textor. Cologne: Kölnischer Kunstverein, 1974

Saul Steinberg. Essay by Harold Rosenberg. New York: Whitney Museum of American Art, 1978

Steinberg. 4. Internationale Triennale der Zeichnung. Essays by Italo Calvino and Curt Heigl. Nuremberg: Kunsthalle Nürnberg, 1988

Saul Steinberg: Fifty Works from the Collection of Sivia and Jeffrey Loria. Essays by John Updike and Jean Leymarie. New York: Jeffrey H. Loria & Co., 1995

Saul Steinberg. Essays by Dore Ashton, Roland Barthes, Italo Calvino, and Colin Eisler. Valencia: Institut Valencià d'Art Modern, 2002

Interviews with Steinberg

Jean vanden Heuvel (Jean Stein), "Straight from the Hand and Mouth of Steinberg." *Life*, December 10, 1965, pp. 59–70

Pierre Schneider, "Steinberg at the Louvre." *Art in America* 55 (July–August 1967), pp. 82–91

Grace Glueck, "The Artist Speaks: Saul Steinberg." *Art in America* 58 (November–December 1970), pp. 110–17

Adam Gopnik, "Le Nain de la Maternelle." *Egoïste* 1, no. 12 (1992), pp. 100–05

Articles

Russell Lynes, "A Man Named Steinberg." *Harper's*, 209 (August 1954), pp. 44–48

Manuel Gasser, "Steinberg as an Advertising Artist." *Graphis*, no. 67 (September–October 1956), pp. 376–85

John Ashbery, "Saul Steinberg: Callibiography" (1970). Reprinted in Ashbery, *Reported Sightings: Art Chronicles, 1957–1987*. New York: Alfred A. Knopf, 1989, pp. 279–84

Robert Hughes, "The World of Steinberg" (1978). Reprinted in *Nothing If Not Critical: Selected Essays on Art and Artists*. New York: Alfred A. Knopf, 1990, pp. 259–67

Joseph Masheck, "Saul Steinberg's 'Written' Pictures." *Artforum* 16 (Summer 1978), pp. 26–30

Marc Treib, "Maps of the Mind." *Print* 41 (March–April 1987), pp. 112–17

Jane Kramer, "Mission to China." *The New Yorker*, July 10, 2000, pp. 59–65

Adam Gopnik, "What Steinberg Saw." *The New Yorker*, November 13, 2000, pp. 141–47

Vincent Baudoux, "Saul Steinberg: Le dessin revisité." *9e Art: Les Cahiers du Musée de la Bande Dessiné*, no. 10 (April 2004), pp. 32–39

The Covers, 1945–2004

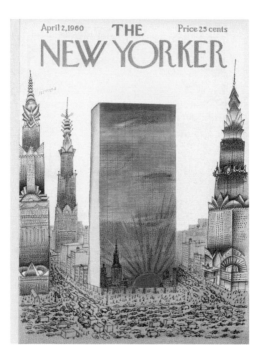

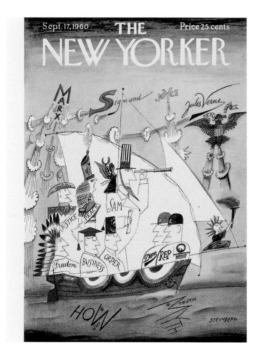

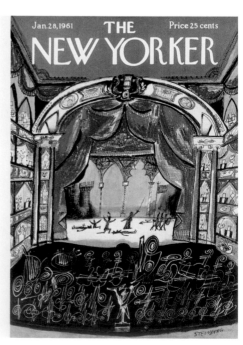

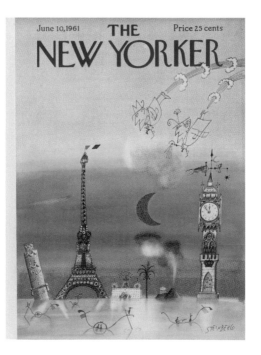

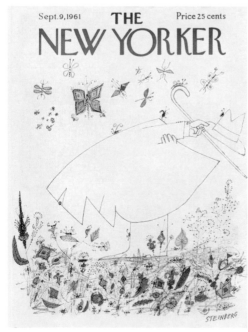

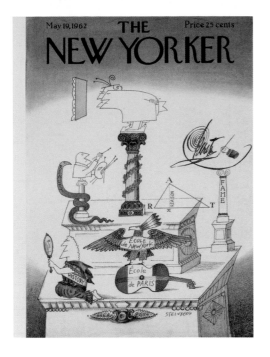

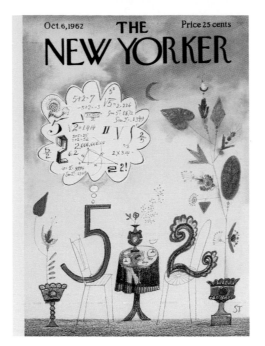

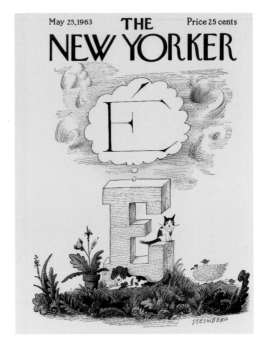

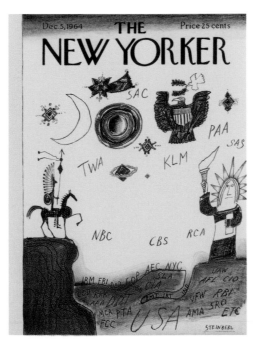

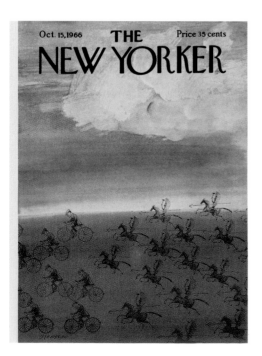

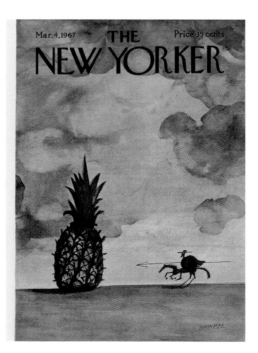

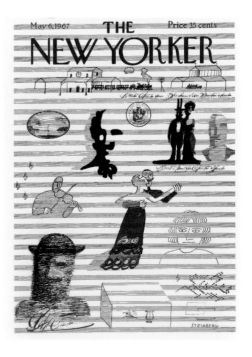

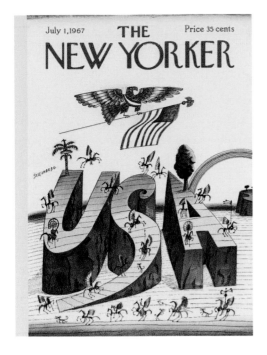

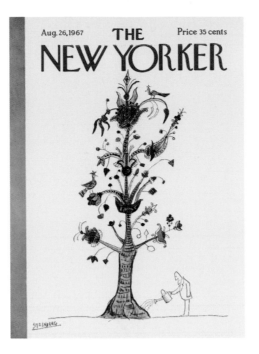

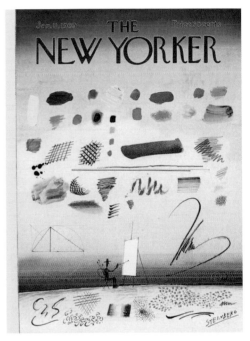

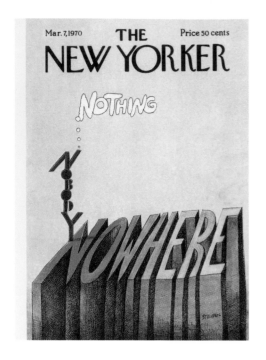

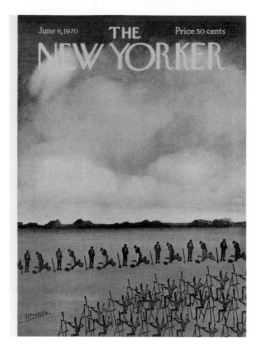

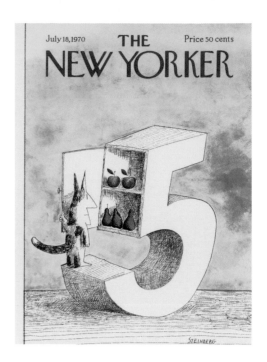

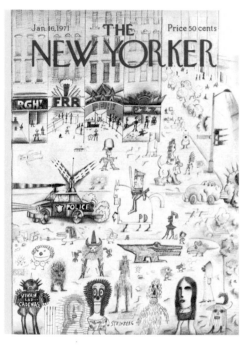

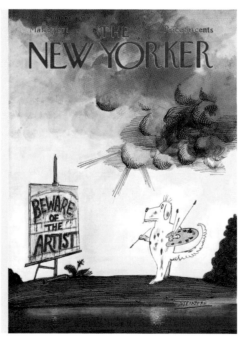

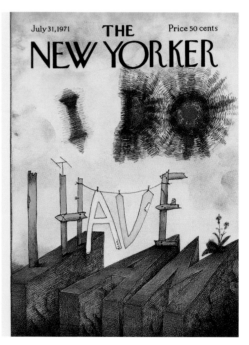

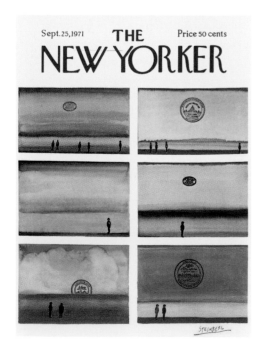

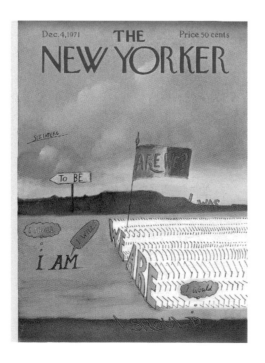

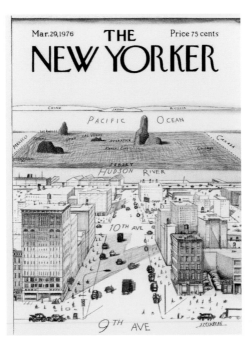

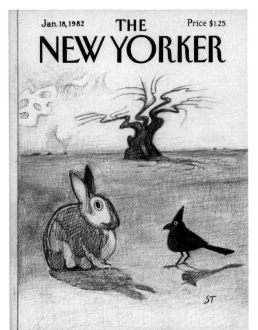

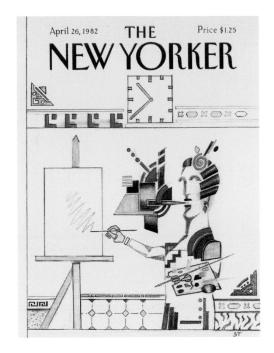

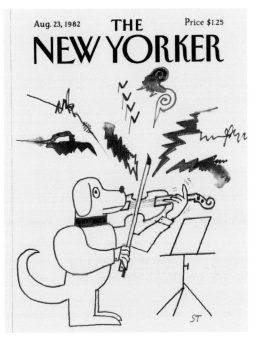

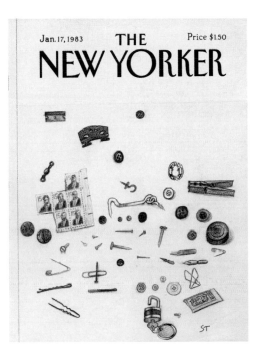

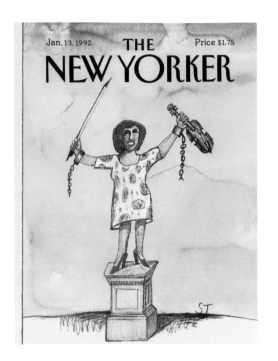

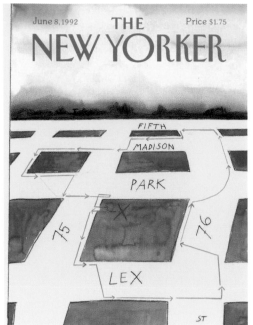

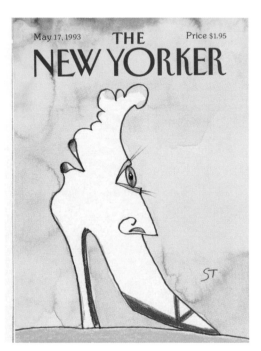

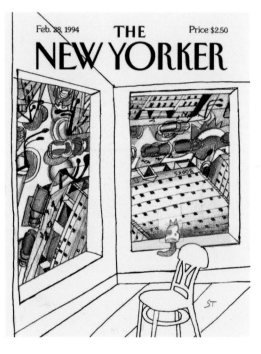

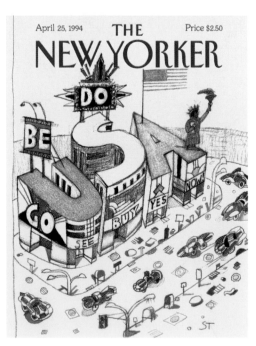

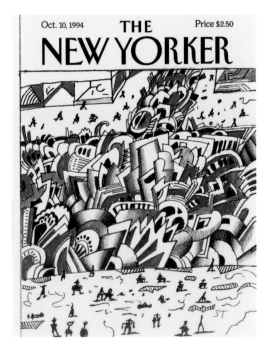

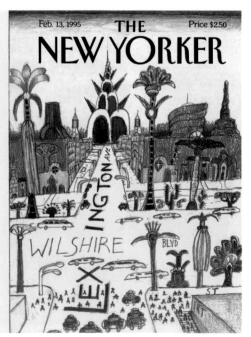

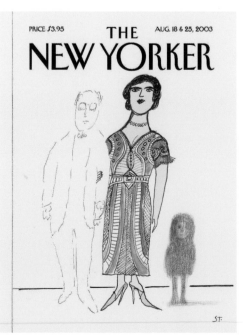

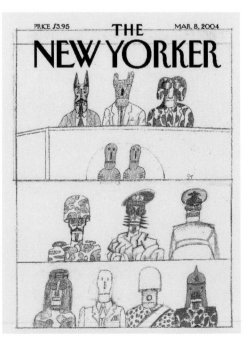